D1217384

SIMON STARLING

DIETER ROELSTRAETE
FRANCESCO MANACORDA
JANET HARBORD

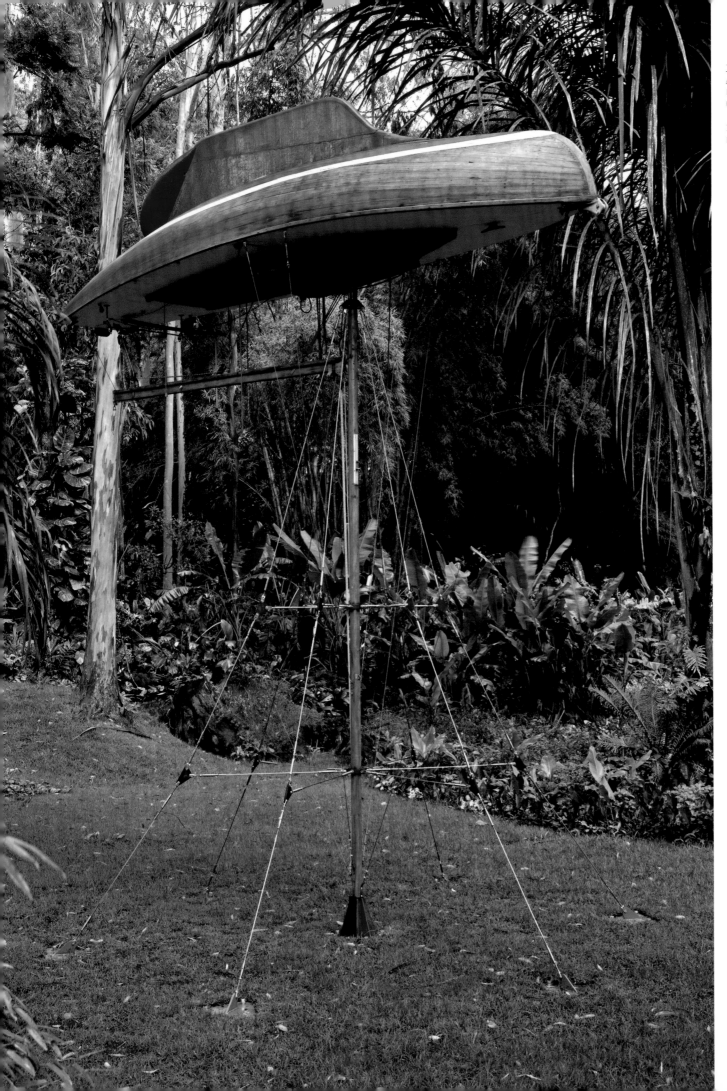

THE MAHOGANY PAVILLION (MOBILE
ARCHITECTURE NO. 1), 2004
LOCH LONG SAILING BOAT, RIGGING
640 X 600 X 350 CM

INSTALLATION VIEW IN INHOTIM,
BELO HORIZONTE, BRAZIL

CONTENTS

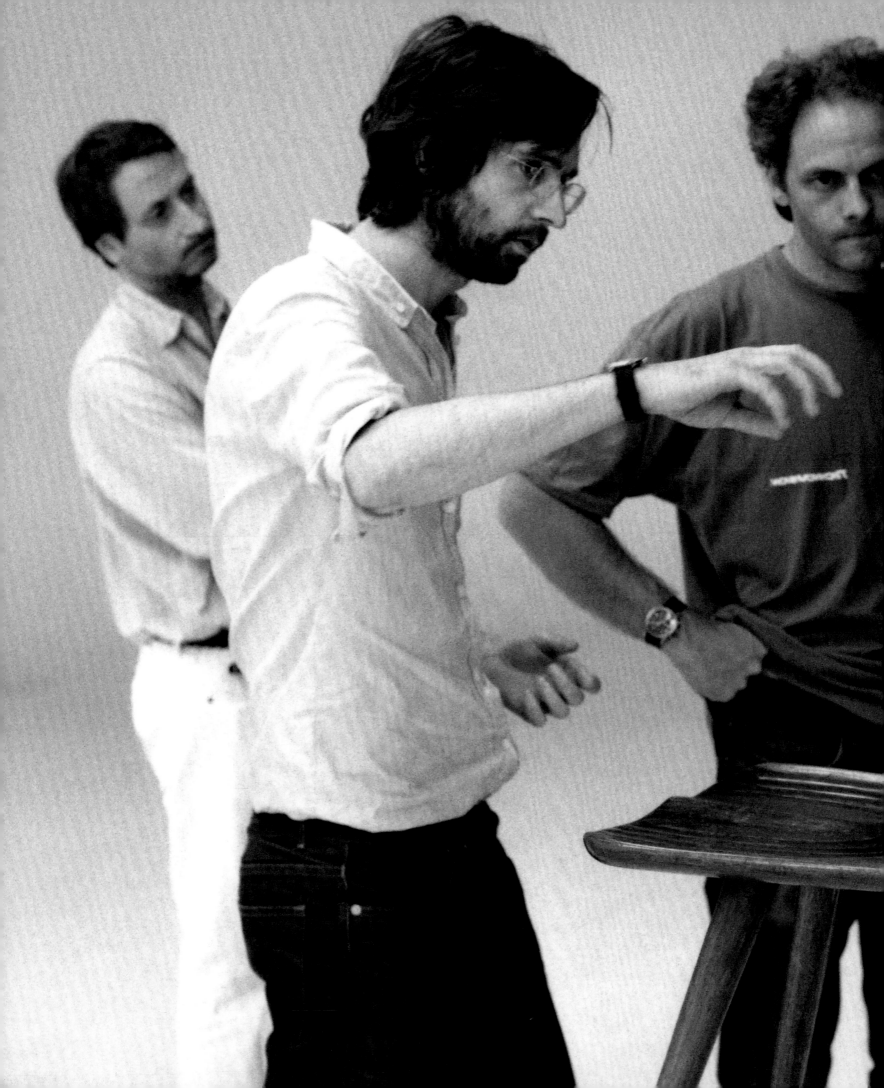

previous pages,
SIMON STARLING AT WORK ON FOUR
THOUSAND SEVEN HUNDRED AND
FORTY FIVE (MOTION CONTROL/
MOLLINO) AT LUMIQ STUDIOS,
TURIN, 2007

below,
PROJECT FOR A MASQUERADE
(HIROSHIMA), 2010
FILM PROJECTION
25 MIN. 54 SEC.
SCREEN 300 X 500 CM

INSTALLATION VIEW AT
KUNSTHAL CHARLOTTENBORG,
COPENHAGEN

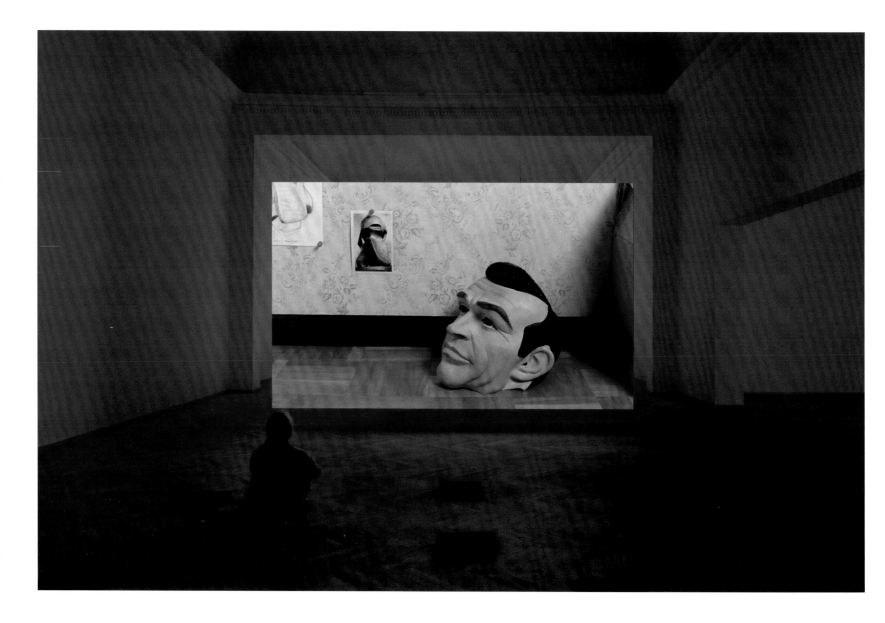

FRANCESCO MANACORDA: *I think that a nice way to start is to look at your latest works and go backwards in time. In particular I would like to begin with one of your recent works:* Project for a Masquerade (Hiroshima) *(2010-11), a complex project that articulates into two different exhibitions. To a higher degree than previous works, it implies multiple overlapping narratives and several historical and fictional situations. Can you tell us what are the different elements that you brought together?*

SIMON STARLING: Structurally it's typical of a number of works that I've made in the last ten years that have a rather fluid form. The work exists as a set of masks, a set of nine characters, but also as a film, which is in turn a proposition for a theatrical performance. The film documents the making of the nine masks while simultaneously overlaying this visual narrative with a web of further narratives in the form of a voice-over. One is a Japanese folk tale reworked in the sixteenth century as a Noh play, the story of a young noble boy escaping his troubled past to make a new life in the west of Japan. Another is the story of a sculpture made by Henry Moore in the 1960s that can be understood to have developed a double identity. The sculpture exists as a large public monument in Chicago, which marks the site of the first sustainable nuclear reaction, the beginning of the atom bomb project in the US, but it also exists as a

smaller bronze edition in a number of international collections, including, bizarrely enough, the Hiroshima City Museum of Contemporary Art. In Chicago it is know as *Nuclear Energy* (1967), while in Hiroshima it carries the name *Atom Piece* (1964-65). Of course, in those two very different cities, and historical contexts, the work has rather different connotations, and I was interested in how a sculpture could have two such different lives.

MANACORDA: *Especially when the two geographical sites are connected by such an historical tragedy, which involves the similar travel of the bomb from the US to Japan.*

STARLING: Yes, exactly. It seems that when the Hiroshima museum bought the work it was partly under duress from Moore, who was in the last years of his life. They made an agreement that he would sell them a large bronze arch (*The Arch*, 1963) – a public sculpture that now sits outside the museum – and, as part of the deal to bring the large work to Hiroshima, Moore seems to have pushed them to buy *Atom Piece,* too. I had a sense that it was a moment of resolution for him, something that he wanted to do at the end of his life to, I don't know, balance the sense of the work, its very specific connection with the beginnings of the atom bomb project and then its other life, which was probably, in a way, its original life as something a little bit more questioning, more overtly political, I guess, in relation to the atom bomb.

MANACORDA: *Yes, I can imagine the disquiet in committing to a public art piece as a monument to the first nuclear chain reaction. It is not something easy to celebrate. It was a great scientific achievement but …*

STARLING: I think it was something that he was clearly very conflicted about, especially as someone who'd been involved in the early days of the Campaign for Nuclear Disarmament (CND) in Britain. But, at the same time, he was very much a pragmatist, and on one level it was good business. I suppose the thing I was interested in was whether he understood what he was doing as being somehow a radical or subversive act – slipping a critical work in under the radar, so to say – or whether he was simply being pragmatic. Moore's making of the twelve-centimetre-high plaster maquette in 1963 coincided with CND's publication of a landmark poster by the graphic designer Frédéric Henri Kay Henrion, a fellow Hampstead resident before the Second World War. The poster famously collages a human skull onto an image of a mushroom cloud, and it seems clear that Moore's death's-head maquette echoes Henrion's image. Besides agreeing to change the name from *Atom Piece* to *Nuclear Energy* – in 1970, long after the work was completed – he went back into the studio with the small maquette and asked the photographer Errol Jackson to make a series of photographs of him working on the sculpture next to an elephant skull – as if for the first time. So there was this deliberate attempt to distance the work from its original source. I suppose that was, for me, one of the fascinations of working with the story – this interest in how artists orchestrate their own history, edit their own practices as they unfold.

MANACORDA: *Backwards.*

STARLING: Yes, both in retrospect but also as it happens. This retrospective rewriting connects to my interest in Carlo Mollino,[1] whose careful editing of his own performative life I investigated in the work *24 hr Tangentiale* (2006). In the case of the Cold War saga surrounding Moore's sculpture, I started to think about the idea of the masquerade. Moore seemed to have created a disguise for his human death's head. And with that in mind and in the context of Hiroshima, I connected this story to the tradition of masked Noh theatre in which the old become young, men become women and, most interestingly perhaps, the dead assume living form.

PROJECT FOR A MASQUERADE
(HIROSHIMA), 2010-11
6 WOODEN MASKS (CARVED
BY YASUO MIICHI), 2 CAST
BRONZE MASKS
HEIGHTS VARY FROM 18 TO
28 CM

METAL STANDS
HEIGHTS VARY FROM 150 TO
170 CM
BOWLER HAT, SUSPENDED
MIRROR, HD PROJECTOR,
MEDIA PLAYER, SPEAKERS,
SUSPENDED SCREEN/MIRROR,

16 MM FILM TRANSFERRED
TO DIGITAL
25 MIN. 45 SEC.

INSTALLATION VIEW AT
KUNSTHAL CHARLOTTENBORG,
COPENHAGEN, 2011

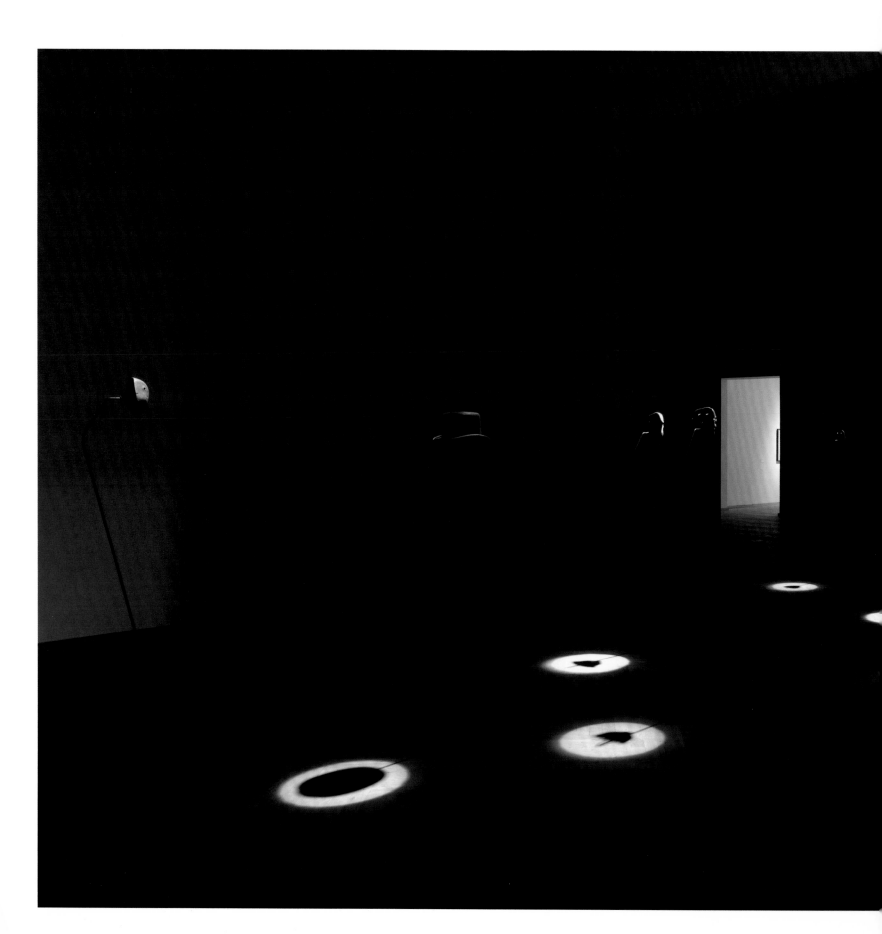

PROJECT FOR A MASQUERADE
(HIROSHIMA), 2010-11
6 WOODEN MASKS (CARVED
BY YASUO MIICHI), 2 CAST
BRONZE MASKS
HEIGHTS VARY FROM 18 TO
28 CM

METAL STANDS
HEIGHTS VARY FROM 150 TO
170 CM
BOWLER HAT, SUSPENDED
MIRROR, HD PROJECTOR,
MEDIA PLAYER, SPEAKERS,
SUSPENDED SCREEN/MIRROR,

16 MM FILM TRANSFERRED
TO DIGITAL
25 MIN. 45 SEC.

INSTALLATION VIEW AT
KUNSTHAL CHARLOTTENBORG,
COPENHAGEN, 2011

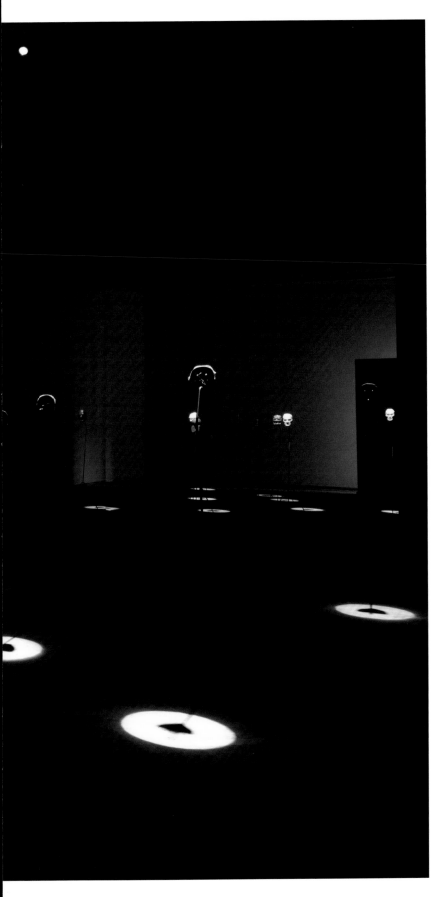

MANACORDA: *It's not uncommon for you to establish and follow a web of connections across the globe and across history, and many of your works are constructed around a sort of rhizomatic structure. But in this case you pushed it further by taking these interrelated pieces of history, politics and fiction and adapting them to an existing, quite strict situation, which is Noh theatre. Did the latter come first – did you try to fit one into the other – or did they come parallel?*

STARLING: I went in search of a traditional Japanese tale that rhymed with the story of Moore's sculpture and began reading some plays in translations. Ernest Fenellosa and Ezra Pound were very involved in bringing Noh theatre to the consciousness of the West, and I waded in and very quickly came across *Eboshi-ori*, this story of disguise and reinvention. The play tells the story of a young noble boy who is trying to escape from his past, to make a new life in the east of Japan. His father has been defeated and killed but he is sent into exile in the mountains. And at the beginning of the play he escapes and hooks up with two gold merchants and then goes to a hat-maker who makes him a disguise, a particular, encoded kind of hat that allows him to travel with the gold merchants through Japan and escape. I understood there to be very clear parallels between this young noble boy's reinvention and the reinvention of the Moore sculpture in Japan, or vice versa.

But in a way, like many of my works, there are these chance collisions, these rather serendipitous meetings that, at a certain point, start to drive the form of things, and while the work clearly demanded an open, propositional approach, in a surprising way there was very little shoehorning involved. Things fell into place rather easily. One of the exciting things about the space of Noh theatre is the sense that it's a space of both temporal and geographic exception. You can make anything happen there. You can summon up the dead.

MANACORDA: *That's very similar to the way that you have linked together different stories, historical times and geographical locations, but in this case the theatrical play functions as a skeleton to this particular web.*

STARLING: Although I've never confronted theatre before, it just seemed to make so much sense in this case.

MANACORDA: *The other element of Noh theatre that you looked into is the mirror room, the space where actors get dressed and prepared before going on stage. How is it used?*

STARLING: It's a space adjacent to the stage that is linked to it by a bridge. It's a heavily ritualized space in which the actors assume their character. Physically they fit their masks, but there's this sense that when the mask goes on they're actually being possessed by the ghosts of the characters they'll perform on stage. There's a very strong sense of a transfiguration that happens in this space before the actors cross the bridge onto the stage. In the Glasgow installation *Project for a Masquerade (Hiroshima): The Mirror Room* (2010), the notional antechamber to the main exhibition in Hiroshima, the masks were exhibited staring at themselves in a suspended mirror.

MANACORDA: *The mirror room also seems to be very close to your interest in transforming elements in your works into something else, which across your career has taken many different shapes and forms.*

STARLING: Yes. Often it's been a very material shift. Perhaps the form is retained,

THREE BIRDS, SEVEN STORIES, INTERPOLATIONS, AND BIFURCATIONS (1:1 SCALE MODEL OF THE 5TH FLOOR OF VIA GIULIA DI BAROLO 9, TURIN), 2007
WOOD, GLASS, PLASTERBOARD, PLASTER, CONCRETE, ELECTRICAL FITTINGS, PAINT
780 X 380 X 280 CM

INSTALLATION VIEW AT GALLERIA FRANCO NOERO, TURIN, 2008

THREE BIRDS, SEVEN STORIES
(PHOTOGRAPH OF AN OFF-SET
PRINT OF A PHOTOMONTAGE OF
THE EXTERIOR OF MANIK BAGH
PALACE, 1933), 2007
PLATINUM/PALLADIUM PRINT
40 X 50 CM

THREE BIRDS, SEVEN STORIES
(THE EXTERIOR OF MANIK
BAGH PALACE), 2007
PLATINUM/PALLADIUM PRINT
40 X 50 CM

but the constituent material of that form is changed, or alternatively the materials are morphed into new forms – bikes become chairs, chairs become bikes, sheds are transformed into boats. Both forms and their substance, their raw materials, can thus be understood to have cultural, political or economic specificity.

MANACORDA: *The mirror room really casts a new light onto that process because of what you just said – this idea of the actors being possessed by ghosts. This metaphor makes your sculptural process less a mechanical and scientific one and more a theatrical or séance-like one, in which objects are possessed by a certain energy, quality or biographical aspect pertaining to politics or the history of ideas.*

STARLING: Yes, that is perhaps an interesting way to understand a work like *Bird in Space, 2004* (2004) which charged a simple slab of Romanian steel with a complex of art historical and political connections, collapsing the story of Brancusi's battle with the US customs in the 1920s onto the very political manipulation of the global trade in steel under George Bush. This could be understood as a kind of possession – two and a half tons of haunted steel.

MANACORDA: *The other element that is coming to the foreground in* Project for a Masquerade (Hiroshima) *is this idea of overlaying multiple narratives that cut across space. Travelling in space is clearly a trope of your work, but in this case it also goes across time.*

STARLING: That's something that's been slowly evolving in my work. This building that we're sitting in [Galleria Franco Noero in Turin] was also the site for an exhibition titled 'Three Birds, Seven Stories, Interpolations and Bifurcations' (2008), which was very much related in its narrative structure to the project for Hiroshima. Within this impossibly narrow building, there was an attempt made to mix all sorts of geographical locations, historical moments and also different narrative forms. The central narrative in *Three Birds* is the real-life tale of the German architect Eckhart Muthesius going to India in the early 1930s to build a modernist palace for a Maharaja, a story that had actually already been told in *The Indian Tomb*, Joe May's 1921 film adaptation of a Fritz Lang and Thea von Harbou screenplay. The work was an attempt to hold this complex of rather tangentially linked phenomena in play in a single constellation of sculptures, images, and texts – to make them talk to each other. There is a constant interplay between fact and fiction. Forms mutate, are transposed, reconstructed. Even Muthesius himself fictionalized his own work in a series of collages that portray his pitched-roofed palace as a flat-roofed, functionalist white box. The structure that resulted in this case, which you rightly described as rhizomatic, has been carried forward and adapted in the latest work.

MANACORDA: *Rather than not committing to a linear narrative, the Hiroshima work commits to polyphonic narratives, so you have three, four, five stories simultaneously. In the film, the action follows the mask-maker in his workshop – that's already quite an incredible narrative – but you also have a voice-over telling the story of the original Noh play, followed by the story of the cast of characters that you brought together. Are polyphonic structures becoming more prominent in your later work?*

STARLING: Yes, but what is also exciting is when these complex works find a form that seems able to contain them. I suppose for me *Wilhelm Noack oHG* (2006) – the four-minute looped film about a company of metal fabricators in Berlin who

THREE BIRDS, SEVEN STORIES
(INTERIOR OF THE 5TH FLOOR OF VIA
GIULIA DI BAROLO 9, TURIN), 2007
PLATINUM/PALLADIUM PRINT
40 X 50 CM

INSTALLATION VIEW AT GALLERIA
FRANCO NOERO, TURIN, 2007

FLAGA 1972-2000, 2002
BOOK
GRAPHIC DESIGN BY PHILIPP
ARNOLD

FLAGA 1972-2000 (FIAT 126
PRODUCED IN TURIN, ITALY, IN 1974
AND CUSTOMISED USING PARTS
MANUFACTURED AND FITTED IN
POLAND, FOLLOWING A JOURNEY OF
1,290 KM FROM TURIN TO CIESZYN),
2002
FIAT 126
PRODUCTION PHOTOGRAPHS

manufactured the loop machine that the film is shown on – was a very important moment in terms of finding a form in the work that allowed for those more complex narrative to co-exist. It took me by surprise how compact and formally resolved that work became. As a working structure it allowed for a very complex story to be told linearly and in a relatively short space of time, while still retaining the scope and complexity of the material. It was an attempt to redeploy a reductive, rhetorical structure, which could perhaps be seen to have come directly from Conceptual Art, in a way that it could contain complexity.

MANACORDA: *It's interesting that you've said 'story to be told', as this makes me think of your interest in publications conceived as integral parts of the work – in particular, for* Three Birds, Seven Stories, Interpolations and Bifurcations. *Did the book act as a goal that helped you to edit the work?*

STARLING: In this case, the book was considered as a primary manifestation, and the exhibition, in large part, a way to edit that book. The architecture of the gallery gave form to the book, and conceiving the exhibition as a book gave structure to the exhibition. I've made three solo exhibitions here in Turin, all of which have found very specific form as books in the end. In a way, I think it's this idea that the work might have three or four manifestations. For example, *Flaga 1972-2000* (2002) exists as a 'performative' event (i.e. a journey from Turin to Poland in a red Fiat to exchange some body panels), as a sculpture (a car shown hanging on the wall like a painting), as a very carefully produced book, and as an anecdote. For me, all of those things have equal value. The book is as important a manifestation as the sculpture that hangs on the wall in the museum. In that way, the form of the work remains somehow fluid or elusive.

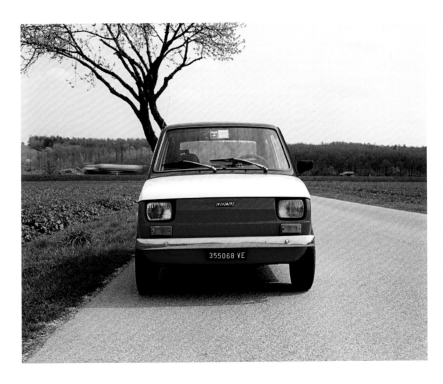

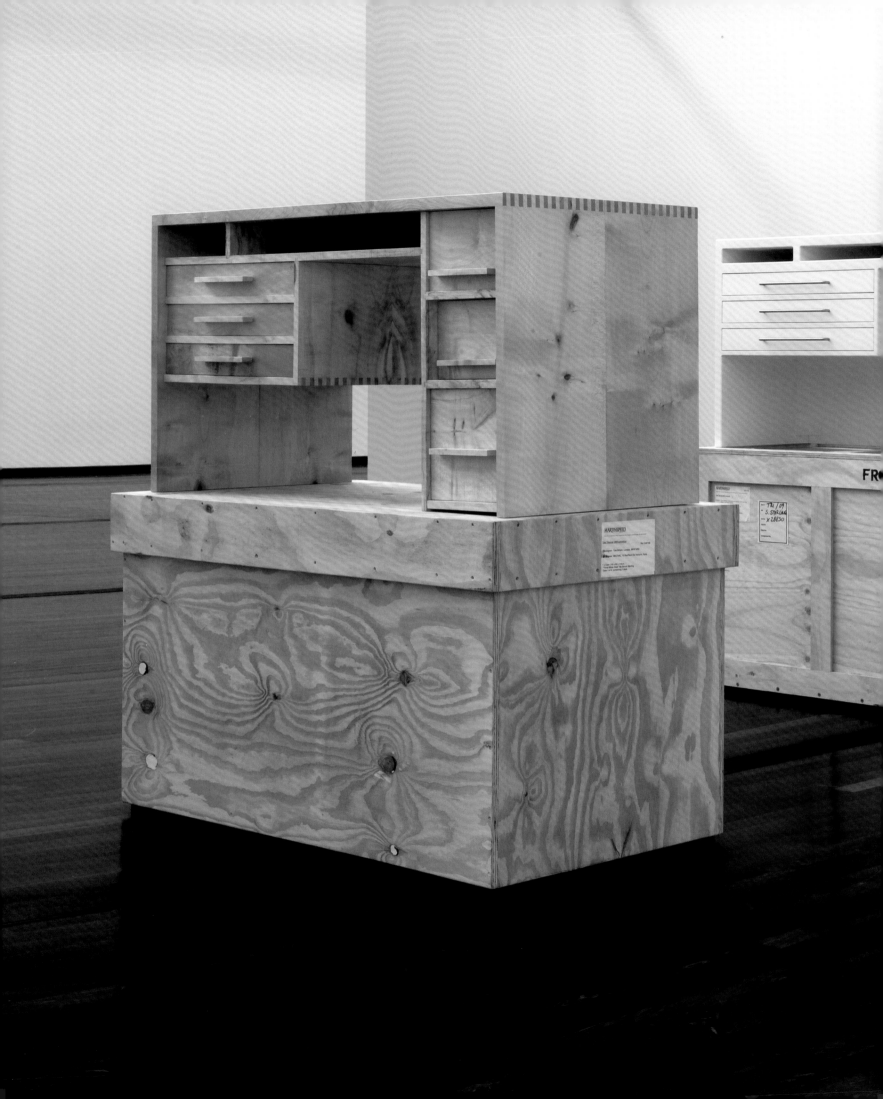

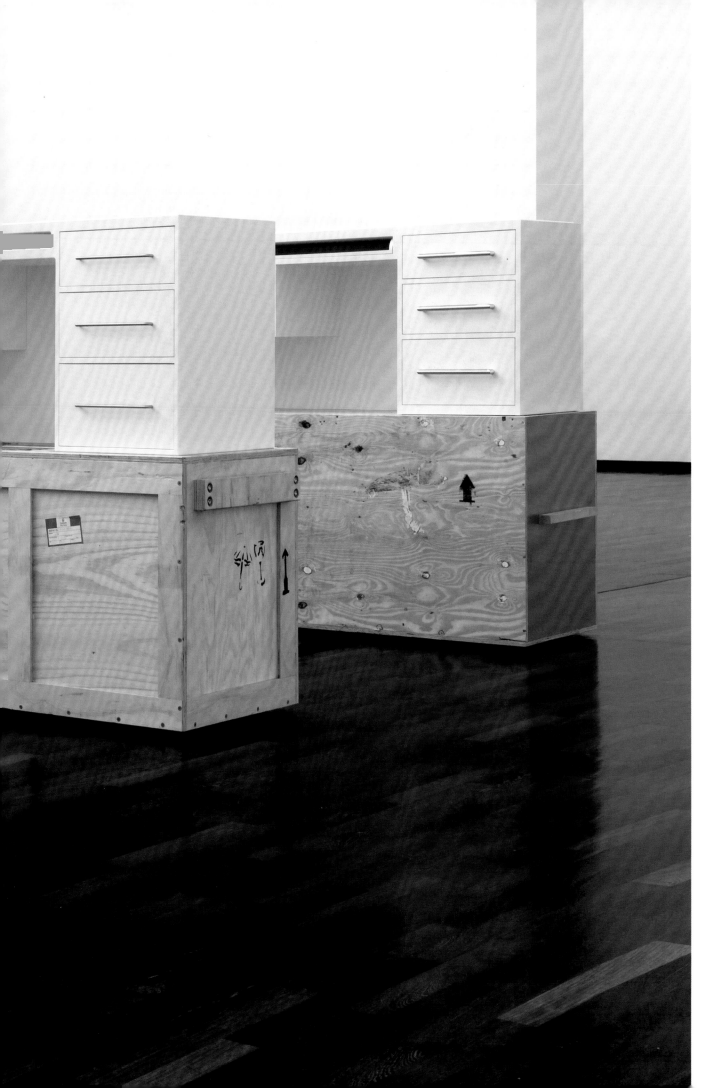

THREE WHITE DESKS, 2008-09
3 DESKS
77 X 226 X 62 CM
75 X 180 X 60 CM
73 X 147 X 65 CM
3 CRATES
88 X 247 X 70 CM
85 X 201 X 72 CM
82 X 160 X 82 CM
PRINT
89 X 65 CM

INSTALLATION VIEW AT MUSÉE
D'ART CONTEMPORAIN DU VAL-
DE-MARNE (MAC/VAL), VITRY-
SUR-SEINE, FRANCE, 2009

QUICKSILVER, DRYFIT, MUSEUMBRUG (90 AMP-HOURS OF SOLAR POWER HARNESSED ON THE 30th AND 31st OF OCTOBER 1999 ON THE SURINAME RIVER BETWEEN PARAMARIBO AND THE AFOBAKA DAM, AND USED ON THE 7th OF NOVEMBER 1999 TO DRIVE AN ALUMINIUM BOAT THROUGH THE CANALS OF AMSTERDAM

MINE, SURINAME, REPRODUCED IN AN EDITION OF 16 USING 26 KG OF METAL FROM A QUICKSILVER ALUMINIUM BOAT), 1999
ALUMINIUM BOAT, CABLES, BATTERY, VINYL TEXT, POSTERS, CAST ALUMINIUM, TARPAULIN

INSTALLATION VIEW AT DE APPEL, AMSTERDAM, 1999

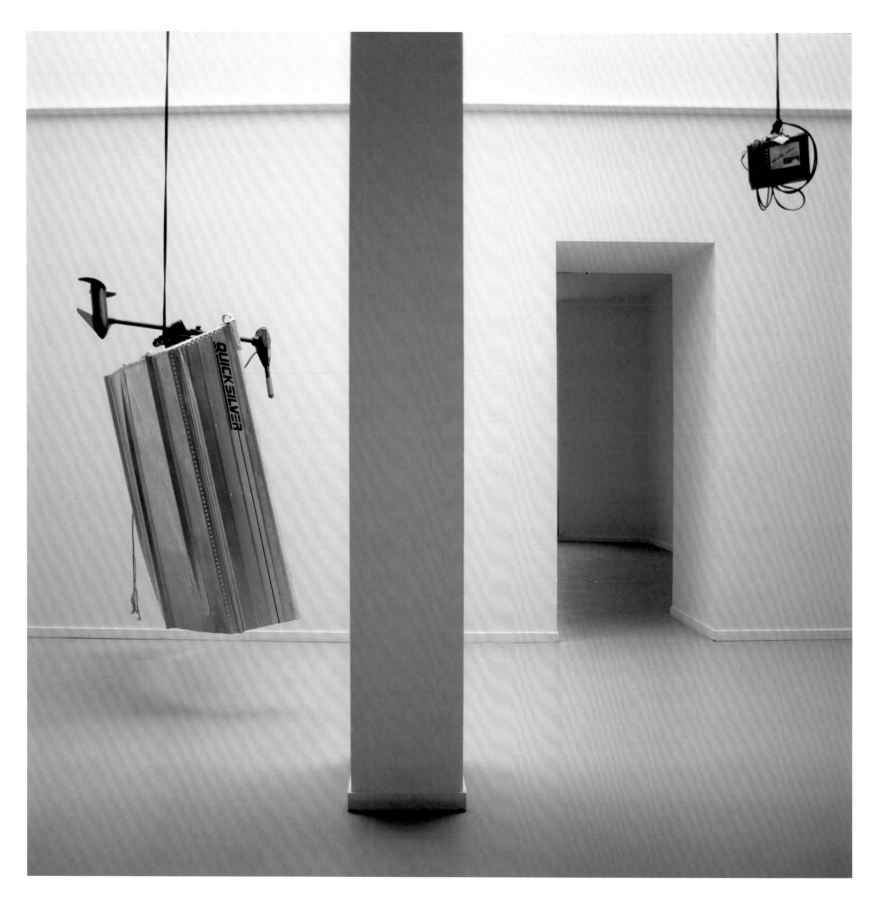

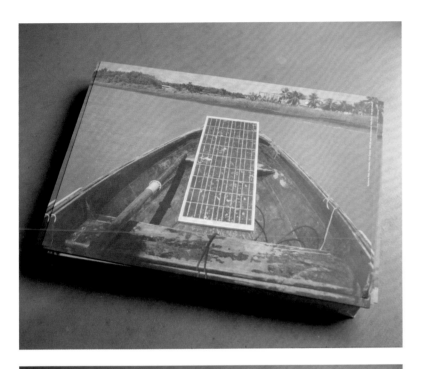

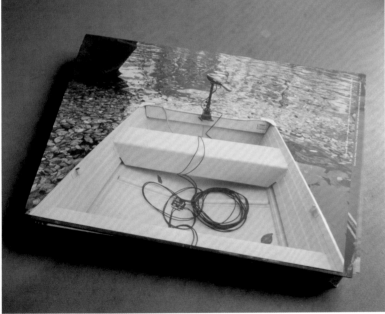

MANACORDA: *Do these last works have a sort of editorial moment as literary stories, jumping from one bit of narrative to another, as opposed to your earlier works that you refer to as 'recipes'?*

STARLING: The recipes were simply a form of framing device that mapped a set of coordinates. In some instances the early works had very clear narrative structures but in a more reduced form – simple, often circular poetic trajectories as opposed to the more complex, rhizomatic structures of late. Circular narratives as models or structures for storytelling, known in literature as ring compositions, appear in all sorts of far-flung cultures throughout history and seem to have evolved almost as a by-product of the functioning of the brain, and I suppose that's been a very useful tool for me over the years. Lately, as you suggest, I've become more and more interested in these complex, polyphonic or layered narratives, while perhaps sometimes retaining an element of that circularity.

MANACORDA: *The way you spoke about literature reminds me of W. G. Sebald[2] and how he inserts a photograph into his books to bring the narration to a completely different time or place and then brings it back, and then …*

STARLING: Yes, its not surprising that Sebald has had such a following among artists. I suppose what I've been doing in the Hiroshima project is co-opting different characters from different pieces of literature, taking James Bond from Ian Fleming and relocating him in a Noh play, or Colonel Sanders, who's become an interesting literary trope in Japanese fiction. In Haruki Murakami's novel *Kafka on the Shore* (2002)[3] the Colonel is – in Noh-like fashion – the physical manifestation of what is described as a 'concept'. All the time, I'm mixing real historical figures with fictional characters, but in the end the fictional characters appear just as real as the historical ones. Everyone's identity is suspect. Everyone has two faces – even a sculpture.

MANACORDA: *Not all the actors in your play are humans. In your practice inanimate objects often come to life, especially when you activate their political or economic history or when their constituent material becomes an embodiment, a concept of something. I'm thinking of* Quicksilver, Dryfit, Museumbrug *(1999), for example, and the solar energy that you have harnessed in Suriname to use in Amsterdam.*

STARLING: Perhaps, as you say, it's like giving a biography to matter and energy.

MANACORDA: *This reminds me of a project you're working on that involves some of your works being retold in the miniaturized set of the marionette theatre.*

STARLING: The proposal with the puppet theatre is to conflate four or five boat-related works, which I've made over a period of fifteen years, into a single narrative and to use the often rather slapstick sense in those works, their almost cartoon-like quality, as the basis for a piece of puppet theatre. It's an idea that evolved out of both staging Moore's work in *Project for a Masquerade (Hiroshima)* and from this natural process of slippage that occurs as the narratives of these works are told and retold. Confusions and conflations occur in this Chinese-whispers process, and the scenario for the puppets simply pushes this to its dramatic conclusion. I like the idea that works don't die but keep being remade, reconstituted or retold in different ways.

THE EXPEDITION, 2011
WOOD AND GLASS
CONSTRUCTION, PUPPETS,
STAGE SET, LIGHTING, SOUND
EQUIPMENT, MIXED MEDIA
530 X 450 X 470 CM

INSTALLATION VIEW AT
KUNSTHAL CHARLOTTENBORG,
COPENHAGEN, 2011

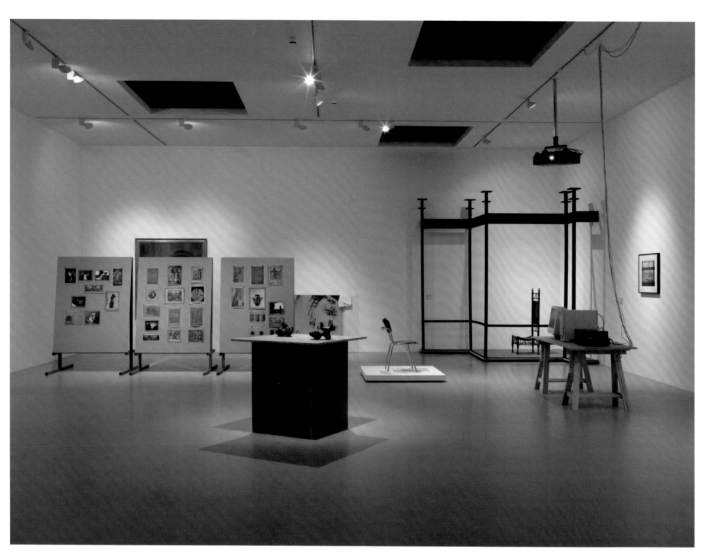

MANACORDA: *It's again this kind of further polyphony, a show of five or six of your works becoming sort of a theatre play.*

STARLING: Yes, but perhaps here it will be more of a cacophony, all these stories played out on this very small stage – this image of somebody cutting up a steamboat to feed the boiler or making and burning a boat to produce charcoal to cook the fish that have just been caught in the boat. One of the references is to early cinema – Charlie Chaplin, Buster Keaton – those self-defeating, destructive, calamitous comedies. And it seemed that a puppet theatre was a good place to re-enact those things and, as you say, to create a retrospective within a bigger exhibition context.

MANACORDA: *A sort of fictionalized retrospective, something similar to what Moore was doing with his own work, but you do it in the public rather than the private!*

STARLING: The exciting thing about being given the opportunity to make rather bigger museum shows now is that I can start to reactivate the works in the context of the oeuvre as a whole and establish new connections, or indeed contradictions. I am able to bring together works made for very specific contexts or specific moments and give them a new sense. The puppet theatre work is very much a continuation of that process.

MANACORDA: *Like treating your own works as just one more element for further reuse – it's meta or second-degree work, in a way.*

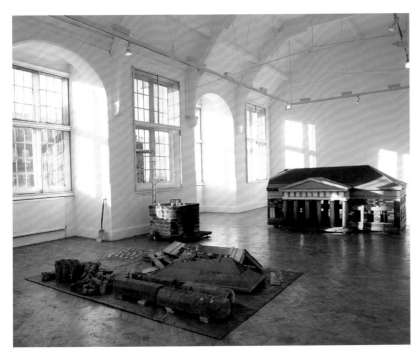

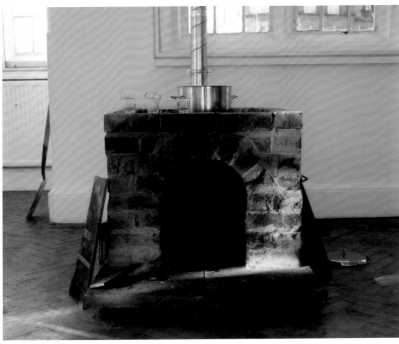

STARLING: Yes, it also perhaps leads us on to the exhibition I recently selected at Camden Arts Centre, which was another way of expanding and developing my practice via the selection and re-installation of a group of works by other artists. The exhibition, 'Never The Same River (Possible Futures, Probable Pasts)' (2011) existed both as a *Gesamtkunstwerk* of mine and as a situation that allowed the individual works within it to retain their own sense and their own life. As we've discussed, I've been working with other artists' works, taking those preexisting things on new journeys or transposing them into new contexts, and so it was a very easy step to make, conceptually, to then start thinking about how to piece together an exhibition like the one at Camden.

MANACORDA: *One fundamental element of that exhibition is the idea of the time machine, the show generated through time-travelling. Visitors entered into the Camden Arts Centre to see works in the very spot where those works had been shown in past exhibitions. They were like ghosts that you were summoning up, now sharing not only the space but also the time.*

STARLING: I have a strange personal relationship to that place, because my maternal great-great uncle was the architect of that building, and there was this strange and rather beautiful moment when, while my work *Burn-Time* (2000) – which involved a small brick stove being built – was being shown at Camden, the architects came to make plans for the refurbishment of the building and drew my brick stove into the plans for the building as if it had always been there and was a part of the structure! I subsequently understood this little brick stove as a kind of portal into the past.

MANACORDA: *The brick stove was also built with some historical bricks from the building, right?*

STARLING: Absolutely. They read it right, in a way. They saw that the bricks were the same, and they thought, 'Okay this must be how it always is.' Actually, the idea for the exhibition, the collapsing of fifty years of exhibition-making into a single moment, came very directly out of that. It just seems such an obvious model for making an exhibition with and about an institution – one that I would have thought would have been used many times before, but apparently not.

MANACORDA: *But at the same time I think it's something an artist can be more entitled to do – because, for example, after the assembly some works were sort of cramped together in corners.*

STARLING: It demanded a great deal of collaborative belief on behalf of all the artists involved because there were some technical issues that arose while trying to gather all these different things from different eras in the history of Camden Arts Centre and to make them coexist in the space at one time. For instance, it created problems for projections that were originally in dark spaces, which now had to be shown in semi-illuminated spaces. But working with Mike Nelson, for example, was extremely exciting. His work was one of the inspirations for making the show in the first place. He re-installed a fictional studio that was in turn a proposal for a number of future works. He's constantly reiterating or re-working his own works, but to reproduce ten years later what was a projection of the future was really exciting. Mike talked about being almost haunted by his ten-years-younger self, always there over his shoulder telling him what to do and what not to do. Then to juxtapose that with the wonderfully simple video by Stefan Gec, *Lure* (1991/5), showing a hawk flying through that space, it was almost as if the bird was flying right through Mike's phantom studio – as you can with phantom studios, I guess! The installation of the show started to generate amazing things, a lot of which I hadn't even anticipated. I simply put a system in place, and then it very much did its own thing. That's really exciting.

MANACORDA: *It also became some sort of geological experience.*

STARLING: Yeah, it's like cutting back through the space's historical strata.

MANACORDA: *But that's not the first time that you connect time-travel to the museum. For example, the project in Essen* (Nachbau, 2007) *had to do with the same theme in different ways because you reconstructed a room that didn't exist anymore.*

STARLING: It happened at a moment that was almost like a cut in the history of the Museum Folkwang. They invited me to make the last exhibition in a rather nasty 1970s extension to the museum that was being demolished to make way for a new building. It seemed like a moment of temporal rupture ready to be explored. I knew that Albert Renger-Patzsch[4] had a history with the museum before the Second World War. He was actually the museum photographer. They gave him a studio and darkrooms in return for documenting their displays and objects and he made some very beautiful photographs as a result. I found one set of photographs that documented the same space in one of the original villas that made up the museum prior to the war, and these provided enough information to be able to actually rebuild and rehang that space. We used the movable wall system from the 1970s building that was about to be demolished and transformed it into a very detailed reconstruction. Apart from a little bit of speculation concerning colour, it was precise in every way. Then we put back the works that had been there in the early 1930s when Albert Renger-Patzsch made that set of photographs – ultimately allowing me to remake his images seventy-five years on.

MANACORDA: *I remember that some of the works are not in the collection anymore because of the 'degenerate art' dispersal.*

STARLING: The dispersal of some works before the Second World War meant that, for example, one of the Franz Marc paintings is now in a collection in Boston. Some of those objects were replicated in different ways. That Franz Marc painting, which was seen only through a doorway, was actually a slide projection of that work. That chapter in the history of the museum was evoked through those stand-in works.

MANACORDA: *This brings back to mind something you said about the mask being like photography, something that doesn't die. This work has some similarities also with* Project for a Masquerade (Hiroshima), *the recreation of something from the past through the undead. And also it's a theatre set in a way, could you walk through it like an actor on stage?*

STARLING: Or a temporally dislocated museum-goer, perhaps? You could walk through the space, but you approached it from backstage, so to speak. The nature of the illusion was very overt. Once inside, you were contained by the experience, giving the impression of displacement – you really felt thrown back through time. But in another sense, it was just a by-product of the process of remaking the photographs. Again, the formal manifestation of the work remains somewhat elusive.

MANACORDA: *Another loop in that work was made clear in Bruno Haas's catalogue essay, which talks about the space created by museum vitrines as a loss of world. He talks about artworks being put in a vitrine and thereby isolated from their original setting. They were meant to encase objects from a pre-modernist culture that wasn't, like modern art, produced for the museum itself. It also served to hold together that particular display, because – again, similarly to your work – it was quite an experimental collection of different cultures being put in the same room.[5]*

STARLING: A single cabinet could contain objects made thousands of years apart.

MANACORDA: *It already was some sort of time-space machine. It is probably more correct to talk about that.*

STARLING: Absolutely, I was adding one more layer to a succession of temporal and geographic ruptures. The result of that project is a series of photographs: my remakes of Albert Renger-Patzsch's images are very much based on the notion of a detour rather than simply re-photographing or appropriating his originals. The work goes on this very long detour, only to return to that starting point, the same few images. If you take the long way around, all those complexities get played out. The machinations

of history that are somehow lost in those images when you see them in the museum archive come back into play when you attempt to reconstruct those things, to re-enact them. The complexity comes from the detour.

MANACORDA: *The detour in this particular work takes its starting point from a photograph, so a two-dimensional work becomes three-dimensional, but also four-dimensional because it includes travels across time. After this process it goes back into the two dimensions as a photograph. This passage from one dimension to the other is something that has been explored in relation to your practice – for example, by Mark Godfrey's essay 'Simon Starling's Regenerated Sculpture' in* Cuttings.[6] *Lately it has taken different directions, though.*

STARLING: There are some other examples: using vintage photograph of a Henry Moore sculpture and then interrogating a single silver particle that constitutes a tiny fragment of the bigger image and then enlarging it in order to create a small bronze sculpture (*Silver Particle/Bronze After Henry Moore*, 2008). In the work there are constant shifts from image to object, object to image. And from material to information, digital to analogue, etc.

MANACORDA: *And perhaps also form. As you said, form has become a structural way to organize information as well, and, when you feel it's resolved, it reiterates some of the concerns that you can find in the information. The work you just mentioned is a good example. You took a particle, you enlarged it, and then the final sculpture looks like the biomorphic shapes that Henry Moore was interested in. Can we talk a little bit about your interest in photography in relation to sculpture? Were you trained as a photographer?*

STARLING: I suppose in a way one of my formative creative experiences was when, at the age of ten, I developed my first black and white print in a darkroom. Witnessing the chemically induced appearance of an image was extraordinary somehow. I later built a small darkroom at home, and the messy, toxic business of silver-based photography became very important to me and is something that I've carried through into my later career. As that kind of technology is disappearing so rapidly, it has come into focus more for me. Both its imminent obsolescence and its replacement by largely dematerialized digital picture-making, which in turn accentuates silver photography's materiality, has given it a certain new relevance. I've also been consistently working with the idea of interrogating the nuts and bolts of art-making, the material nature of those processes. This has included tracking things back to source – going to Ecuador to find a balsa tree to build an airplane, for example.

MANACORDA: *Would you say that in some works photography really becomes sculpture because you're investigating the platinum or the silver particles that compose the final object even if the object is flat?*

STARLING: The object is apparently flat, but it is of course made up of hundreds of thousands of three-dimensional particles. In this way an image archive could be understood as a kind of stratified geological deposit. *One Ton II* (2005), for example, makes a very direct sculptural equivalence between image and material. The work involved travelling to make an image in a platinum mine and then producing as many platinum prints of that image as is possible from one ton of ore from that mine. A single motif was reproduced as many times as possible with the tiny quantity of platinum that comes from that ton of rock. They're photographs, but they're very much sculptures too. And it's interesting that you can almost feel the way they're made in the surface of the platinum prints. Their hand-coated, rather crystalline nature lends a real physicality to the surface of the images. I suppose that that work then led to others. Initially there was a film piece that was made for Wiels in Brussels (*Particle Projection [Loop]*, 2007), which took a single silver particle from a series of images made of the Atomium, which in turn replicate a series of images made by Marcel Broodthaers during the building of the Atomium. Since they were re-cladding the entire Atomium a few years ago when I was working on the project, it was possible to actually remake almost directly one-to-one copies of those Broodthaers photographs. He was working as a labourer on the job and made some photographs to sell as a story for a newspaper. It was just a way to generate a set of possible silver particles, but clearly there's an implied loop created between the diagrammatic building in the photographs and the particle itself. We then selected one individual particle and created an animation using an electron-microscope and a piece of software called Spider, which takes a number of 2-D images and creates a 3-D model from them. This experiment then led to other works such as the *The Nanjing Particles* (2008), made for MASS MoCA, which has a more specific sense in relation to the geopolitics of labour. The work collapses the story of early Chinese immigrant labour on the east coast of the US (embodied in the stereoscopic image of the Chinese workers at the Sampson shoe factory) onto that of the contemporary outsourcing of manufacturing to China – a complete obsession in the US at that time.

MANACORDA: *There is some sort of mirror-inverted relationship between the historical labour conflict in Massachusetts, where immigrants were 'imported' to take down costs, and globalization's current outsourcing. Around the latter issue in China there is not only the price reduction but also the lack of human rights conditions.*

STARLING: I suppose one of the interesting aspects of the labour involved in this work was that, with forging, the labour essentially disappears. The better the work is done, the more time spent on it, the less visible it is. It's about obliterating signs of handcraft, in a way. So the more you polish, the more you buff that mirrored stainless steel surface, the less the craft is visible.

MANACORDA: *Although in the book there are several pictures of the fabrication, which again brings the photography back into two dimensions, in which we can see the fabricators reflected in the steel's surface.*

INVENTAR-NR. 8573 (MAN RAY),
4 M-400 NM, 2006
80 BLACK AND WHITE
TRANSPARENCIES
EACH 6 X 7 CM
2 GOTSCHMANN SLIDE
PROJECTORS, KODAK PDC
DISSOLVE CONTROL UNIT, CD
AND CD PLAYER
8 MIN.

INSTALLATION VIEW AT
MUSEUM ABTEIBERG,
MONCHENGLADBACH, 2006

following pages,
HOMEMADE HENNINGSEN PH5
LAMPS, 2001
RECYCLED METAL
LAMPSHADES, STEEL,
ELECTRICAL FITTINGS
SIZES VARY FROM 21 X 31 X 31
CM TO 40 X 59 X 59 CM

STARLING: The surface becomes a distorting mirror for whatever or whoever's around it. The audience at MASS MoCA, of course, saw their distorted selves framed by the almost baroque reflections of the refurbished industrial architecture around them, and in a confusion of gazes their distorted reflections could in turn be understood as fused through space and time with the images of the Sampson workers, and indeed the reflections of the contemporary Chinese workers in Nanjing worrying at the surface of the stainless steel. While the stereoscopic image from which the particles were derived once created the illusion of depth, the reformulated 3-D particles had the feeling of being an illusion, of being virtual somehow.

MANACORDA: *So you would say that sculpture can function as an image in that case?*

STARLING: Yes, those sculptures seem to sit somewhere between objects and images – phantom things perhaps?

MANACORDA: *Is one recurrent aspect in your use of photography some sort of ghost-like quality – either from the past or some ghost you conjure up by replicating a situation that you've seen before?*

STARLING: At times there's almost a redoubling of photography's apparitional sense, yes.

MANACORDA: *When you talked about an image appearing the first time you developed a black and white photograph, it sounded like some sort of invocation, like in some of the sculptural works we discussed.*

STARLING: It perhaps links back to our discussion of Noh theatre and the sense of possession that the actors undergo when they fit their masks and assume their characters. Hiroshi Sugimoto's wonderful text in his book *Noh Such Thing as Time*,[7] which was important for me in formulating an approach to Noh theatre, makes very clear connections between photographs, in which the subject defies time and remains eternally young, and the temporal gymnastics possible in masked theatre.

MANACORDA: *Another project that comes to mind, thinking of these issues, is* Rescued Rhododendrons *(2000), in which you took plants back to south of Spain. And I remember an incredible aspect – you always repositioned the plants outside your Volvo in the same position and light orientation.*

STARLING: The landscape changes around a stable configuration of plants, lights and car, so a very condensed spatial collapse is possible when those images are seamlessly dissolved one into the other. The spatial becomes the temporal as the return of the plants to their source is completed after 250 years in some kind of botanical exile. Sometimes photography is used in a much more straightforward sense. For example, in the case of the *Autoxylopyrocycloboros* (2006) I had to find an appropriate form to mediate and retell that event in which the boat consumes itself. This was resolved through finding a formal or sculptural equivalence between the steam engine, which is the central motif of the images, and this beautiful big medium-format slide projector that has a very rhythmic mechanical life within the work. The two machines are caught in a symbiotic embrace – the projection screen becomes a kind mirror for the mechanics of display, just as it did in *Wilhelm Noack oHG*.

MANACORDA: *Another series that works in that way is the series of the Unité d'Habitation visited by bicycle* (Heinzmann, Unisolar, Trek, *1999). It connects photography – which is obviously produced with light – with Le Corbusier's use of sunlight in architecture but also with the sun captured by solar panels you were using to harness electrical power while travelling.*

STARLING: Yes, it had a very clear relationship to the logic of the buildings, which were conceived by Le Corbusier as solar machines. This idea that the sun would penetrate the apartment blocks both in the morning and the evening creates the image of a great concrete sundial marking time on the bucolic French landscape.

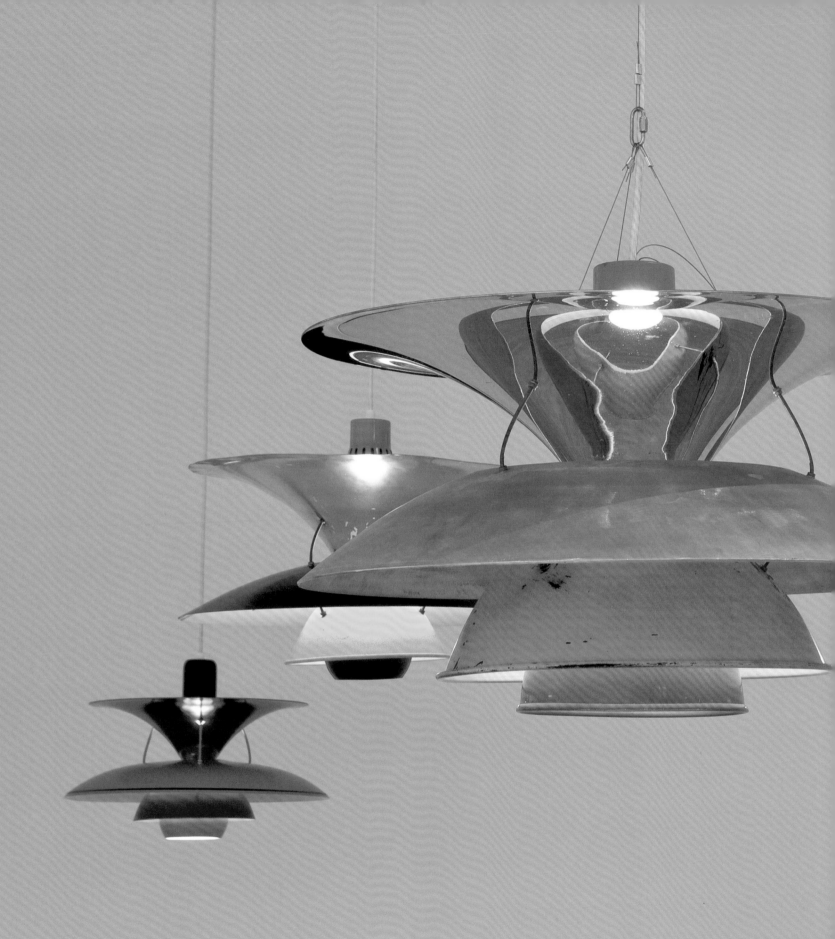

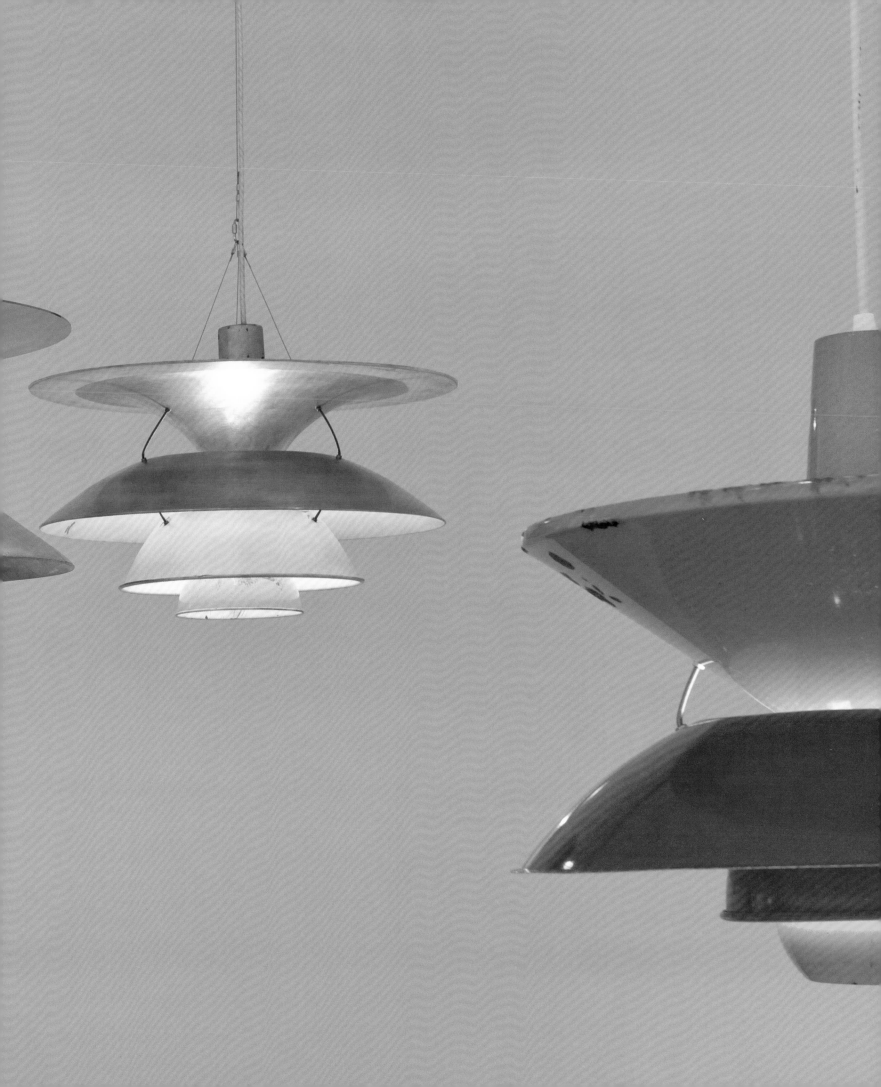

So it's a journey that begins and ends exactly in the same place, in a sense, collapsing geographical distance – another type of detour – and all powered by solar energy.

MANACORDA: *Can we talk a bit about the notion of the reverse prototype or 'de-prototype' related to your series of 'made-readys'?*

STARLING: Earlier I was talking about the investigation into the nuts and bolts of making, and this also goes one step further back to the idea of the prototype, the first thought, and the idea of reversing that, taking a mass-manufactured object and then re-enacting its evolution – reinvesting it with a sense of innocence, perhaps. The most obvious example is the *Homemade Henningsen Lamps* (2001), an ongoing series of lamps that were all based on a mental image of the Henningsen PH5 lamp, which was given form by finding lampshades or bits of metal objects that could be configured to create the required shape. It's a reversal. It takes an object that's all about capital and gives it back into potential again.

MANACORDA: *Something similar also happens when you make an architectural model of an existing building. Take the CAC Malaga project (1:1, 1:10, 1:100, 2010) for example, in which you took away the parts that were hiding the fascist nature of the building to make a maquette of its original structure.*

STARLING: I used the building material, the plasterboard and the MDF that created the museum walls, but in doing that, in stripping away the walls, you reveal the structure below – as you say, the original fascist architecture, the market hall that was buried beneath a contemporary art institution, all the iconography of that moment that had been covered over. The 1:10 scale model, which in turn housed the existing 1:100 model of the planned refurbishment of the building, in a sense allowed you under the skin of the museum.

MANACORDA: *What is your relation to the political content of your work? I don't think of your work as overtly political. What you put forward is a problem, rather than a solution.*

STARLING: Yes, I'm concerned with finding a point of balance between the politics and poetics in the work. In recent years the works have evolved out of finding myself in certain situations. I lived in Berlin for a while and always wanted to find a way to make a work about that city and its history, because they're so present in everything you do there – the fabric of the buildings and the people that you work with. Suddenly this opportunity arrived, again in a bizarrely serendipitous way, whereby I took the plans for a Lilly Reich glass screen to these fabricators in Neuköln to ask if they could remake the metalwork to support the screen, and they could only laugh. It turned out that the company had made the originals for Lilly Reich.[8] So that quickly sparked off an idea into my head, and I eventually managed to get them to open up their huge archive and go digging in there to piece together the incredible relationship they have to Berlin and its history and politics. This became the work *Wilhelm Noack oHG*. In 2006 I was invited to Cove Park on the west coast of Scotland, an artist residency that overlooks the nuclear-submarine-infested waters of Loch Long. I started thinking about the activities of the peace camp outside the Faslane nuclear submarine base and the amazing performative things that they orchestrate to keep the issue alive, and that became the context for making *Autoxylopyrocycloboros*. You always bring your own baggage, interests, methodologies or half-formed ideas to these situations, but it's as if these things suddenly fit in relationship to a particular context. They find a home.

MANACORDA: *Do your political considerations also come out of your interest in ecology and economy?*

STARLING: I'm interested in ecology in its broadest sense and in an expanded notion of an ecosystem as a realm of connectivity. Ecological ideas are fused with historical, cultural and political concerns. This methodology has, for example, been mapped out in the text that I wrote in relation to *Kakteenhaus* (2002), in which I was trying

1:1, 1:10, 1:100 (1:100 ARCHITECTURE MODEL OF CAC MÁLAGA), 2010
RECYCLED PLASTERBOARD AND MDF
200 X 110 X 540 M

INSTALLATION VIEW AT CENTRO DE ARTE CONTEMPORÁNEO DE MÁLAGA, SPAIN, 2010

Simon S
Recent

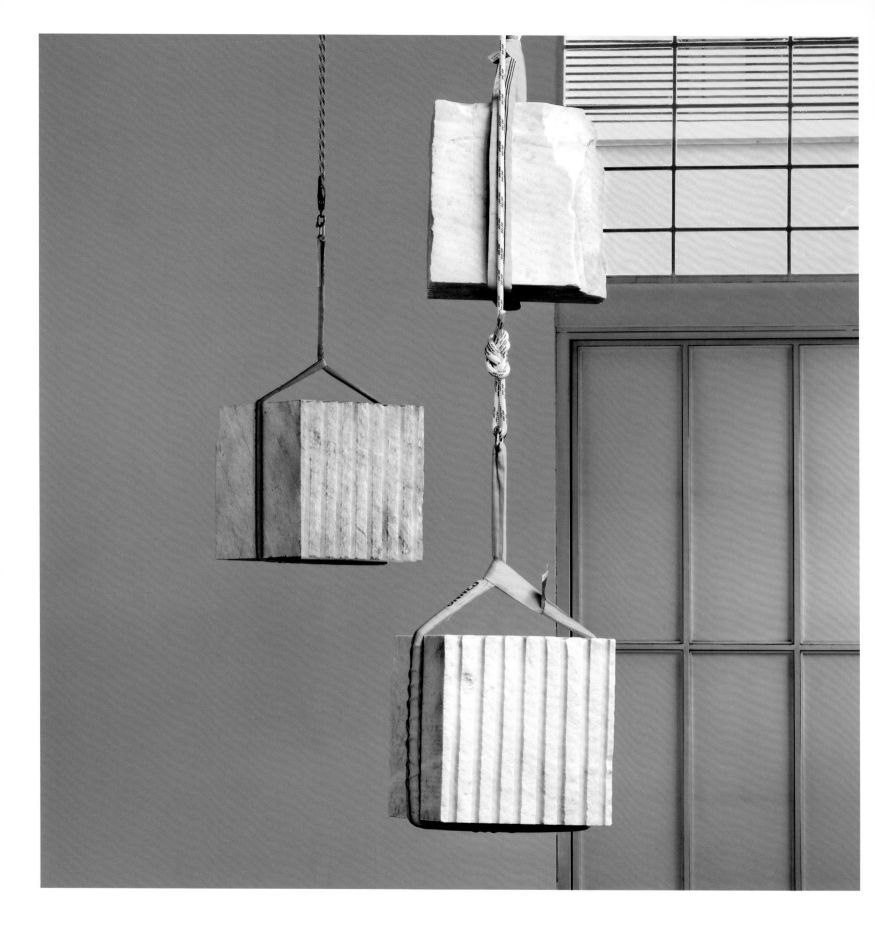

to create a sort of conceptual ecology for that project. Such models, in turn, perhaps reflect back on what we currently understand to be the ecological problem.

MANACORDA: *What you said evokes very interesting loops and circular things, because ecologies are closed systems and work in closed patterns of interdependency, similarly to the way that your works put forward constellations of elements. Furthermore, the interest in mining or in atomic energy, which has become prominent in your work, is probably also generated by the particular story that you are putting together, but also–*

STARLING: –out of a sense of currency. Those issues have a poignancy or relevance at the moment. What I really like are these moments in which the two different kinds of ecologies collide at points in history. I was thinking just now about the *Archaeopteryx Lithographica* (2008-09), a work that is about this moment when the desire to create lithographic images, to be able to create images and texts, collided with some very important palaeontology. At a time just after Darwin had published *On the Origin of Species*[9] there was the discovery of a feather that came from a creature occupying an evolutionary halfway-house somewhere between a dinosaur and a bird. This important piece of evolutionary evidence was only discovered because of this drive to produce lithographs. The main source for this quality of limestone is Solnhofen in Southern Germany, which used to be an inland lagoon and consequently produced perfect seamless stone but also perfect fossils. The story folds onto itself once more when they published the results of the palaeontological find. They reproduced the illustrations through lithography – they made a lithograph of the feather.

MANACORDA: *So you are suggesting that the fossil is like a natural photograph, the reverse portrait of an object that is the same as the negative.*

STARLING: Many of the processes I'm interested in seem to come together in this work. The fossil is produced through a process akin to lost-wax casting – sedimentation in a negative form left by the rotting feather. And in turn the lithograph of that feather is photographed using another negative to positive process – photography. And, as with masks and negatives, fossils retard time.

MANACORDA: *And again there's the passage between three dimensions, with fossil and lithograph, and two-dimensional images, with the print and the photograph.*

STARLING: This idea is also at the centre of *Red Rivers (In Search of the Elusive Okapi)* (2009), which tracks various journeys, mapped out in the form of a film. Paralleling the conflation of two journeys made in the Congo and North America, exactly one hundred years apart, is a third journey of sorts – that of the making of a black and white photograph in a dark room. The film culminates with images of stuffed okapi in a diorama in the Museum of Natural History in New York. Suddenly there's a sense of equivalence between what's going on in the lab to print the images and the stuffed animals in the images. Science and art-making are constantly mirroring each other, folding back onto each other.

MANACORDA: *The work is also an investigation into the politics of discovery and the colonial aspects of what it means to 'capture' an image.*

STARLING: Yes, it certainly alludes to that. As I said, there are two parallel journeys – one made by Herbert Lang at the beginning of the twentieth century to try and find and bring back an okapi to the Museum of Natural History, the other a contemporary trip with my specially built okapi-striped canoe down the Hoosic and Hudson rivers through what once was the frontline of the American Revolutionary War.[10] We passed a replica of the Half Moon, a boat that arrived in the Hudson three hundred years ago. Place names also constantly evoked that history. We followed deer tracks on a beach. And the resulting images, while clearly made in North America, start to rhyme with the tales of exploration recounted in the film's voice-over. While he would later argue that the camera should replace the rifle, there's a strong sense in 1909 of Lang's rifle and camera being one and the same thing.

FOUR THOUSAND SEVEN
HUNDRED AND FORTY FIVE
(MOTION CONTROL/MOLLINO),
2007
FILM PROJECTOR, LOOP
MACHINE, VITRINE, METAL
TRESTLES, 35 MM FILM
COLOUR, SOUND
3 MIN. 9 SEC. LOOP

MANACORDA: *Something else I wanted to ask you about is the notion of hero or anti-hero and the idea that some characters populate several of your works – from Le Corbusier and Henry Moore to Broodthaers, Mollino and Brancusi.*

STARLING: Another cast of characters in a way.

MANACORDA: *Also others that I jotted down are more methodological characters: Robert Smithson, Michael Asher and Robert Barry. That's three people who interrogated the museum and its relationship to the outside. How do you live with this extended family?* [laughs]

STARLING: They all have rather different roles I think. Broodthaers, for example, had this very playful, rather self-deprecating but also critical sense of Belgian national identity that in part manifested itself in works using mussel shells. His work seemed to have a very particular resonance in relation to the story of the infestation of the Great Lakes by Russian zebra mussels and the ecological threat posed to a balanced ecosystem by this type of introduced species. I transposed Broodthaers's approach to Toronto, where it collided with Henry Moore's practice of generating sculpture from evocatively shaped pebbles picked up on the beaches of England. A steel replica of Moore's 1954 sculpture *Warrior with Shield* was thrown into Lake Ontario for eighteen months, where it played host to a colony of zebra mussels. Both artists seemed to have a specific role in the evolution of that work. My interest in Mollino, as I was saying earlier, has a lot to do with my interest in how, as an artist, you mediate your own practice or your own history, how you stage the self. He struck me as being somebody who did that in a very particular and interesting way. Partly because most of the buildings he made disappeared or were knocked down, and he never mass-produced furniture because he wasn't really interested in that idea. It was a very ephemeral life, one of action as much as object-making, and seemed to have certain resonances in relation to my own process-obsessed practice. There isn't really a clear methodology for engaging with the work of other artists, but it does seem to be something that's come back time and time again. The hope is that these redeployments of existing works always have a resonance in the present – are contemporary – however archaic that present might be.

MANACORDA: *It's also very important that they're always one of the elements of the narrative that you're constructing.*

STARLING: As we've talked about, there's very often a moment in which the art world meets another world, the world of palaeontology perhaps or, in the case of *Bird in Space, 2004* (2004) – in which the story of Brancusi's attempt to import his sculpture into the US as an artwork – the world of international trade. The referenced artworks are just one part of a larger complex whole.

MANACORDA: *One of the recurrent factors in your predilection for transformation and parallel stories is the shift of register or context in your work. You jump from economy to chemistry or, for example, from Noh theatre to James Bond. Within those leaps, some sort of surplus meaning is harnessed, and that's why, for a long time, thermodynamics have been used as a metaphor to describe your work. One element is transforming into another, and energy is spent to do that. But that energy, metaphorically, can be meaning.*

STARLING: Yes, perhaps it's both the meaning of making and the making of meaning?

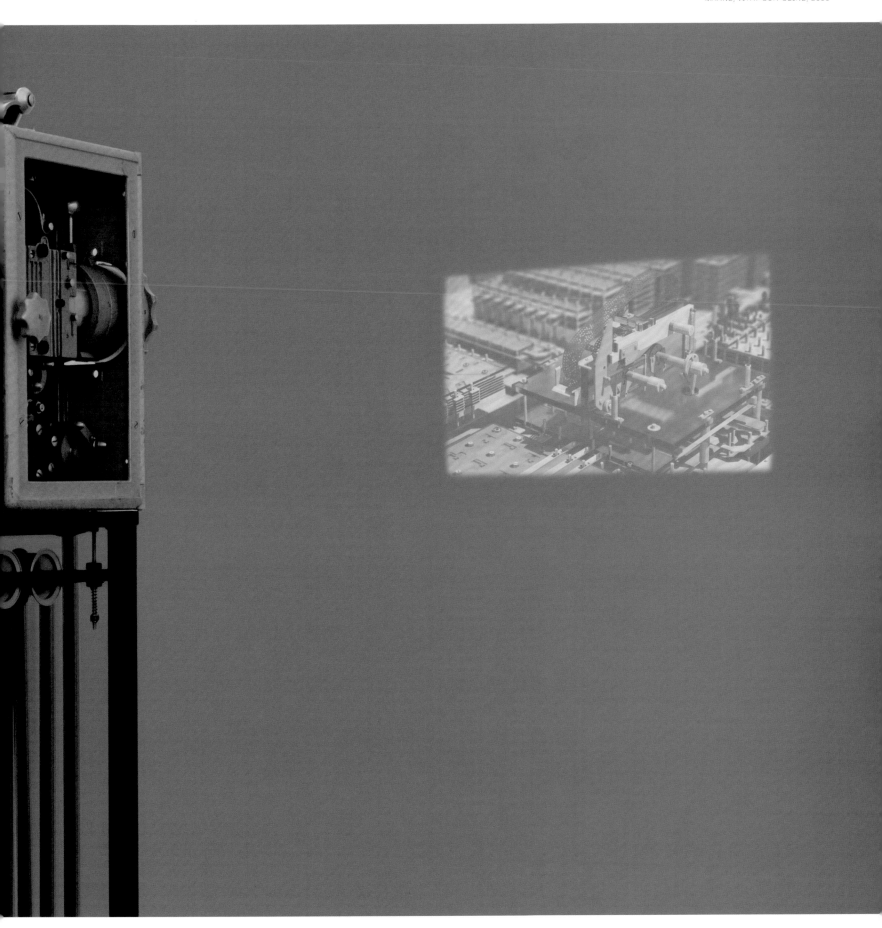

D1-Z1 (22,686,575.1), 2009
35 MM FILM, D1 PROJECTOR
30 SEC.

INSTALLATION VIEW AT MUSÉE
D'ART CONTEMPORAIN DU VAL-DE-
MARNE, VITRY-SUR-SEINE, 2009

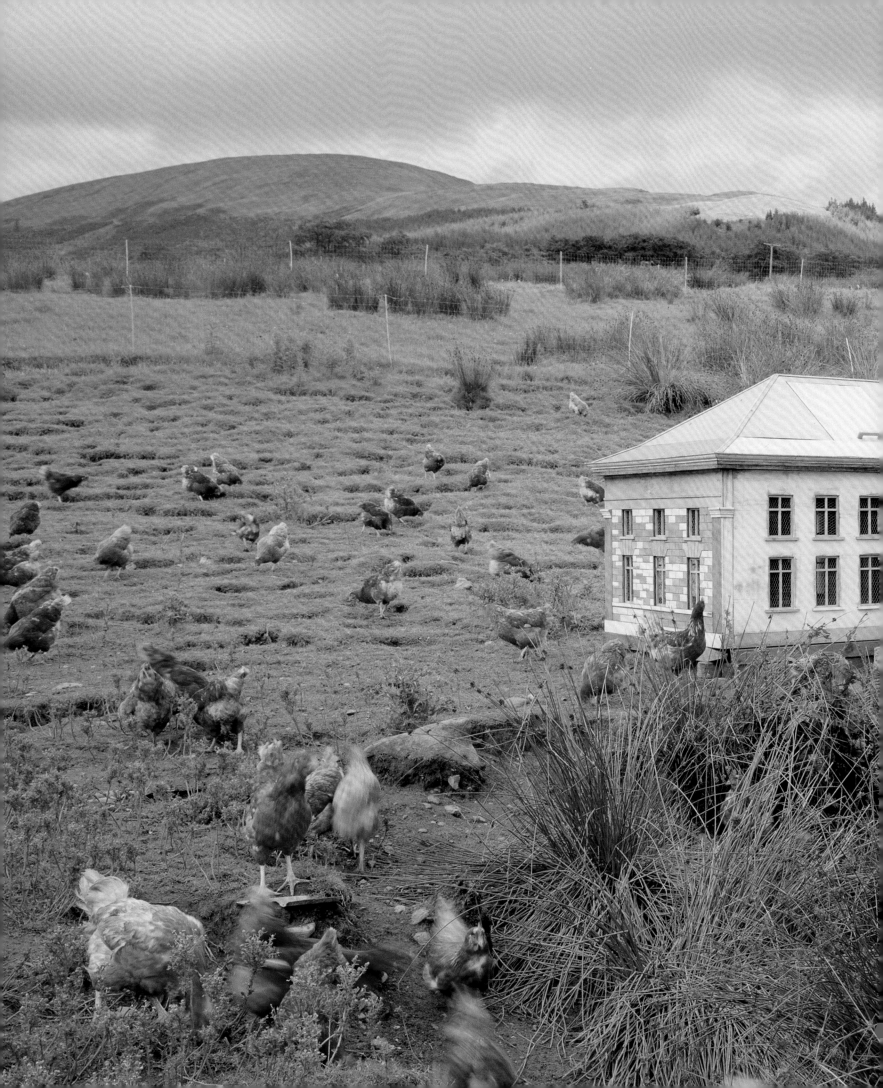

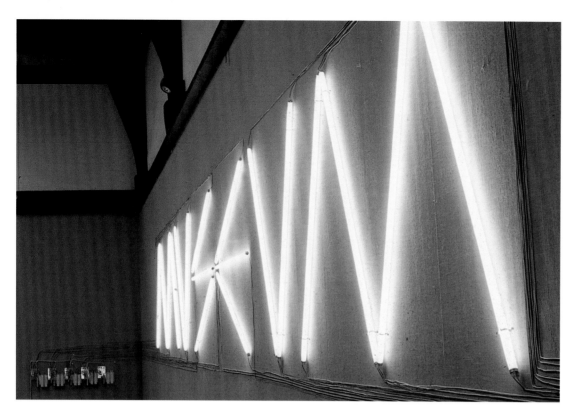

MUSEUM PIECE (WITH PAUL
MAGUIRE), 1991
19 FLUORESCENT LIGHTS
EACH 120 CM
CABLES, CHOKES, CAPACITORS,
STARTERS, GLASS

INSTALLATION VIEW AT
MACKINTOSH MUSEUM,
GLASGOW, 1991

previous pages,
BURN-TIME, 2000
HENHOUSE BUILT FROM
RECYCLED WOOD

PRODUCTION PHOTOGRAPH,
STONCULLIN FARM, STRONE,
SCOTLAND

To begin with, a smattering of dates – no mere arbitrary markers for an artist with such a vivid interest in numbers, as well as in history, of both the natural and cultural kind. Simon Starling was born in Epsom, Great Britain, in 1967, into a world that was readying itself for a cultural revolution so momentous that the year of its occurrence is still with us as shorthand ('1968') for radical action. And, of course, for an artist whose work is located in the and/or post-conceptual tradition, it is worth noting that this cultural revolution also included the Conceptual revolution in art – a movement for which Starling's birth year of 1967 is regularly held up as an *annus mirabilis*.[1]

In 1987 Starling enrolled in Nottingham Polytechnic to study photography, the century-and-a-half-old technology that continues to provoke some of his most radically materialized sculptural ideas. (It is also worth noting here that Starling, who kicked off his studies in Nottingham by building a pinhole camera, hails from a family of architects and chemists rather than artists and *littérateurs*.)[2] In 1990, just as another set of revolutions was altering the course of world history (one effect of which was the end of the Cold War), he moved to Scotland to study at the famed Glasgow School of Art at a time when the city – a former industrial powerhouse reeling from the onslaught of Thatcherism – was fast becoming a magnet for a prodigiously gifted generation of British artists, many of whom would go on to redefine the face of sculpture in the 1990s.[3]

Starling's first important exhibition took place at the Glasgow School of Art itself in 1991. It was made in collaboration with Paul Maguire and titled *Museum Piece* – a reference to the fact that the Charles Rennie

Mackintosh building in which the art school was housed inevitably drew its fair share of tourists looking for a museum experience rather than the latest and newest in contemporary art. The work consisted of the word 'museum' spelled out, Dan Flavin-style, in fluorescent lighting tubes that had been removed from their fittings elsewhere in the building and dramatically installed on a landing in one of the stairways. The work could have been read as an early exercise in institutional critique, a genre still very much in its infancy then, if it were not for the fact that Starling's interest in museums and museum work was decidedly more partisan than critical. In the early 1990s he worked at Glasgow's influential Transmission Gallery, a job that entailed organizing and installing (floor-painting, wall-building and problem-solving of all kinds) as much as curating and artistic research, and would prove influential in preparing him for the complex research-based art projects for which he is best known today, so often involving trans- and para-institutional teamwork and behind-the-scenes diplomacy.

Team spirit was also integral to the Glasgow art experience of the 1990s, and it is worth stressing the importance that living and working in what could be called the margins of the established art world had for the subsequent development of some of Starling's key concerns. For another early piece, *An Eichbaum Pils beer can found on the 6th of April 1995 in the grounds of the Bauhaus, Dessau, and reproduced in an edition of nine using the metal from one cast aluminium chair designed by Jorge Pensi* (1995), he had the site of his first London solo show, an independent art space called the Showroom, rebuilt at full scale in an abandoned industrial building in Glasgow that was subsequently used as a studio/workshop, inviting friends and colleagues to an informal

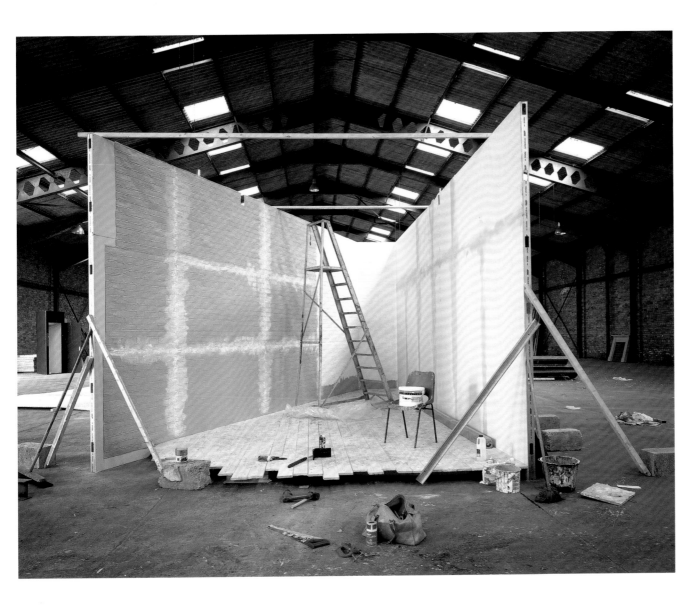

AN EICHBAUM PILS BEER CAN
FOUND ON THE 6th OF APRIL 1995
IN THE GROUNDS OF THE BAUHAUS,
DESSAU, AND REPRODUCED IN AN
EDITION OF NINE USING THE METAL
FROM ONE CAST ALUMINIUM CHAIR
DESIGNED BY JORGE PENSI, 1995
HAND-PAINTED CAST ALUMINIUM
CANS, VINYL TEXT, 2 TELEVISION
SETS, 2 VCRS, POSTERS, GLASS,
1:1 REPLICA OF THE SHOWROOM
GALLERY, LONDON

left, PRODUCTION VIEW AT TRAMWAY,
GLASGOW

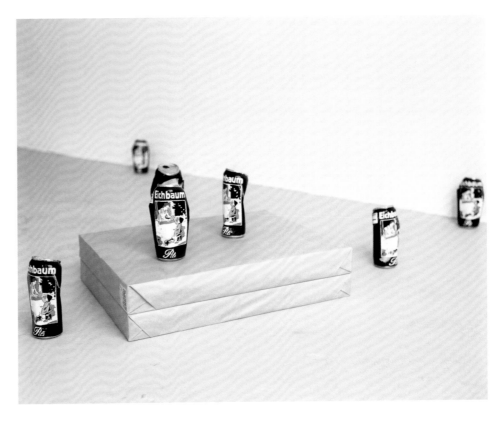

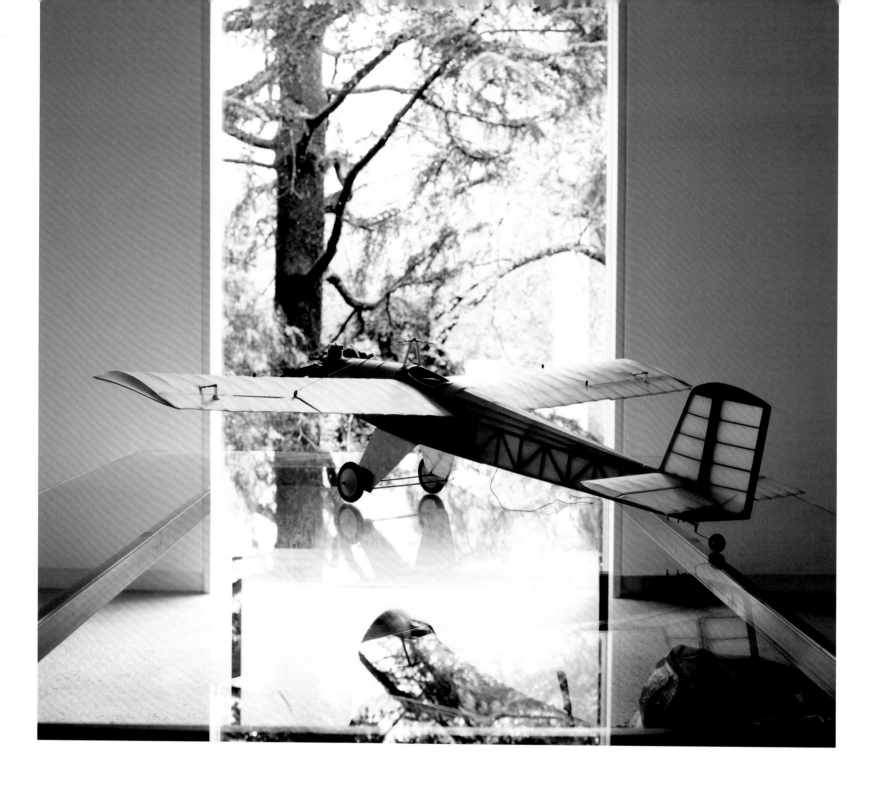

opening in Glasgow's replica *before* the exhibition's actual opening in the art capital down south.[4]

In this brief introductory historical sketch, we have encountered a handful of tropes and concepts that continue to inform and guide much of Starling's art practice to this day: an interest in technology and production (characteristically conflating the old with the new, analogue with digital, the obsolescent with the cutting-edge); dislocation, decentralization and the geography of making; *genius loci* and site-specificity; collaborative practice and the interrogation of author-ship (the gradual disappearance of the artist's 'touch', contrasting with a programmatic interest in the haptic and tactility); copies and doubles; the production and staging of artworks where once other, more useful things were produced. More important, however, is the sketch's broad historical framework: the end of the Cold War and the onset of globalization. In a sense, the years 1989-91 could be seen as closing off an era in which the political constituted the guiding principle of the world's organization and sense of self, and inaugurating an era (the 'now') in which the economic came in its stead. I have already referred twice to the Cold War, and with good reasons; it is the highly distinctive backdrop of some of Starling's most ambitious art projects, but it is also the period in which 'we' (the artist born in 1967, the author born shortly thereafter) were formed as political subjects – a world defined, by and large, by ideological difference. This world, clearly, is no longer with us, which is why the particular spirit of modernity that was, as a particular brand of modernism, its cultural complement (or supplement) now strikes us as foreign, exotic, antiquated, and is so easily transformed into an object of nostalgic longing – a nostalgia whose moorings in a well-defined material culture have been the object of some of Starling's best-known works.[5] If today's world is a post-ideological, possibly even post-political one – although the claim that we live in post-ideological times is of course eminently ideological in inspiration, being a cornerstone of the neoliberal world order, which is ultimately a political one – this is largely so because we inhabit a world in which only economy seems to matter,

or where the negotiation between the economic and the cultural sphere no longer has any need for politics. And economy, more specifically the globalized economy guided along by an updated version of Adam Smith's invisible hand, may well be the frame of reference against which Starling's work can be read and interpreted most clearly and comprehensively – and be shown to be paradigmatically contemporary: of its time, of this world. It is, in short, a product of socio-economic conditions and political circumstances, and clearly aware of its conditioning too, yet never directly – that is, didactically – 'political'.

The key concepts in Starling's art are circulation and trade; migration, mobility and speed; traffic and travel. Travel in one form or other (the search, the pilgrimage, the expedition) is crucial to almost all of his work, and the actual means of transmission and transportation are regularly featured in the resulting artworks, sometimes as a sculptural element, sometimes as the project's actual subject. There are many bikes, boats and cars to be found in his oeuvre – as well as a plane, in the important early *Le Jardin Suspendu* (1998), one of his first works fully to address the reticular complexities of the global economy. (The work's subtitle reads, 'a 1:6.5 scale model of a 1920s French *Farman Mosquito*, built using the wood from a balsa tree cut on the 13 May 1998 at Rodeo Grande, Baba, Ecuador, to fly in the grounds of Heide II, Melbourne, designed in 1965 by David McGlashan and Neil Everist').[6] The use of cars in particular comes complete with certain politico-historical overtones, most notably in the case of talismanic brands like Volvo and Fiat, which again serves to inscribe the work into the broader framework of a history that is economic above all else.[7] Furthermore, moving from one place to the other, or moving things from one place to the other, could be viewed as a crude metaphor for the marvel of metamorphosis, on which all art, as a form of magic intended to create or produce value, is based.[8] In most cases, however – and here Starling is a product, clearly, of a culture of post-Enlightenment disillu-sionment about such hallowed concepts as progress and development – all this moving about amounts to

absurdly little. The topic of circulation in Starling's work often implies exactly that: walking in circles, closing a circle, and looping, with the pathology of the loop often acting as a source of unexpected, deadpan humour.[9] Or, alternatively, it amounts to much more than any straightforwardly linear course of action would ever do, in which case the fascination with cycles and circulation often results in experiments with a literal-ized mode of recycling – a key factor in the (inevitably reductive) reading of Starling's work as implicated in environmental politics. It is against the backdrop of this complex tangle of concepts and concerns, tools, methods, means and ends, that I now propose to look at Starling's artistic production of the last fifteen years in greater detail.

Two works made in 1997 could be considered, in combination and retrospect, as blueprints for many things to come. One, made for the group show 'Glasgow' at the Kunsthalle Bern, was called *Work, Made-Ready, Kunsthalle Bern*. The other, *Blue Boat Black*, was origi-nally made for an exhibition in Marseille. For the first work, Starling took an icon of twentieth-century design, an Eames office chair, which he slowly and systematically took apart, replacing each successive metal element with pieces taken from an aluminium bike – a process that resulted in two objects that did not look radically different from what they had once been but were of course very differently made. Not surprisingly in a work featuring a stationary, immobilized bicycle, the ghost of Marcel Duchamp – whose publicly staged aversion to work has given us the readymade (as we all know, a very different Duchamp was quite literally at work behind this meticulously managed facade) – could be seen scuttling around Starling's experiment in three-

dimensional collage. But the work was also very much a quasi-traditional sculpture, ingeniously pulling into the orbit of its discussion some of the craft's basic concepts and concerns (balance, gravity, mass, material, weight). For, at some point during its destruction-*cum*-construction, there was neither a chair nor a bicycle: the moment when a perfect balance was reached, not just between two objects but also between the two value systems (high and low) that each object represents. The artist has pointed to another source in the work's conception, namely *The Third Policeman* (published, incidentally, in the year of his birth), a novel by Irish author Flann O'Brien featuring a bike-obsessed policeman whose atoms dissolve into those of his beloved bicycle during one particularly bumpy ride – not as absurd an event as it may sound, in the speculative world of particle physics, and a potent reminder of the potential proximity between artistic thinking and scientific thinking.[10]

One object collapsing into another via the detour of an experiment in which all entities are viewed as data streams rather than solid states: this is a description that could equally be applied to *Blue Boat Black*, a project in which Starling turned a Victorian display case from the National Museum of Scotland in Edinburgh into a small boat with which he could go fishing outside Marseille harbour. (During a later stage of the project, the fish were fried over a fire made from pieces of the boat.) In one photograph documenting the project, a young, tanned Starling is shown setting off on such a fishing trip. In addition to being a lesson in self-imposed problem-solving for which a certain technical talent was required, the work also has a decidedly romantic, well-nigh luddite dimension, dramatizing the loneliness

BLUE BOAT BLACK (A DISUSED
MUSEUM DISPLAY CASE FROM THE
NATIONAL MUSEUM OF SCOTLAND,
EDINBURGH, TRANSPORTED TO
MARSEILLE AND TEMPORARILY
RESURRECTED IN THE FORM
OF A SMALL FISHING BOAT. THE
RECONFIGURED VITRINE WAS THEN
PUT TO SEA AND USED TO FISH IN
THE WATERS AROUND MARSEILLE.
WHEN SEVERAL FISHES HAVE
BEEN CAUGHT, THE BOAT WAS
THEN FURTHER TRANSFORMED
INTO CHARCOAL IN ORDER THAT
THE CATCH MIGHT BE COOKED
AND CONSUMED. COMING FULL
CIRCLE, THE REMAINS OF THE BOAT
RETURNED TO THE MUSEOLOGICAL
REALM IN THE FORM OF THE
CHARRED REMAINS), 1997
PRODUCTION PHOTOGRAPHS,
MARSEILLE

RESCUED RHODODENDRONS
(SEVEN RHODODENDRON PONTICUM
PLANTS RESCUED FROM ELRICK
HILL, SCOTLAND AND TRANSPORTED
TO PARQUE LOS ALCORNOCALES,
SPAIN, FROM WHERE THEY WHERE
INTRODUCED INTO CULTIVATION IN
1763 BY CLAES ALSTROEMER), 1999
2 OF 5 C-TYPE PRINTS
EACH 79 X 101 CM

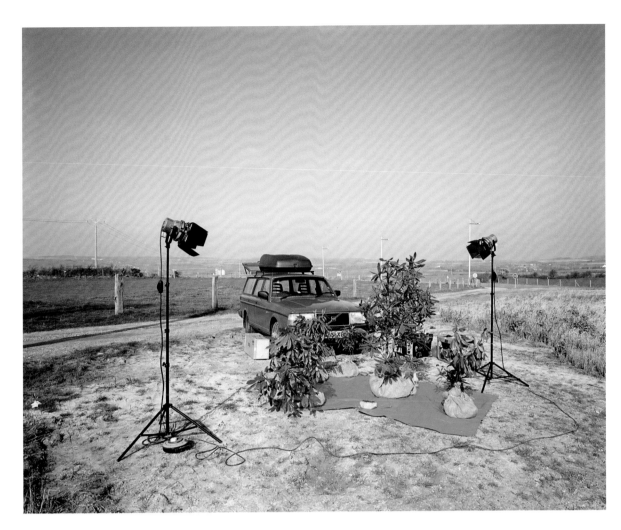

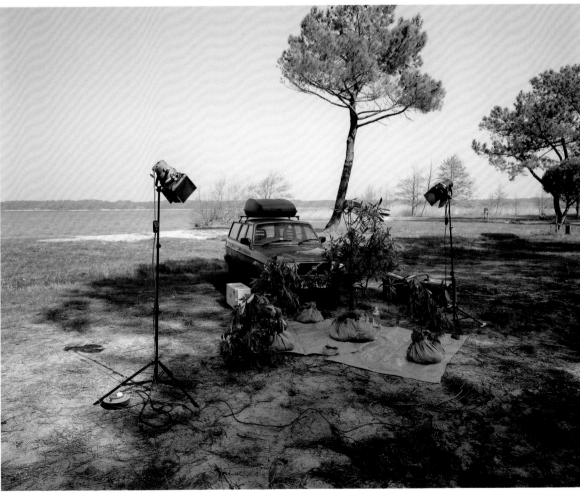

AUTOXYLOPYROCYCLOBOROS, 2006
38 COLOUR TRANSPARENCIES
EACH 6 X 7 CM
GOTSCMANN MEDIUM FORMAT
SLIDE PROJECTOR, FLIGHT CASE
51 x 65 x 43 CM

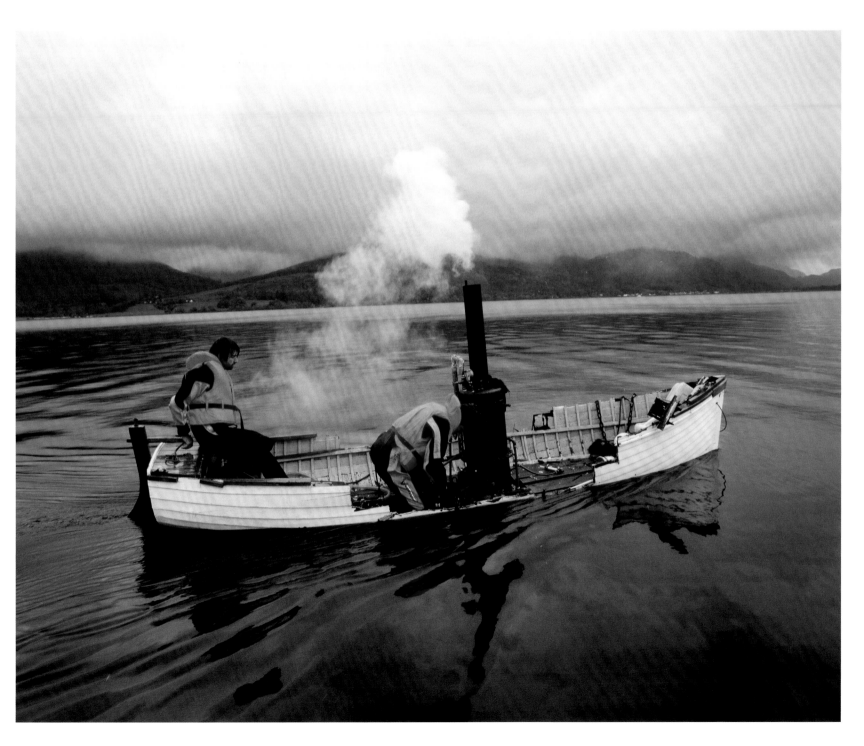

KAKTEENHAUS (A CEREUS
CACTUS, FOUND GROWING IN THE
TABERNAS DESERT, ANDALUCIA,
ON THE SET OF THE TEXAS
HOLLYWOOD FILM STUDIOS, DUG
UP AND TRANSPORTED 2,145 KM TO
FRANKFURT IN A VOLVO 240), 2002
VOVLO 240 ESTATE, CEREUS
CACTUS, PIPING, CABLES, TEXT

right, PRODUCTION PHOTOGRAPH AT
TEXAS HOLLYWOOD FILM STUDIOS
IN TABERNAS, ALMERIA, SPAIN

below, INSTALLATION VIEW AT
PORTIKUS, FRANKFURT, 2002

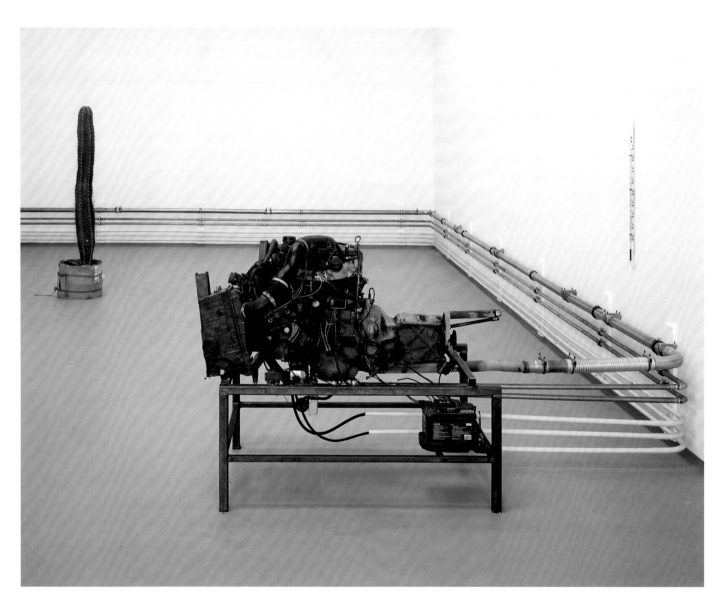

ISLAND FOR WEEDS (PROTOTYPE),
2003
SOIL, RHODODENDRONS, WATER,
PLASTIC, METAL, SELF-REGULATING
PRESSURE SYSTEM
244 X 366 X 610 CM

INSTALLATION VIEW AT THE
SCOTTISH PAVILION, VENICE
BIENNALE, 2003

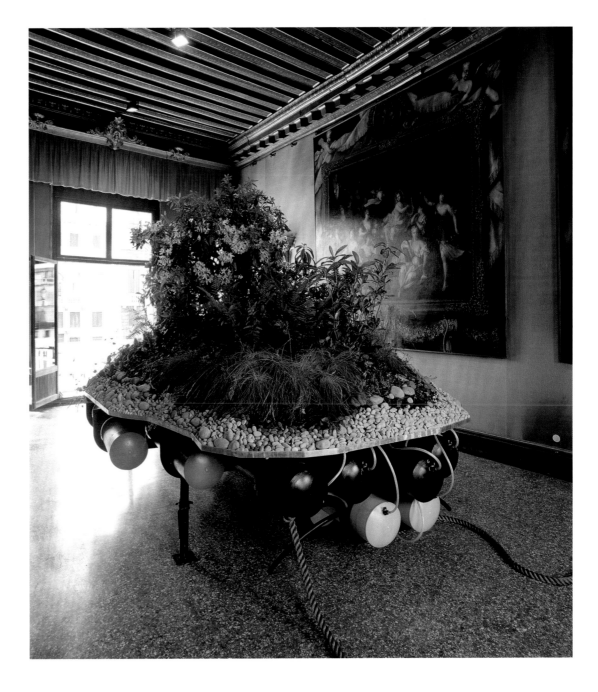

of the producer in his struggle for a certain measure of autarchy. It is also the first work featuring boats and other river-faring vessels, and a direct predecessor of the better-known *Autoxylopyrocycloboros* (2006), a boat whose steam engine was powered by a small wood-burning stove fed with the boat's own wood. The inherently dynamic presentation of the later work clearly marks the progress made since *Blue Boat Black* – a work still haunted, on the one hand, by the unbridged gap between the *image* of the boat in the final stages of its transformation from a piece of museum furniture into a mode of transportation and, on the other, by the charred remains of its slow *auto-da-fé*.

From the twin sources of *Work, Made Ready* and *Blue Boat Black*, an intricate mesh of conceptual narratives and storylines can be seen to emerge. In one loosely grouped body of works, Starling's fascination with cycles, circles and circulation is articulated by means

of trips, odysseys, journeys, expeditions – and I use the latter term precisely because of its association with colonial history and the natural sciences that very often acted as colonialism's epistemological corollary. In two such works, *Rescuing Rhododendrons* (2002) and *Kakteenhaus* (2002), the artist's own beloved Volvo 240 – a design icon much like the Eames office chair – played a pivotal role. For the first work, which started out as a public-art project and is part of a series involving botanical research, Starling took seven rhododendrons from a national park in Scotland – where, as the subspecies *R. Ponticum*, they are now considered a pest, their picturesque past in Scottish heraldic history notwithstanding – and drove them back to the environs of Gibraltar in the south of Spain, from where they were originally imported in the second half of the eighteenth century. Like other works involving the shifting meaning of what constitutes a weed, both in Starling's own practice and in that of other artists, *Rescuing*

THREE DAY SKY, 2004
EMULSION PAINT

INSTALLATION VIEW
AT MUSEUM FÜR
GEGENWARTSKUNST,
BASEL, 2005

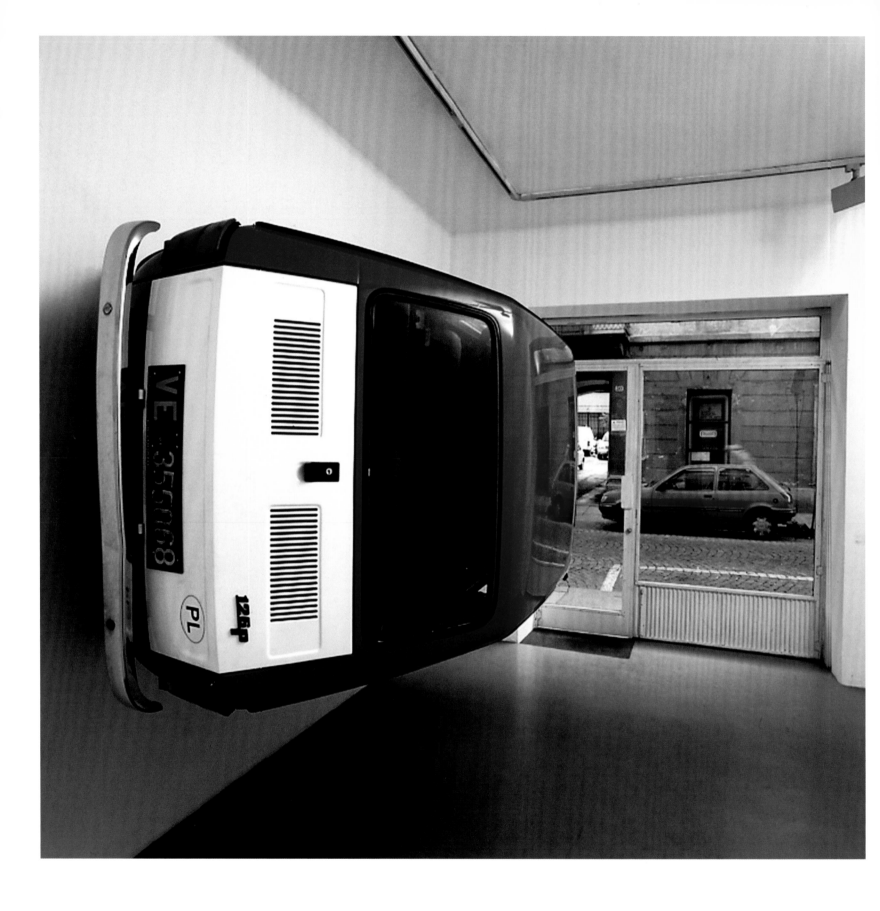

Rhododendrons inevitably brings into play the notions of intrusion, infestation and contamination. And with the national complexes of Scotland and Gibraltar in particular in the background, it is of course tempting to read the piece as a commentary on the culture of fear and anxiety that circles around issues concerning migration – an alternative definition of which could be the simultaneous travels undertaken by huge throngs of 'unwanted' people – and the foreigner. (The immediate counterpart of *Rescuing Rhododendrons* is *Island for Weeds*, another 'failed' public project first presented at the Venice Biennale in 2003.)[11]

Driving through the same sun-scorched plains of Andalusia – the only real desert in Europe – in 2004, Starling came across another emblematic plant species that owed its presence there to the winds of global trade: a Cereus cactus brought over from Mexico in the 1960s to add some local colour to the sets of the Texas Hollywood Film Studios in Tabernas, Andalusia, in which Sergio Leone was shooting his first spaghetti westerns. Starling decided to dig up the giant succulent and drive it to Frankfurt in the same red Volvo 240 Estate. In Frankfurt's Portikus art space – itself something of a Potemkin village, much like the Texas Hollywood Film Studio[12] – the cactus became the centrepiece of *Kakteenhaus*, an installation in which the (not particularly energy-efficient) engine of Starling's Volvo was used to provide the heat required to assure the cactus' survival in Northern Europe's colder climes.

As already noted, the Volvo brand was not innocently chosen, and the same was certainly true of two projects that involved the Fiat brand and are intimately connected with the city of Turin, the site of three important solo exhibitions by Starling, two of which involved experiments in and with car manufacturing. The first, *Flaga* (2002), involved a Fiat 126 produced in Turin – the traditional centre of Italian automobile production, and a city blessed with a rich history of both artistic experimentation and industrial innovation. The car was customized using parts manufactured and fitted in Poland, following a journey of 1,290 kilometres from Turin to Cieszyn, the city to which production of the Fiat 126 had been moved during the 1970s, the decade that saw so many traditional industries suffer the first in a series of cataclysmic crises. The Fiat 126, or 'Maluch' (meaning 'little one' in Polish), its white doors and boot lid a shiny, speckless white in the car's carmine body, was later attached to the gallery wall, where it resembled the flag of its country of 'origin'. As a three-dimensional painting of sorts, it also functioned as a still life or memento mori, conjuring the ghost of the car industry – once the mighty citadel of labour activism – in a city now more closely associated with art ('post-production') than Fordism ('production').

In 2006 Starling returned to Turin for *24 hr. Tangenziale*, a term derived from geometry that is used in Italy to refer to the dense web of highways circling its cities. Here, he took as his point of departure the work of one of Turin's most famous sons: Carlo Mollino, a multi-talented eccentric known as much for his love of skiing, biomorphic furniture designs and nude photography as for the groundbreaking design of his Bisiluro, the race car that took centre stage in *24 hr. Tangenziale*. While researching the history of the Bisiluro, Starling came across a couple of photographs of Mollino's car during a pit stop in the 1955 Le Mans 24 Hours car race, and discovered that one of the pictures – in a gesture long familiar to researchers of, say, the history of Stalinist Russia or Maoist China – had been cropped in such a way as to hide the fact that the car's fantastically advanced-looking radiator didn't quite function as it should. (The mercurial Mollino had to withdraw from the race shortly after the photograph was taken.) This

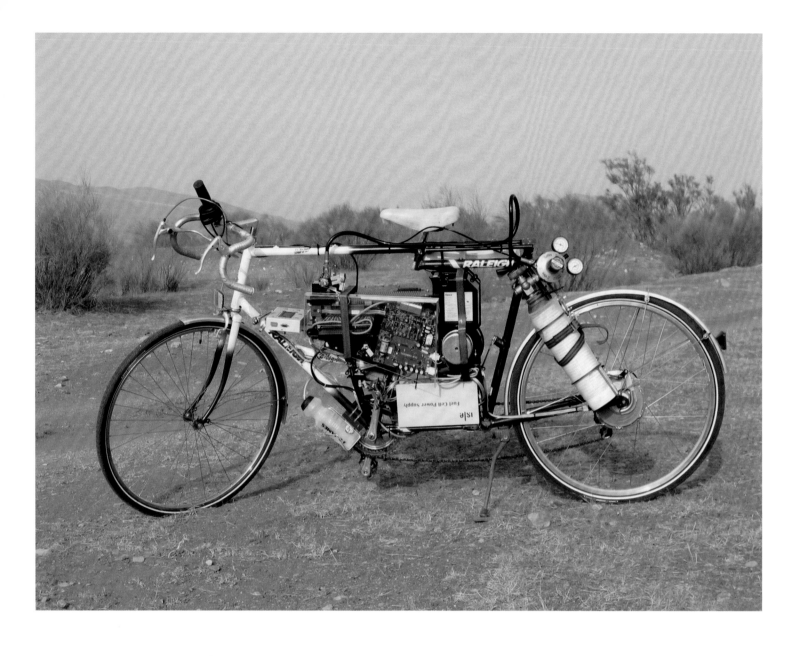

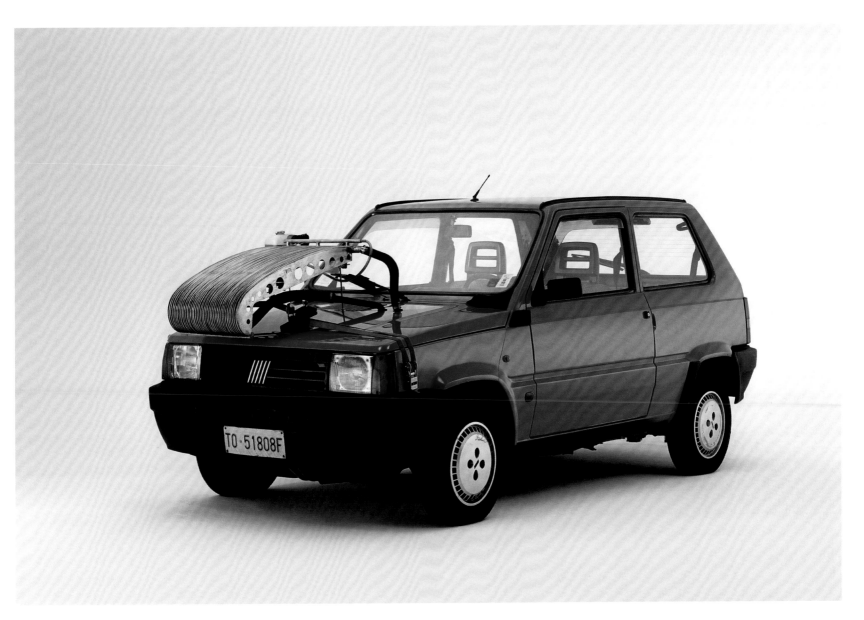

above,
24 HR. TANGENZIALE (A REPLICA
OF THE RADIATOR FROM THE
BISILURO DESIGNED BY CARLO
MOLLINO AND MARIO DAMONTE
FOR THE 750CC CLASS AT THE 1955
LE MANS 24-HOUR RACE, FITTED
TO A 1986 FIAT PANDA AND DRIVEN
FOR 24 HOURS ON 28-9 MARCH
2006 AROUND THE TANGENZIALE,
TURIN), 2006
LAMBDA PRINT
79 X 97 CM

opposite,
TABERNAS DESERT RUN, 2004
FUEL-CELL-POWERED BICYCLE
PRODUCTION PHOTOGRAPHS,
THE TABERNAS DESERT,
ALMERIA, SPAIN

led Starling to seek out an engineer who could rebuild the doomed radiator after Mollino's maverick design. Having achieved this challenge – not so impossible, it turned out, in a city known for its strong backyard manufacturing tradition – Starling had the radiator fitted to a 1986 Fiat Panda, which was then driven around the Turin *tangenziale* for the twenty-four hours that Mollino had never managed to complete.

In the works that have involved the building and rebuilding of boats, the cyclical nature of production is brought out more starkly due to the vessel's timeless nature – the basic elements of boat design have remained essentially unchanged since their invention millennia ago – while also foregrounding the notion of the expedition (the 'search' in 'research') that is so crucial to Starling's understanding of the journey. In addition to *Autoxylopyrocycloboros*, mentioned earlier, *Shedboatshed* (2005) and *Red Rivers (In Search of the Elusive Okapi)* (2009) deserve special attention here. *Shedboatshed*, whose title is reminiscent of *Blue Boat Black* (Starling likes triads and triangulations), was produced when the artist was invited to exhibit at the Museum für Gegenwartskunst in Basel, a city whose life and times

SHEDBOATSHED (MOBILE
ARCHITECTURE NO 2), 2005
WOODEN SHED
390 X 600 X 340 CM

PRODUCTION PHOTOGRAPHS,
RIVER RHINE, SWITZERLAND

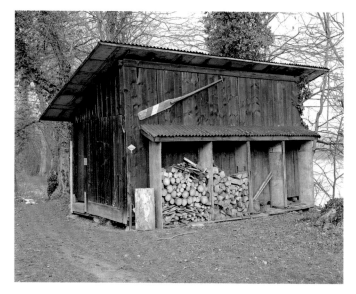

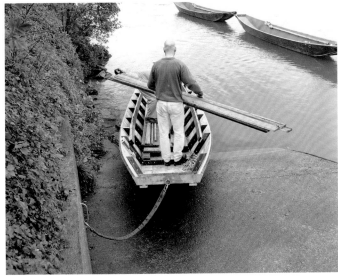

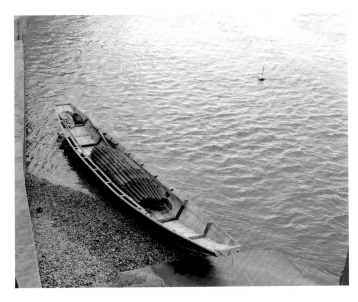

are inextricably bound up with the river Rhine. A walk along its banks during one of his site visits provided Starling with just the right kind of inspiration – clearly, the Eureka moment figures prominently in his working method. Seeing a ramshackle wooden hut with a paddle stuck to its outside wall, he decided to approach the shed's owners and propose its dismantling and subsequent transformation into a boat so that it could then be paddled to the museum down the river (by a museum guard who happened to double as an occasional oarsman), where it would again be taken apart and turned back into a shed, complete with the traces of its short-lived double identity.

In *Autoxylopyrocycloboros*, the boat in question was warranted no such afterlife. Starling and a fellow passenger sailed up Scotland's scenic Loch Long in a small smack whose steam engine was powered by a small wood-burning stove fed with the boat's own wood. The slide show that documented the boat's one-way trip to the bottom of Loch Long (projected from an archaic Görtschmann machine whose analogue rhythm resembles the chugging steam-engine of the boat) concludes with a sequence of images showing floating debris and, just before that, the artist's own inescapable submersion. The moment is not without slapstick overtones, which adds some lightness to the fact that this 'performance' was staged not far from Faslane, the United Kingdom's nuclear submarine base and the scene of recurring pacifist and/or anti-nuclear protests. The project's title sums up many of the core issues of Starling's practice: 'auto' means self, 'xylos' wood, 'pyr' fire, 'cyclos' cycle, while the 'boros' suffix refers to Ouroboros, the mythical serpent that eats its own tail.

Whereas both *Autoxylopyrocycloboros* and *Shedboatshed* may perhaps be read first and foremost as ecologic-economic parables, dramatizing the closure of that which is brought full circle, the more linearly constructed *Red Rivers (In Search of the Elusive Okapi)* instead opens up the discussion of Starling's work – among other strands, the important one of 'naturalism' that runs through much of his oeuvre. A site-specific Massachusetts/New York piece, Starling's thirty-five-millimetre film is made up of a variety of thematic threads that conflate displaced natural history with native American history. (The artist would later go on

SHEDBOATSHED (MOBILE
ARCHITECTURE NO. 2), 2005
WOODEN SHED
390 X 600 X 340 CM

INSTALLATION VIEW AT
MUSEUM FUR
GEGENWARTSKUNST, BASEL,
2005

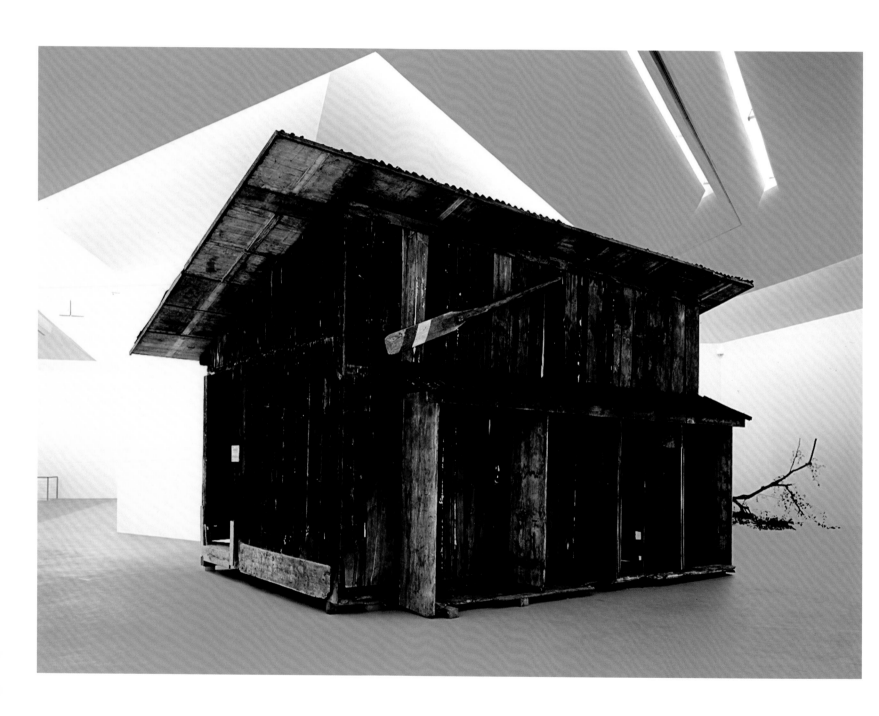

SHEDBOATSHED (MOBILE
ARCHITECTURE NO. 2), 2005
WOODEN SHED
390 X 600 X 340 CM

INSTALLATION VIEW AT
MUSEUM FUR
GEGENWARTSKUNST, BASEL,
2005

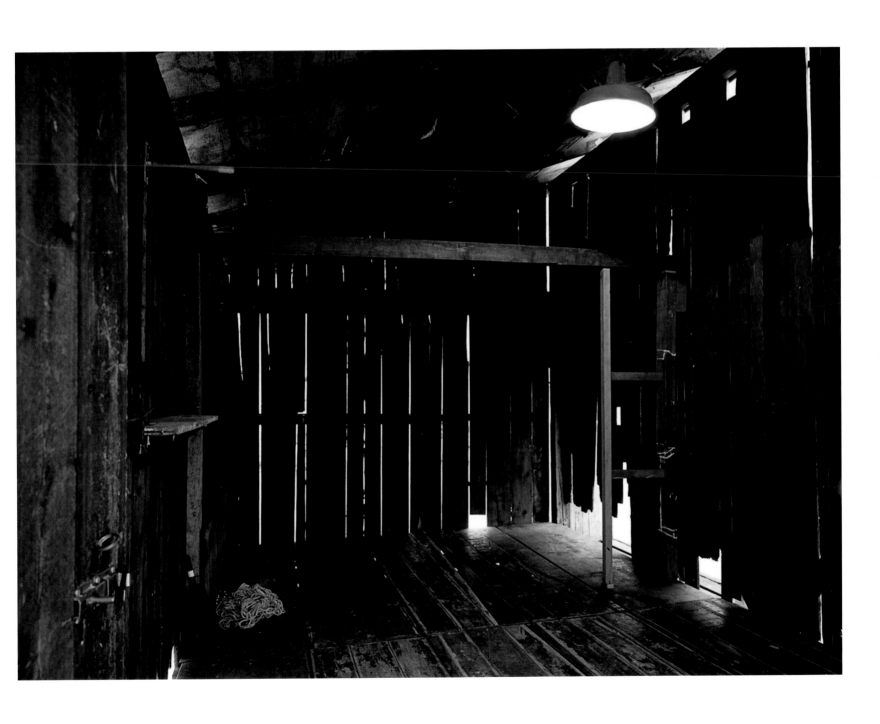

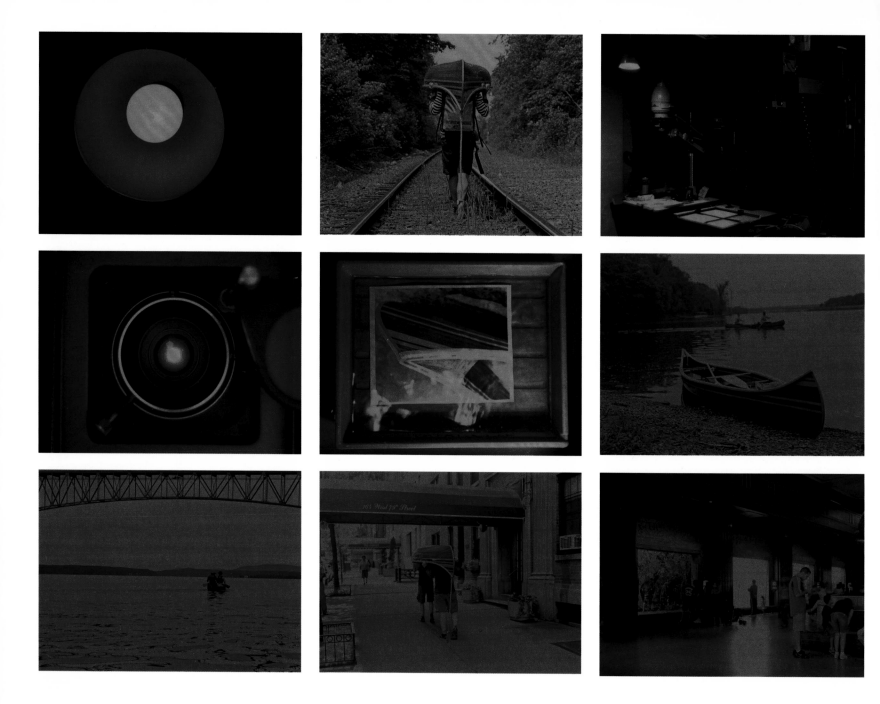

to explore such 'naturalized' histories in greater depth and to even greater effect in a series of works connected to Henry Moore's *Nuclear Energy* sculpture, discussed below.) One of the *Red Rivers* project's triggers was a diorama seen at the American Museum of Natural History in New York containing two taxidermied okapi, a rare giraffe-like animal that was first discovered during the phase of the turn-of-the-century's 'scramble for Africa' that centred upon the mapping of the Belgian Congo. Both okapis were brought to the US by German-American zoologist and avid amateur photographer Herbert Lang, whose account of his 1909 expedition to the Congo basin provides part of the film's narrative spine. Fragments from Lang's diary are read aloud over photographs of Starling's own canoe trip (in a self-made vessel that was first exhibited at Casey Kaplan Gallery in New York in 2007)[13] down the Hoosic and Hudson rivers all the way from North Adams in Massachusetts. These still images are soaked in the red hue of a

darkroom reminiscent of the makeshift technology used by Lang to develop thousands of photographs taken during his many collecting trips for the American Museum of Natural History, some of the most famous of which depict the okapi, then considered to be one of the world's most elusive mammals. (Starling's trip concluded with the artist and his assistant carrying the upturned canoe into the Museum of Natural History in uptown New York and coming to a standstill in front of the okapi diorama.) 'It's not blood, it's red,' Jean-Luc Godard once famously remarked in response to a comment about the violence in his film *Pierrot le fou*, yet the elegiac flow of reddened images documenting a boating trip down an ancient artery of the European colonization of North America, read against the backdrop of the work's evocative title, seems to suggest that in this case the opposite may be true. Red is blood indeed when one considers the fact that one of the museum's most generous supporters during Lang's tenure there, J. P. Morgan, was a close friend of Leopold II, the bloodthirsty king of Belgium who infamously regarded Congo as his private property.

A less jarring instance of cultural history's crossing over into the realm of natural history (or the history of nature's exploration and exploitation) can be found in *Archaeopteryx Lithographica* (2008-09), another example of Starling's interest in the cycles of production symbolized as forces of nature (and vice versa). A series of six lithographs printed on six slabs of limestone – the same type of stone (*lithos* in Greek) used to make the lithographs – depict two different images of a single fossilized feather. The work's title refers both to an archeological find – the feather in question – and to the development of lithography, both of which occurred in the Bavarian village of Solnhofen. The fossil was discovered by one Hermann von Meyer in 1861 (just two years after the publication of Charles Darwin's *On the Origin of Species*, a book whose central tenets von Meyer's discovery would anchor even deeper in actual, historical fact), in Solnhofen, the site of a limestone quarry where, back in the late eighteenth century, the printing process of lithography had originated thanks to the experimenting instinct of the Austrian playwright Johann Alois Senefelder. Serendipity, 'the faculty of making fortunate discoveries by accident', is the key term here; the luckless Senefelder, in debt because of an unsuccessful publishing venture, came across the lithographic printing process by accident, discovering that the Solnhofen limestone mixed well with a particular type of acid-resistant ink. Fate of some other, arguably higher sort ordained that one representative of the prehistoric Ur-bird Archaeopteryx should have left behind a lone feather in a rare geological formation that, eons later, would prove a blessing both for the emerging science of evolutionary biology and for its quasi-contemporary, the mechanical reproduction of images.[14] Inhabiting the roles of both von Meyer and Senefelder (as he did with Lange in *Red Rivers*), Starling here elevates serendipity to one of his practice's guiding principles, reminding us that coincidence, like beauty, is very often in the eye of the beholder. The project was triggered by the invitation, tendered by a Copenhagen-based printer, to make a lithographic print – something that Starling had never done before.

As is the case with many pioneers of the (relatively new) tradition of research-based art practice in which 'research' regularly performs the role of art and vice versa – a trend that is inextricably linked to the

ARCHAEOPTERYX LITHOGRAPHICA,
2008-09
INK, SOLNHOFEN LITHOGRAPHIC
LIMESTONE
53 X 43 X 7 CM
PLINTH
110 X 66 X 55 CM
2 OF 6 LITHOGRAPHIC PRINTS
EACH 45 X 33 CM

INSTALLATION VIEW AT NEUGER-
RIEMSCHNEIDER, BERLIN, 2009

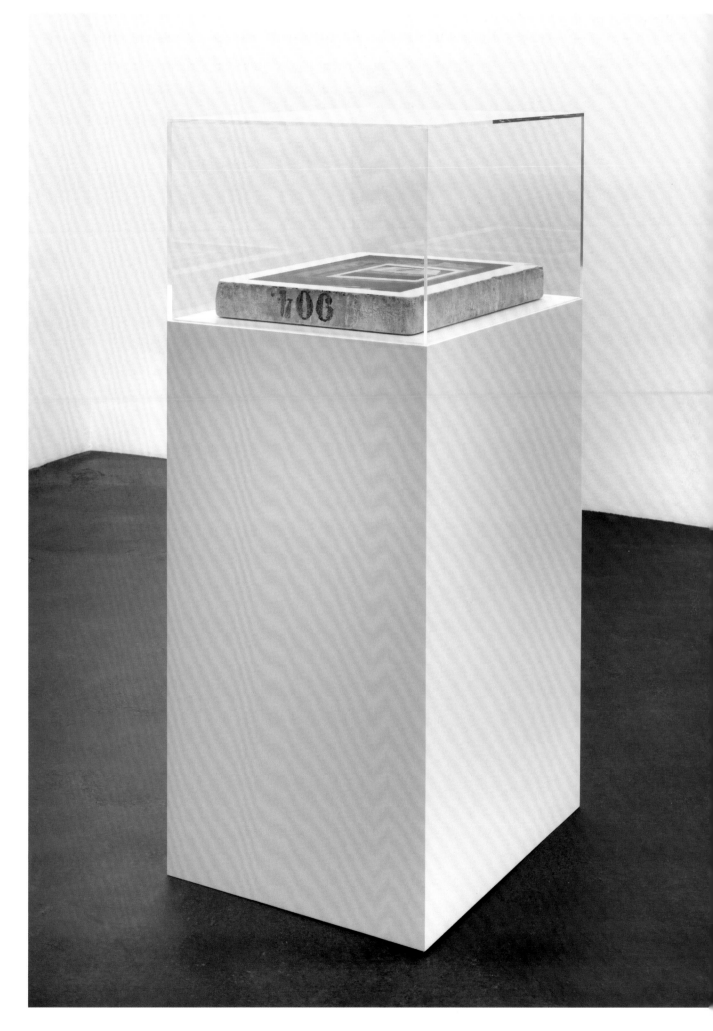

BIRD IN SPACE, 2004, 2004
IMPORTED ROMANIAN STEEL
PLATE, INFLATABLE JACKS,
HELIUM
183 X 610 X 30 CM

above, PRODUCTION
PHOTOGRAPH, NEW YORK
right, INSTALLATION VIEW AT
CASEY KAPLAN, NEW YORK,
2004

academization of art education in recent years – much
of Starling's investigations have taken art's own insti-
tutional habitat as a point of departure: recent and
less recent art history, art-world politics, the economy
of the art world. Deftly avoiding the referential (and
reverential) anecdotalism of much quotation-obsessed
art-about-art, however, Starling's own art-about-art
projects always figure in the bigger picture of his overall
interest in issues that concern the global economy at
large, or recent political history. Paradoxically, yet at
the same time unsurprisingly, they make for some of
his most unequivocally political projects. Two artists
in particular are central to this line of inquiry, and it is
telling that Starling should have chosen for these roles a
pair of protean sculptors who represent the Janus face of
sculpture in the twentieth century: Constantin Brancusi
(1876–1957) and Henry Moore (1898–1986).

The enigmatic Brancusi – a master, much like the
aforementioned Carlo Mollino, of the artful staging of
self, and another committed traveller[15] – is the protago-
nist of Starling's *Bird in space, 2004* (2004), a startling
work based on a well-known art-historical anecdote
dating back to the early days of the avant-garde's gradual
migration from Paris to New York. In 1926 Marcel
Duchamp had arranged for Brancusi's original 1923
sculpture *Bird in Space* to be shipped to New York,
where it was to be included in the collection of Edward
Steichen. The shipment was held up in New York
harbour, however, because the customs officials refused
to accept the elegant, elongated bronze sculpture's status
as a work of art (which would have enabled it to entered

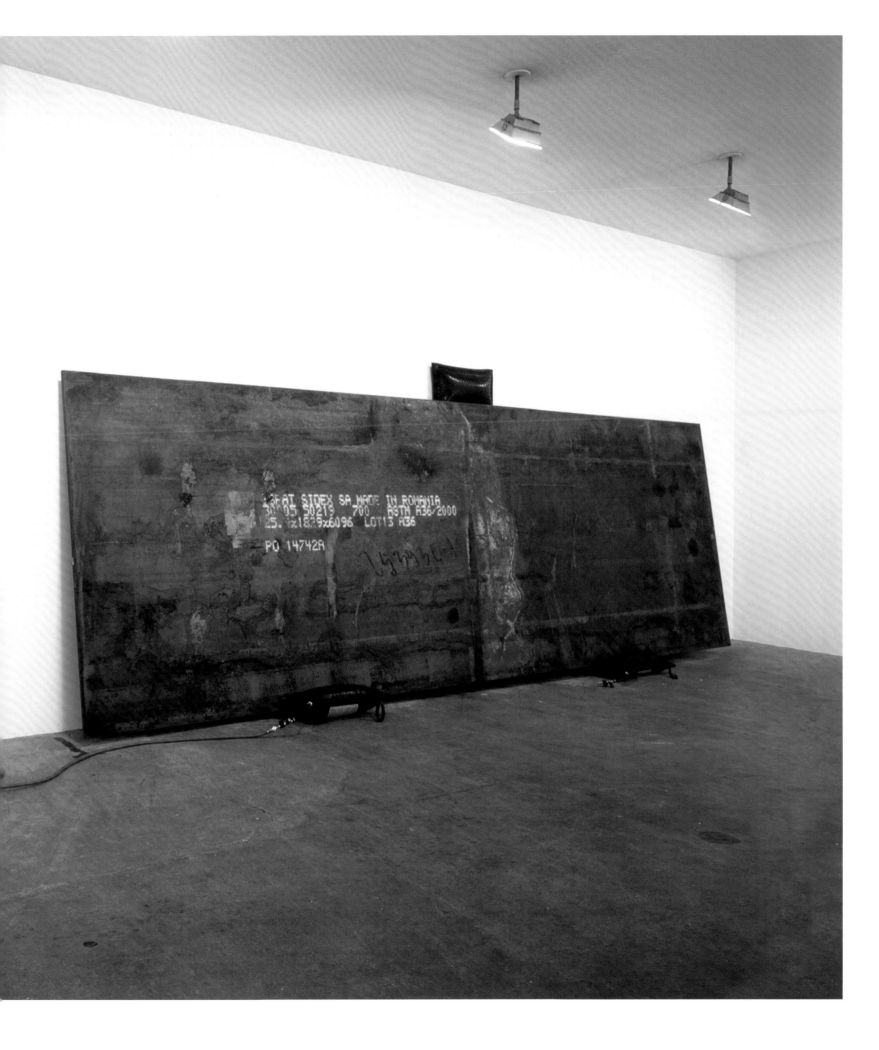

the country free of charge), instead claiming that, as a banal manufactured metal object, it was subject to a forty per cent customs tariff. A widely reported court battle ensued, which eventually concluded with a ruling in Brancusi's favour, declaring *Bird in Space* a work of art. Starling, for his 2004 solo exhibition at Casey Kaplan Gallery in New York, sought to recover something of the (not necessarily malicious) confusion that had seized the city's customs officials eight decades earlier. The visitor to the exhibition was greeted by a huge slab of rusty steel leaning against a gallery wall, held afloat by three air cushions filled with helium.[16] The question here was no longer one that concerned the object's status as a work of art, but rather the material's provenance, namely Romania. The oblong piece of Romanian steel was not only intended to remind the viewer of Brancusi's country of origin but was also consciously used at a moment when George W. Bush was introducing a new import tax of twenty percent on foreign metals, in a populist attempt to favour homegrown steel production.[17] Starling circumvented this tax by labelling a banal-looking slab of European steel a work of art, which, back in the gallery, was transformed into a 'bird in space' by putting it on top of a couple of helium-inflated plastic bags, thereby returning the piece's discussion to the traditional sculptural parameters of weight, gravity and balance.

While the core of Starling's interest in Brancusi may be connected to the latter's ambiguous relationship to the idea of the original (for an artist so visibly invested in the concept of aura, there are lots of *Birds in Space* out there), his fascination with the heroic figure of Henry Moore is more overtly 'political' because of Moore's own emblematic status as both a quintessential Cold

War artist and something like an official British state artist. Indeed, Starling has recounted how, back in the 1970s, a monograph of Henry Moore was probably the one art book to be found in virtually every British household, and growing up as an artist in the England of the 1980s inevitably meant having to confront the long shadow cast by this pre-eminent modernist.[18] It shouldn't come as a surprise, then, that the Henry Moore 'portrayed' in *Infestation Piece (Musselled Moore)* from 2006-08, and in an interlaced ensemble of works circling around Moore's own *Nuclear Energy* from 1964-66, cuts a spectral, ghoulish figure.[19] At first glance, *Infestation Piece (Musselled Moore)* appears directly related to *Island for Weeds* and *Rescuing Rhododendrons*. The mussels in the work's subtitle are Eastern European zebra mussels, originally inhabitants of the Black Sea and considered something of a scourge in Lake Ontario, where they now thrive and where Starling was first made aware of their existence during a site visit to Toronto for a solo exhibition at the Power Plant. Interestingly enough, the molluscs owe their introduction into these faraway waters to the 1980s expansion of global trade; they entered the Great Lakes in the bilge water of Black Sea-based trading vessels. Thus a marine species hailing from a body of water bordering the former Soviet Union is wreaking havoc on the bottom of a lake bordering the US, and this simple fact led Starling to recast his research in the politico-historical terms of the Cold War. Looking around for traces of Moore's presence in this corner of the Commonwealth, he was shown a wing of the Art Gallery of Ontario that was actually named after the British sculptor. One artwork in particular drew his attention: Moore's *Warrior with Shield* (1953-54), part of a series in which the avowed pacifist sought to express his ambiguous attitude towards the discipline's own

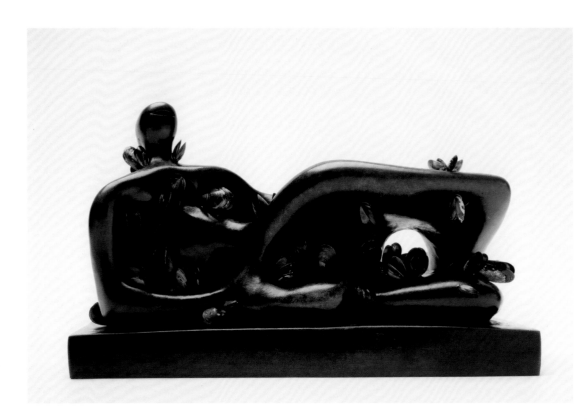

INFESTATION PIECE
(MUSSELLED MOORE)/
MAQUETTE, 2006
MUSSEL SHELLS, BRONZE
SCULPTURE ATTRIBUTED TO
HENRY MOORE C. 1960
155 X 73 X 71 CM

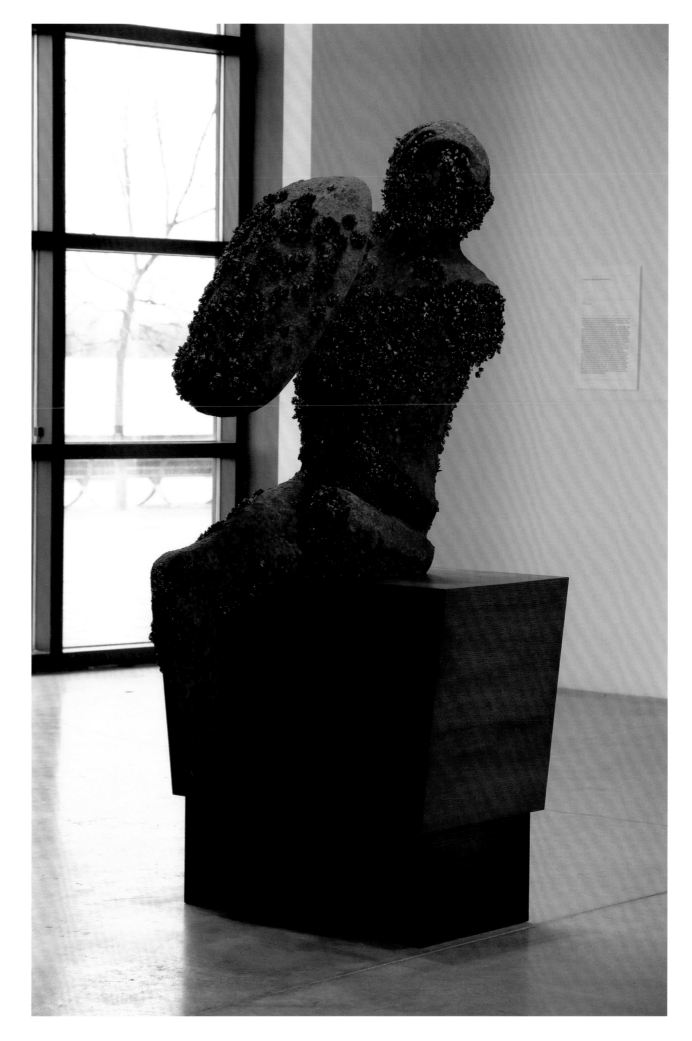

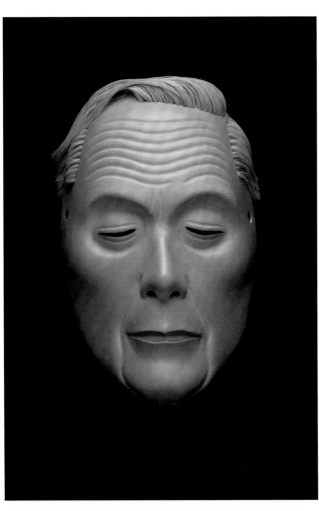

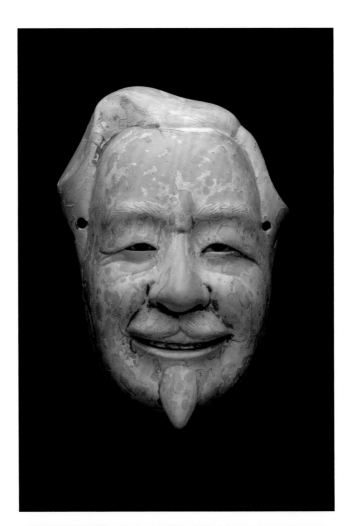

PROJECT FOR A MASQUERADE
(HIROSHIMA), 2010
8 WOODEN MASKS (CARVED BY
YASUO MIICHI), BOWLER HAT
HEIGHTS VARY FROM FROM
18 TO 28 CM

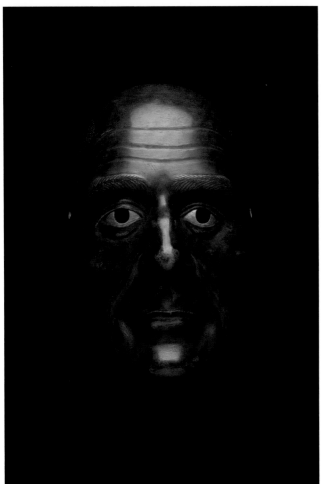

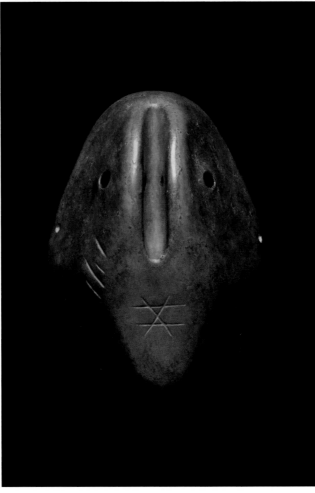

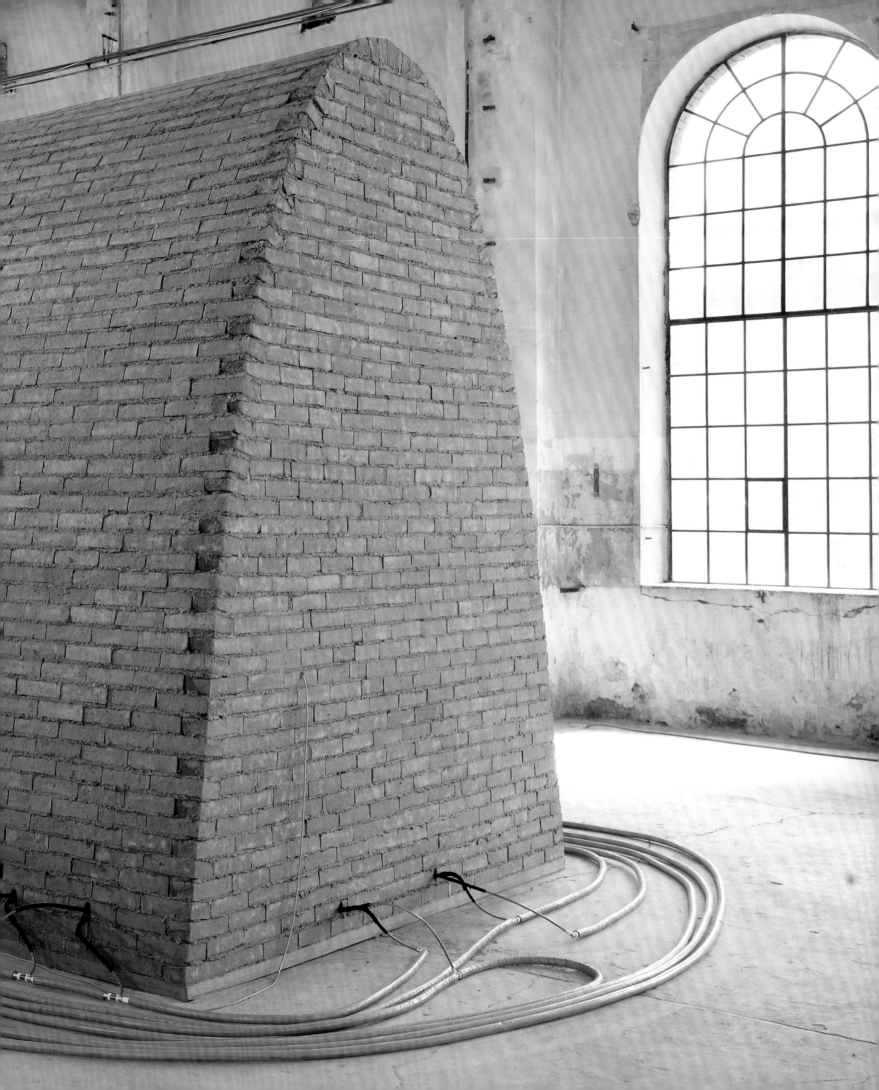

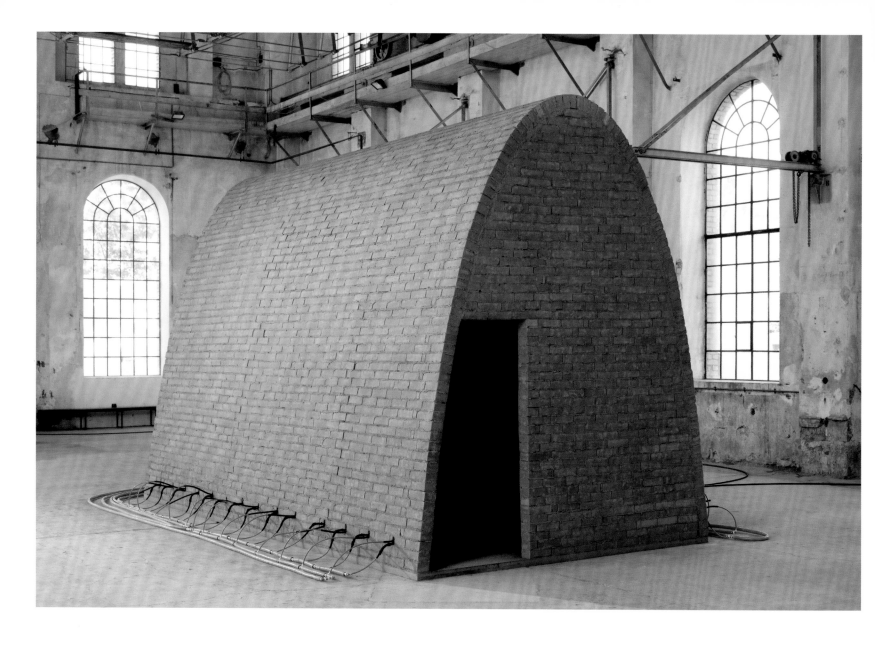

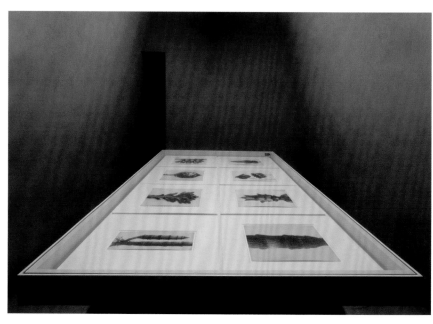

Hirschhorn, Colonel Sanders and a choir named the Back of the Yard Boys. Blunt, appointed Surveyor of the King's Pictures in 1945 and an influential defender of Moore's work, was unmasked as a Soviet spy in 1979; Hirschhorn, whose legacy lives on in Washington's Hirschhorn Museum and Sculpture Garden, made millions exploiting uranium mines in Northern Ontario; Colonel Sanders is the name of the benign Smiling-Buddha-like figure whose effigy graces millions of Kentucky Fried Chicken packages worldwide, an early symbol of the post-war Americanization of Japanese society; the Back of the Yard Boys is the name of a Polish-American teenage gang whom Fermi hired to help build Chicago Pile 1. Starling's two-part project debuted at Glasgow's Modern Institute in 2010, where only the masks were exhibited; here, the work was titled *Project for a Masquerade (Hiroshima): The Mirror Room*, a reference to the mirror-clad rooms in Japanese Noh theatres where the actors put on their masks and become ritually possessed by the characters they will perform on stage. One can easily imagine the mirror room as a metaphor for both Starling's prodigiously associative imagination and this particular work's programmatic

doubling of identities, in which the sight of the-artist-filming-a-mask-maker-sculpting-a-mask-resembling-a-model-of-an-artwork-renamed-*Nuclear-Energy*-by-the-janus-faced-Henry-Moore perfectly captures a crucial aspect of his practice: the studio or exhibition space remade as a hall of mirrors, triggering a cascade of *mise-en-abîmes*, rather than just one mirror room.

Just as these two sculptors lord over the sculptural hemisphere in Starling's material world, two photographers have acted as inspirational source material for elaborate projects that continue his exploration of site-specificity, the German photographers Karl Blossfeldt and Albert Renger-Patzsch, reminding us of Starling's original training as a photographer – always the most scientific of the fine arts, at least in its analogue guise. Blossfeldt is a forefather and Renger-Patzsch a full-blown representative of the influential *Neue Sachlichkeit* movement of Weimar-era Germany. The figure of Blossfeldt, best remembered today for his botanical photography, is the central reference in Starling's *Plant Room* (2008), a work directly connected, in terms of genealogy, to *Kakteenhaus*, though more closely linked

with the labyrinthine question of art-historical method-ology than with botanical research. Indeed, *Plant Room* originated in the Kunstraum Dornbirn in Austria, where, during a preparatory research trip, Starling was told that he could do pretty much anything in the Kunstraum's exhibition space (once again, a disused industrial building)[20] except show light-and-temperature-sensitive photographic material. This inevitably led the artist – motivated by the benevolent curiosity of the inventor rather than by the antagonism of the practitioner of institutional critique – to explore the possibility of doing just that, and the choice quickly fell on a series of photographs from Blossfeldt's canonical *Urformen der Natur* (1928). Starling eventually managed to exhibit a set of vintage prints under the standardized museum conditions (a temperature of twenty degrees Celsius with no more than two degrees of fluctuation, fifty perc-ent relative humidity with no more than a five percent fluctuation, and a light level of fifty lux) in a mud brick hut – an ancient structure that, however improbably, just so happens to match all the requirements of state-of-the-art exhibition spaces. Not only did Starling pay homage to an artist who had grasped the sculptural, even architectonic quality of his photographic subjects – their austerity and modesty reflected in the disarming humility of the little clay house – but *Plant Room* also reiterated his ongoing ecological-economical preoc-cupations. The high-tech cooling system that ensures climatic stability inside the mud hut (and which, in the Temporäre Kunsthalle exhibition in Berlin in 2009, could be seen snaking around the entire building, making a bit of a show of its own absurdity) was a monument to energy efficiency, powered by Starling's beloved, yet no-longer-so-efficient, Volvo 240.[21]

Although known for covering a vast range of photo-graphic subjects, some of which remained close to the 'naturalist' impulse of his great example Blossfeldt, Renger-Patzsch attracted Starling's attention because of his fifteen-year association with the Museum Folkwang in Essen, to which Starling was invited in 2007 for a project marking an important date in its architectural history.[22] The work's title, *Nachbau*, literally translates as 'replica' or 'imitation', and the process of replica-tion that Starling was concerned with here centred upon four installation shots that Renger-Patzsch had made of permanent displays of the Folkwang collec-tion between 1929 and 1933, the twilight years of the Weimar regime. The Nazis' subsequent seizure of power eventually resulted in the war that destroyed the fine original building that housed the museum, still known for its rich holdings of so-called 'degenerate' art. The four photographs depict 'degenerate' paintings by (among others) Franz Marc, Paula Modersohn-Becker, Otto Müller and Emil Nolde, overlooking a connois-seurial grouping of objects hailing from other cultures: a bodhisattva, a Buddha's head, Greek vases. In fact, the self-conscious heterogeneity of the objects' juxtaposition and its obvious disregard for chronology and art-histor-ical disciplinary boundaries presage the current curato-rial fashion for salon-style 'intercultural' arrangements. Taking these photographs as his only lead, Starling proceeded to reconstruct (*nachbauen*) the arrangement in question – both in three dimensions and in the two dimensions of the black-and-white photographs that he himself made of this reconstruction. This meant delving into the Folkwang's vaults with an eye on restoring the works to their immaculately portrayed pre-war dialogue, only to find that some of the works documented in

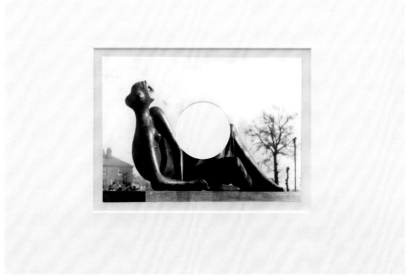

ROCKRAFT, 2008
RAFT, QUARRIED STONE, TIDAL
TRANSPORTATION

PRODUCTION PHOTOGRAPHS,
AVONMOUTH AND THE RIVER
AVON, BRISTOL

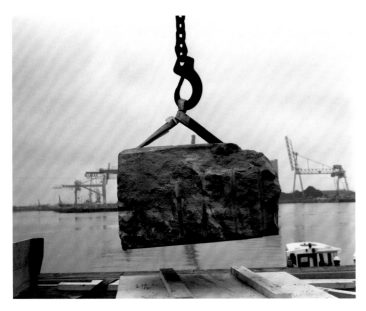
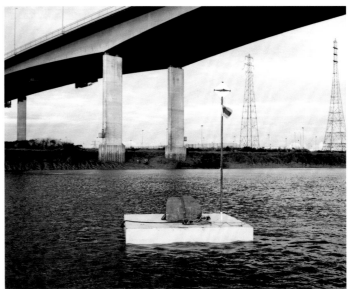
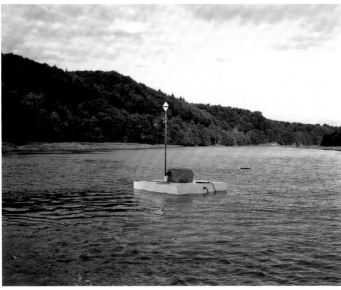

Renger-Patzsch's pictures were no longer there, for obvious political-historical reasons. In Starling's own words, 'Nachbau involved the "faking" of a number of works from the collection that had been confiscated under National Socialism – a Giorgio de Chirico now in Switzerland, a Franz Marc and an Erich Heckel both in the US. Apart from some speculative use of colour and a single missing sculpture, the reconstruction was exact in every detail, even, it was observed, down to its smell.'[23] The accompanying publication consisted of two volumes, one containing the original Renger-Patzsch photographs (also of other museum exhibits, many shot in the style of his photographic record of Germany's belated industrial revolution), another containing photographs made by Starling, in the *Neue Sachlichkeit* style, of his own reconstruction or 'stage set'. The book also includes an excellent essay by philosopher Bruno Haas, who ruefully observes that 'the home of a work of art that has lost its world is the museum'.[24] As *Nachbau* seems to suggest, however, the work of art (which in this case also includes a publication, conceived as an artist's book) can in turn become the home of a museum that has lost its world – literally so, in the case of this historically fraught building that no longer exists.

A brief question, in conclusion, that will perhaps undermine much of the work undertaken in the preceding pages: does one only 'get' Simon Starling's work after having been told its secret ingredients? Does the retelling of the labyrinthine stories that constitute his by-now well-known method – which should of course at no point be confused with the work itself, no matter how much 'collapsing' the work in question may suggest – suffice to lift the veil that shrouds the artwork's essential enigma? For enigmaticalness certainly is a key component of many of his sculptures and sculptural installations – think of the mystery of a mussel-covered Moore, the puzzle of a silver particle, the riddle of *Rockraft* (2008). How, in fact, if not confused and conflated, does this method – which, in a number of cases, could be reduced to a set of heuristic and quasi-scientific formulas – relate to the work at hand?

Without a doubt, Starling is playing a significant role in an ongoing development that encompasses the intensification and upgrading of the concept of research as a key aspect of artistic practice. As an artist who spends a good deal of time reading and researching in libraries and archives or talking to people in the know, learning about certain minutiae of artistic, economic, political or scientific history, he must be considered an important figure in the recent reformatting of artistic practice as a form of 'production of knowledge'. Knowledge is key in (and to) much of his work, making it appear eminently contemporary in a globalized world that likes to think of itself as driven by a knowledge economy first and foremost. If Starling's art partakes of this knowledge economy, however, it always does so as art first and as knowledge (or economy, for that matter) only a distant second. Fittingly, for an art in which nothing is ever what it seems (such as *Bird in space, 2004, The Long Ton* and *Work, Made-Ready, Kunsthalle Bern*), such strategies of deception are also at work at the foundational level of his practice. Much as *Bird in space, 2004* isn't quite what

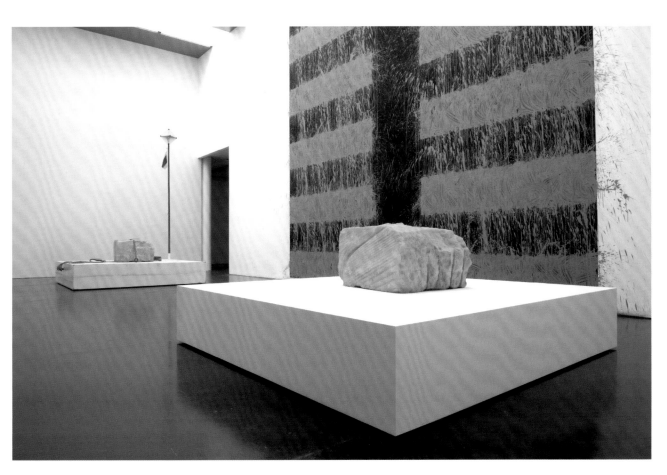

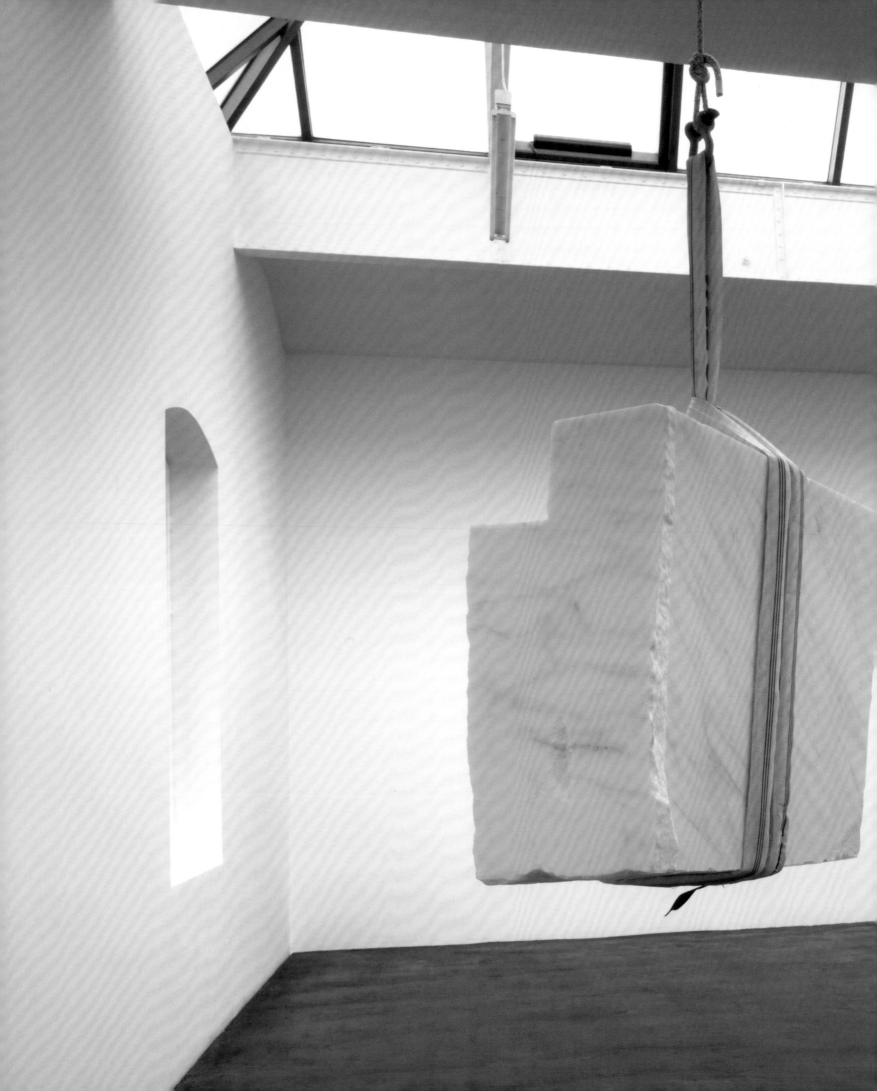

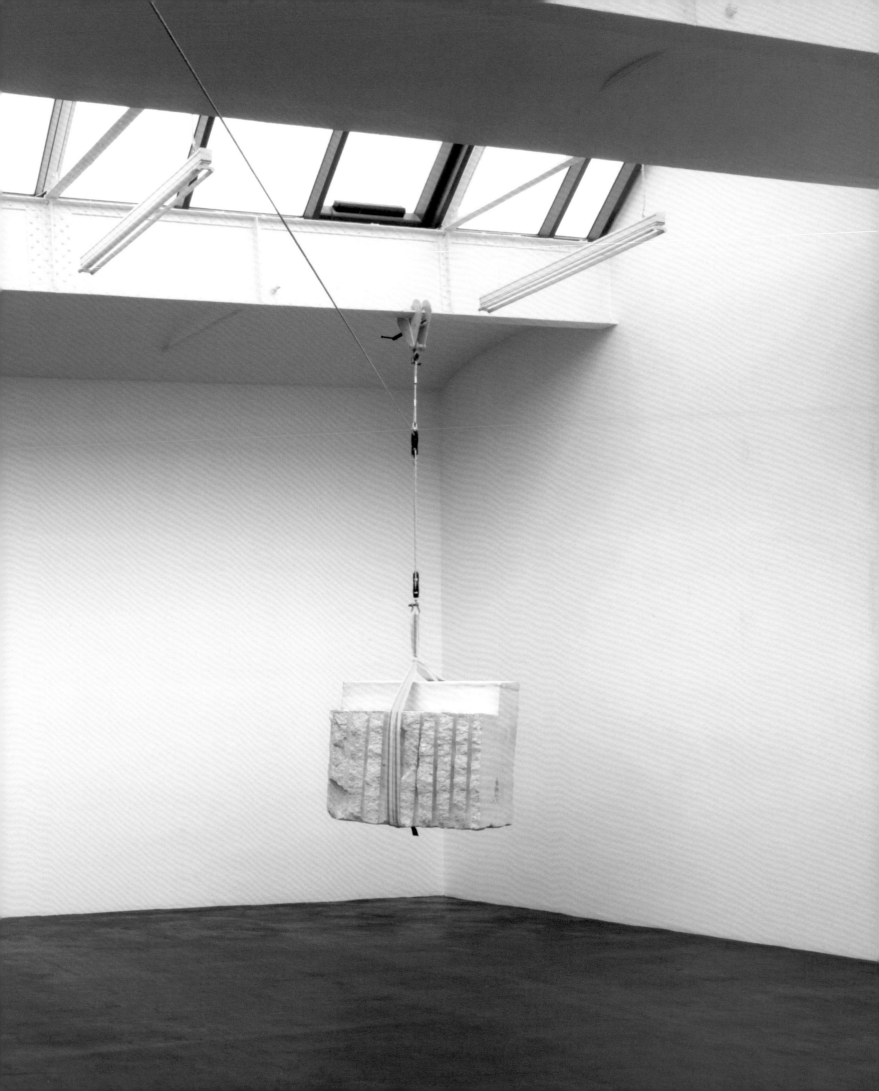

it seems (neither a bird in space nor a Brancusi – and seeing it float on the air cushions would even lead us to doubt whether it is a two-ton plate of Romanian steel at all), Starling's art in general isn't quite what it may seem: namely, a relatively straightforward sculptural or spatial expression of a certain circle-and-cycle-obsessed mode of research, or a relatively straightforward sculptural or spatial application of a certain method. Even if titles like *Cast aluminium replica of a toy pistol found on the 18th of January 1994 on the grounds of the Weissenhof housing project, Stuttgart, photographed and repro-duced in an edition of 3000 for the Institute of Cultural Anxiety* (1994) may send the viewer-turned-reader into a delirium of explanatory overexposure, what matters most in the end is the work on view: the sculptural object that we may – *must* – assume will survive both the artist and the critic or curator as authorial and authori-tative sources of artistic truth.[25] Indeed, in reviewing some of the subdued madness that is at the heart of Starling's art, the work of another great scholar aligned with another Frankfurt school comes to mind: Theodor Adorno, who once remarked that 'the enigmaticalness of artworks is less their irrationality than their rationality;

the more methodically they are ruled, the more sharply their enigmaticalness' – in other words, their own truth – 'is thrown into relief'.[26]

This 'story of deception' is perhaps nowhere more convincingly rendered than in *The Nanjing Particles* (2008). If this work's extensive preparatory research and dizzying economic logic collapses into anything at all, it does so in the very robust enigma of its sheer physical being-there. And it is no coincidence that this is the one work of art by Starling in which inquisitive viewers can see themselves reflected in the object's surface texture: art that looks back at you. Like many of the artist's projects, *The Nanjing Particles* started with a site visit, this time to a museum in North Adams, Massachusetts, where Starling came across a faded stereoscopic group portrait of Chinese migrant workers who had been brought to this secluded corner of New England in the 1870s to work in a shoe factory (at the time paralyzed by a strike) that once stood on the grounds of what is now the Massachusetts Museum of Contemporary Art (MASS MoCA). Using a powerful electron microscope, Starling extracted two silver particles – a technique

previous pages,
THE LONG TON, 2009
CHINESE MARBLE BLOCK
90 X 120 X 50 CM
CNC MILLED CARRARA MARBLE
BLOCK
59 X 74 X 31 CM
PULLEY SYSTEM, CLAMPS,
ROPE SHACKLES

INSTALLATION VIEW AT
NEUGERRIEMSCHNEIDER,
BERLIN, 2009

below,
THE NANJING PARTICLES, 2008
FORGED STAINLESS STEEL
2 PARTS
420 X 150 X 200 CM
450 X 170 X 200 CM
INKJET PRINT (C T SAMPSON'S
SHOE MANUFACTORY, WITH
THE CHINESE SHOEMAKERS IN
WORKING COSTUME, C 1875)
6 X 13 M

INSTALLATION VIEW AT
MASSACHUSETTS MUSEUM OF
CONTEMPORARY ART, NORTH
ADAMS, 2008

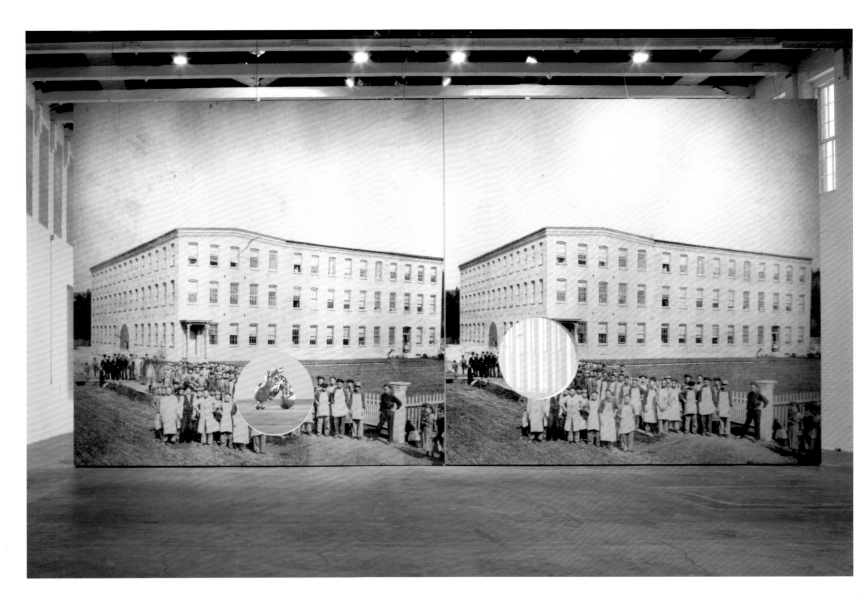

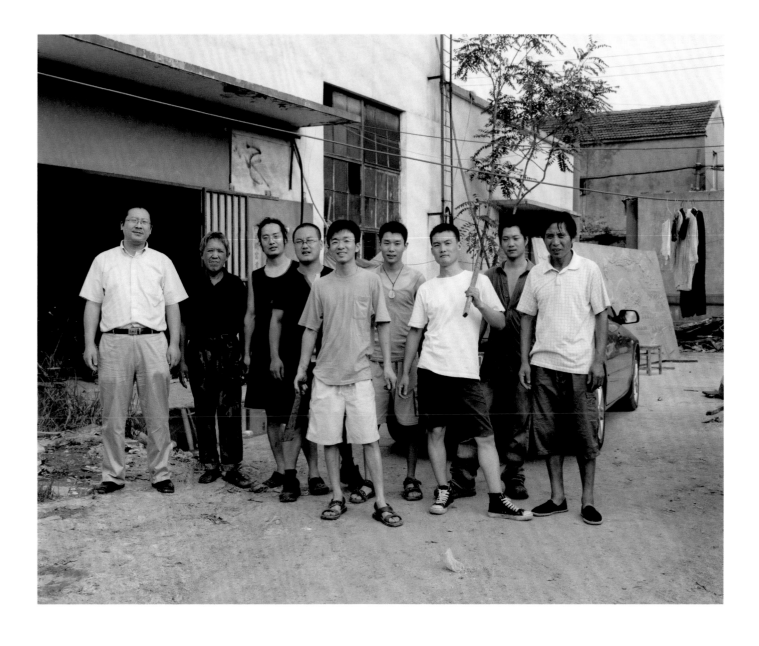

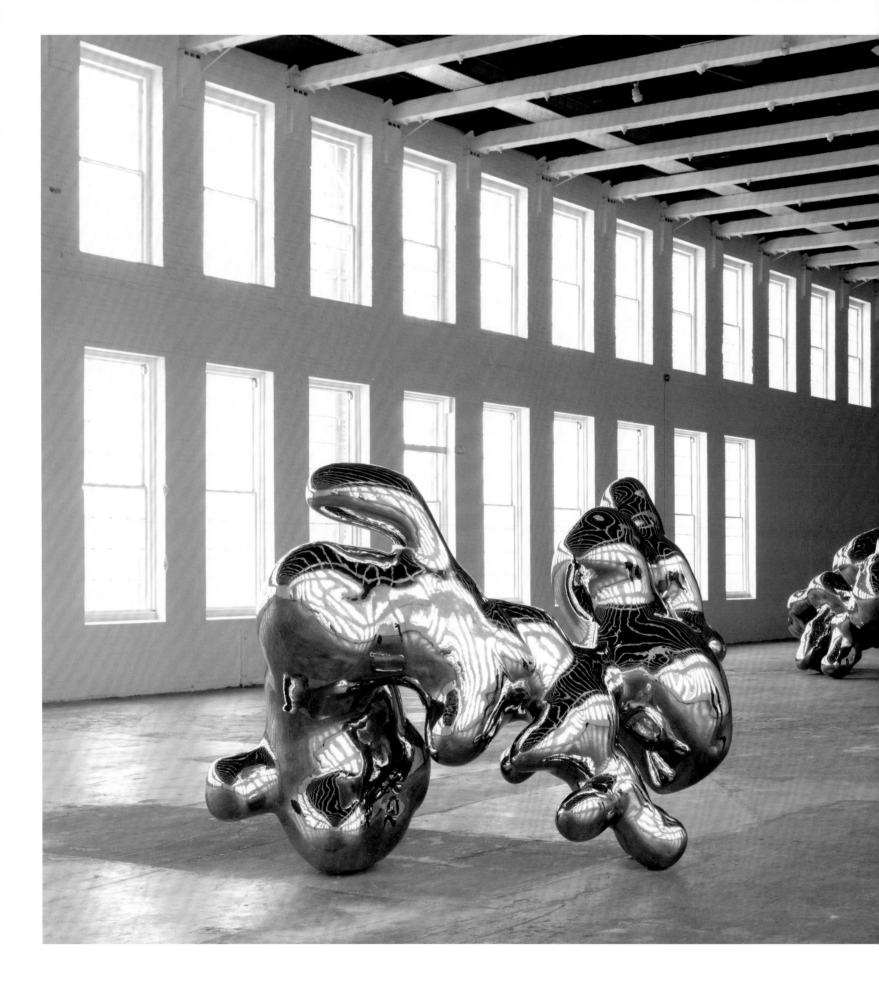

already deployed in *Particle Projection (Loop)* – had them photographed from various angles and used them as models, enlarged a million times, for two mirror-finished stainless-steel sculptures fabricated in the Chinese city of Nanjing. What the visitors to MASS MoCA encountered were two colossal, shiny metallic blobs – the immediate pop-cultural association being that of the shape-shifting mutant in *Terminator 2*, although a more art-historically informed viewer may have thought of Anish Kapoor or of Thomas Schütte's aluminium ghosts – which could be glimpsed, upon entering the space, through two holes in a blow-up of the original 1870s photograph. A veritable exegetic feast for those of us who enjoy 'reading' art as much as, if not more than, experiencing it (seeing it, hearing it, feeling it), this work brings together many of the tropes singled out as constitutive of Starling's research interests at the beginning of this essay, adding some more topical data taken from recent world history to the mix. This being both the US and China after all, and this being an artwork firmly and self-consciously rooted in the economic conditions of globalization, *The Nanjing Particles* brings to mind both the sinophobia that underlies much of America's anxiety around the rise of China as a new economic superpower, and the more specialist issue of the post-Fordist outsourcing that has become an integral aspect of contemporary art production, with much more art 'made in China' than just Chinese art or art by Chinese artists. Starling complicates this picture by stressing the importance of the work's artisanal production (the accompanying publication meticulously charts the process of its coming into being) and of actually naming the Chinese workers involved in this laborious feat of superb, and not terribly modern, craftsmanship. As the sculptures draw nearer to completion, their mirrored surfaces becoming shinier in the process, photographs of the giant particles' production process start to reveal the faces of their makers – another vicarious homage of sorts to the nameless workers in the nineteenth-century photograph whose facial features are slowly being corroded by time.

But in the final analysis, or in the bigger picture, all this information – that which constitutes the work's 'secret ingredients' – may be irrelevant. Starling, as Stuart Morgan put it, 'goes one step further and suggests that it may not matter'.[27] (Of course it does – just not *now*, or just not always.) And he does so by producing the bizarrely shaped yet undeniably beautiful objects – although this is the first mention of beauty in the essay so far, there is no denying its significance in Starling's work – that we look at inside the MASS MoCA, only to see our inquisitive selves reflected in them, distorted yet still fully recognizable. What we 'witness' in this distorted reflection, then, is not so much the *lifting* – the business, ultimately, of science and comparable forms of knowledge production, producing knowledge for knowledge's sake – as the *lowering* of the veil that serves to keep the artwork's essential enigma intact.

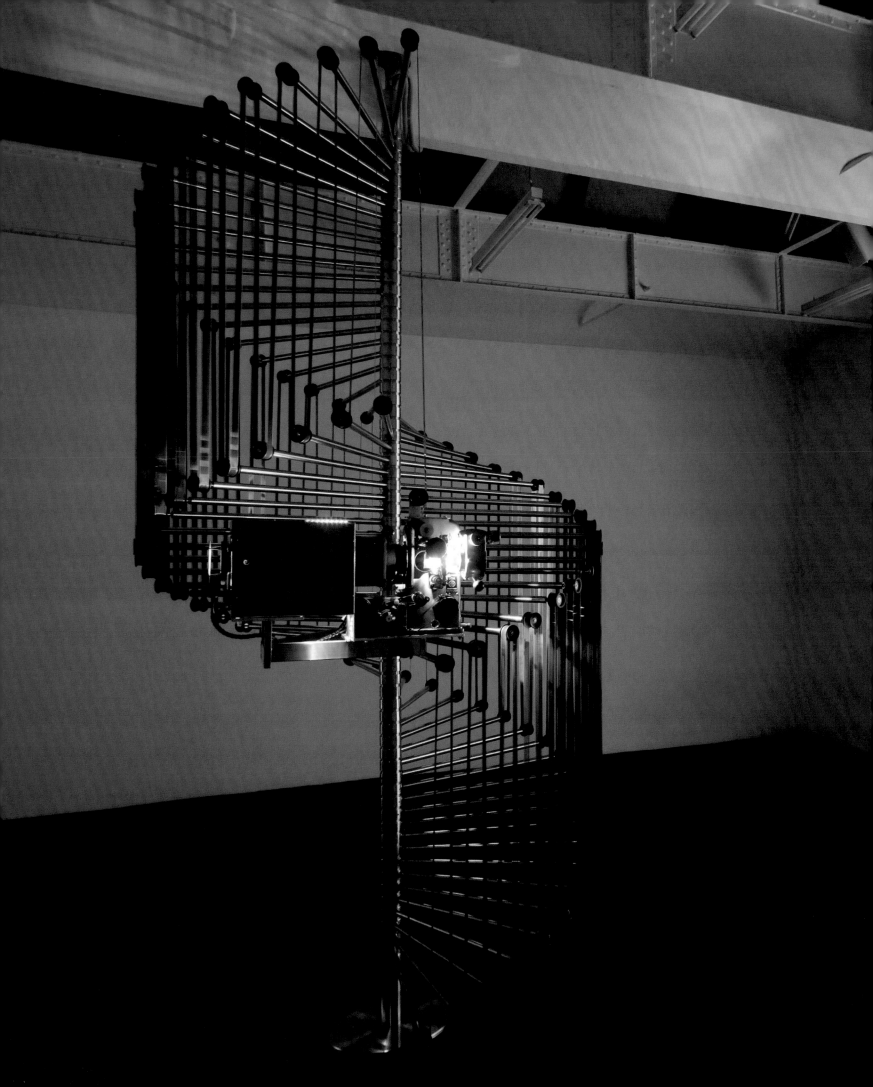

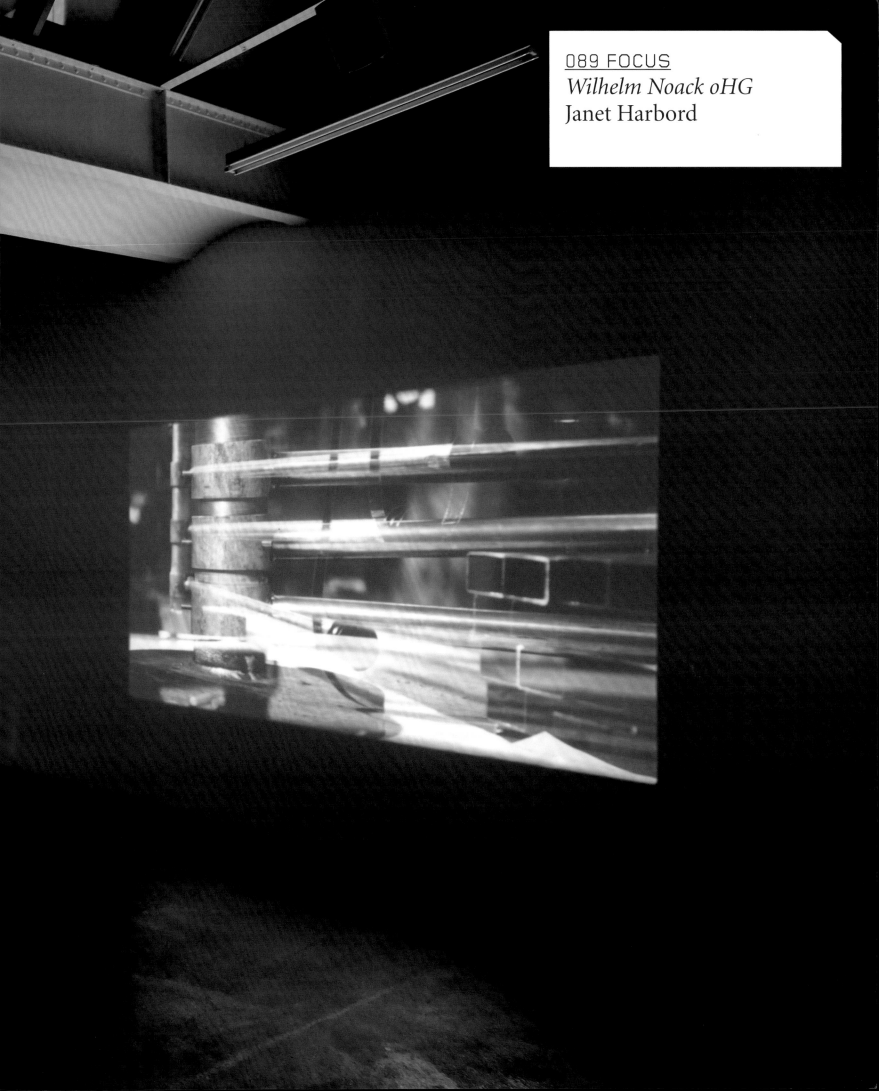

previous pages and opposite,
WILHELM NOACK OHG, 2006
PURPOSE-BUILT LOOP
MACHINE, FILM PROJECTOR
407 X 192 X 192 CM
35 MM FILM
BLACK AND WHITE, SOUND
4 MIN. LOOP

INSTALLATION VIEW AT
NEUGERRIEMSCHNEIDER,
BERLIN, 2006

When Henri Bergson wrote at the end of the nineteenth century, 'Invention becomes complete when it is materialized in a manufactured instrument,'[1] he was expressing something about the way that creativity is changed by its encounter with mechanization. Machines complete invention not by displacing human agency but in demonstrating the potential to make, to enter into an active relation with matter and to transform it. In this sense, the mechanical world demonstrates human creativity in that these intricate industrial forms are human-made. Machines are exemplary in modelling the dynamic possibilities that arise when ideas, materials and action encounter one another, when virtual possibilities become manifest in things.

In the installation Wilhelm Noack oHG (2006), Simon Starling takes a metal production company as subject, although this is not a work about the company but the product of working within it, as researcher, interrogator, experimenter. Wilhelm Noack was established more than a century ago in Berlin and continues to manufacture metal today. Having ridden the various waves of political turmoil and dissent, the company has also contributed to (or very literally shaped the contours of) the century through its crafting of lamps, gates, locks and keys. These objects are both ornamental and utilitarian, and symbolic in their capacity to illuminate and unlock the decades. The installation gets behind the scenes of all this making to animate the process of production itself, to show us what arises in the encounter of people, matter and machines. In so doing, Starling brings into the scene of industrial labour another of the century's great mechanical feats, that of cinema.

Approaching the installation, we enter a darkened room in which a machine is operating and a film is playing on the wall opposite. The machine is a projector but of an extravagant order, a spiral construction in the shape of a staircase. Instead of steps there are metal arms that fan out from the central pillar, equidistant from one another. At the end of each arm is a plastic pulley providing a channel through which strips of celluloid run, passing down to the step beneath, sustained in tension yet continuously moving in an elaborate circuit. In the centre is the light box of the projector, through which the strips of celluloid are passing. Celluloid is given dimension, allowed its length in place of its conventional containment on a reel. And if we move toward the projector we see something more. A miniature film passes by, a series of tiny frames almost suggestive of a cartoon strip. The film is both here in the limbs of this machine and on the gallery wall — tiny and gigantic, elongated as a strip of coated plastic and contracted as a single projected image.

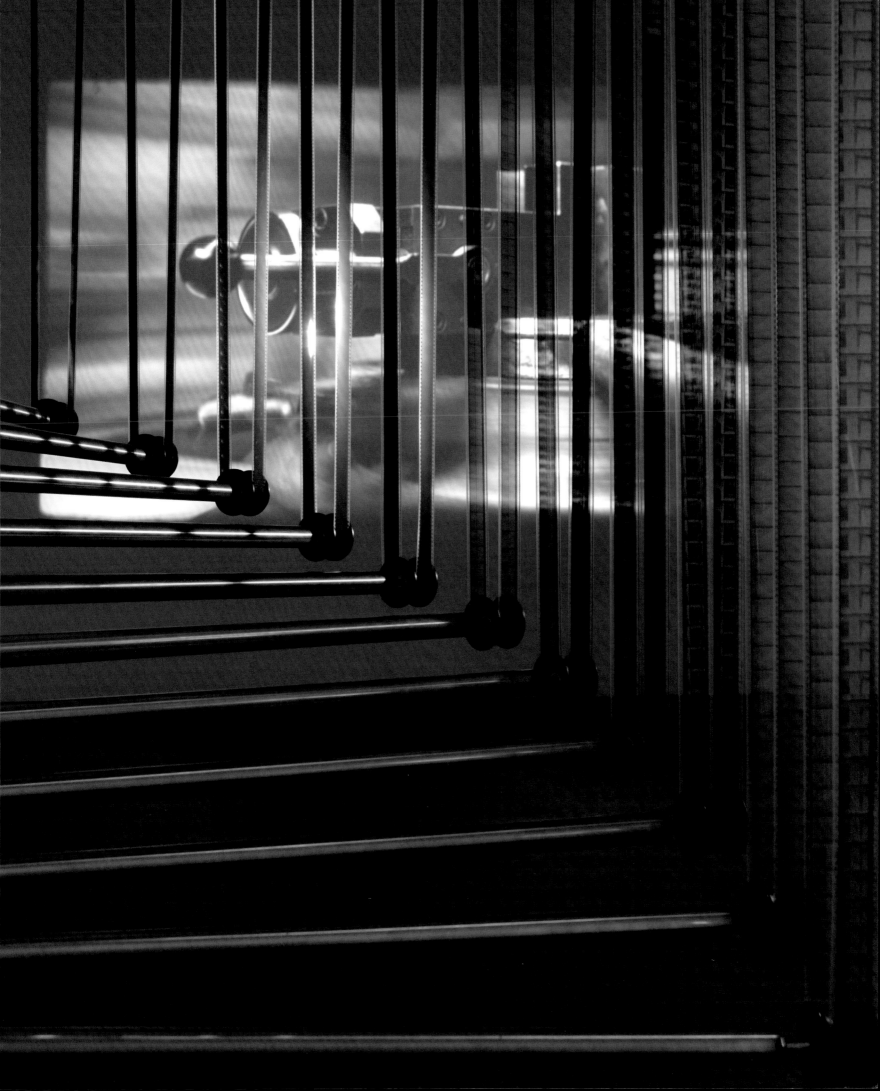

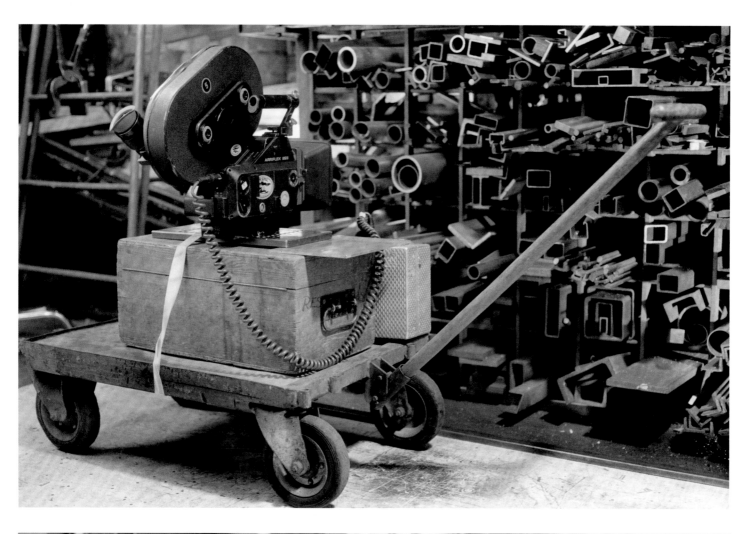

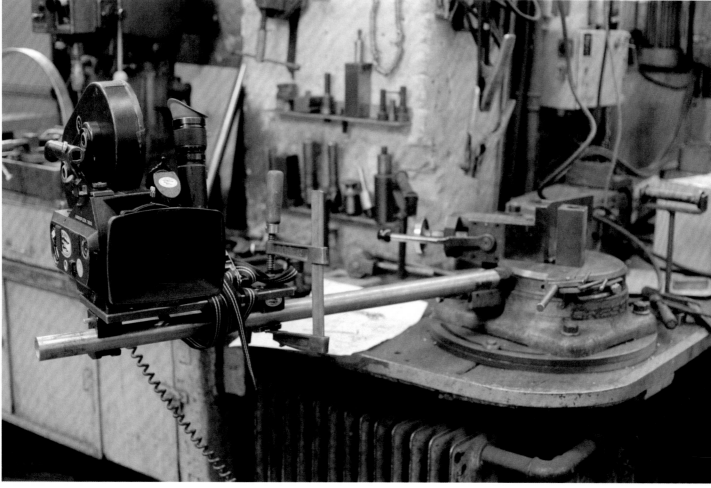

WILHELM NOACK OHG, 2006
PURPOSE-BUILT LOOP
MACHINE, FILM PROJECTOR
407 X 192 X 192 CM
35 MM FILM
BLACK AND WHITE, SOUND
4 MIN. LOOP

PRODUCTION PHOTOGRAPHS

The installation is a type of workshop, the projector a prototype for manufacture, and the film a demonstration of how it (and other things) gets made. We enter a workshop, an interior inhabited or rather filled up by magnificent machines: lathes, drills, saws, anvils, winches, surfaces oiled and gleaming, objects potent in their weight and gravity. The camera spins a full circle to take in the enormity of the workshop, yet it is too fast to make an inventory of what is here. At another moment, the view is through a camera positioned low to the ground. Pulled and pushed around on a trolley, we catch sight of the raw materials gathered in their collectives: stacks of poles and girders, coils of torsioned wire, sheets of metal. Scattered around are the things that have been made from these materials: containers, hooks, handles, signage, a spiral staircase. Alternately elegant and baroque, cumbersome and minimalist, these objects parade a spectrum of styles and tastes for metalwork. Yet the process of industrial crafting seems indifferent to fashion. This workshop is ancient in its power simply to make.

Both of these forms of manufacture, of celluloid cinema and industrial metalwork, are ostensibly outmoded, teetering on the verge of extinction. And yet the installation reanimates their function and, in so doing, rearticulates the relation between the two frames of reference: the world of economic production associated with design and formal purpose, and the cultural world of cinema, the manufacture of images and stories. Cinema, our reliable gateway to the subconscious, is in this instance as material as the making of a garden gate. The material stuff of cinema has, of course, fascinated filmmakers and artists for decades, notably the material form of celluloid. In 1979 Hollis Frampton talked about the composition of film stock, grafted together from guncotton and the gelatine residue of selected ear and cheek clippings from Argentinian beef cattle. 'How's that for magic?' says Frampton the showman, testing our belief in his account.[2] The same open-mouthed astonishment could be turned to this installation, where the act of cinematic projection is re-imagined as a sculpture of mobile lattice-work. Magic might well describe the feat of engineering delicate ribbons of celluloid choreographed through a machine.

If the material form of cinema as a projecting machine is transformed into an artwork, conversely the potent images of cinema have become labour. The experience of this installation is critically dependent on sound, and work is a noisy business. The ring of a hammer as it strikes an object, the chime of a pole as it is struck, and the alarming and sudden hiss of pressurized air release sound fitfully in the room. Sound spatially locates us in two places – the 'there' of the workshop and the 'here' of the installation, with its own mechanical noise of projection – and, like smell, sound provokes sensations, colours and images as it resonates with the body of the viewer. Starling has said that the film was cut to the soundtrack, images following on from sounds, suggesting an analogy between editing and metalwork; images are almost dropped in or

hammered into place to create the sequences. And in the film itself we are witness to the making of the projector; an image of a scaled-down spiral staircase and a drawing that makes reference the object's design lead us to the slow realization that it was manufactured in the workshop of Wilhelm Noack. We see a hand-drawn sketch, in the centre a small box with arrows indicating 'film in' and 'film out'. The plan is provisional, unfinished, as though the artist had lost interest or provided explanation enough. But this detail of the process of making underlines something fundamental to the installation; it is thoroughly mechanical and analogue, insistent on the materiality of making as a collaboration between people and machines, artists and metalworkers. This in turn transforms the work of art into the art of work, labour not opposing expression but a process made expressive.

With Wilhelm Noack oHG, I am reminded of Giorgio Agamben's essay 'The Assistants', which draws on the scurrying, incomplete figures found in the novels of Kafka. Assistants are approximate beings who live in parallel to humans and things, in a world gone slightly awry in scale or distributed features. Their characteristics are idleness, lecherousness, a childish propensity for games. They have neither skills nor equipment, yet they are also agile and fast to learn. Their incompleteness, given in an 'inconclusive gesture', an 'unforeseen grace' or a mathematical excellence in matters of judgement, says Agamben, 'indicate that they belong to a complimentary world and allude to a lost citizenship or an inviolable elsewhere.' For this reason, 'they give us help, even though we can't quite tell what sort of help it is.'[3] Assistants are translators, intermediaries who seem to contribute spontaneously to a situation what they lack in planned agency. To be in the installation Wilhelm Noack oHG feels as though one is experiencing a world created by assistants. This is a playful rendition of a projector but mathematically excellent in its functioning. And here is cinema translated into metalwork, and the craft of metalwork re-mediated by cinema, like a pair of socks rolled together inside-out.

The assistants also have a presence in the film being projected. The camera angles and placements belie the possibility that a human body could be guiding this perception. Drawn along on a trolley low to the ground, or placed between the breastwork of machines, the camera sees in a way that the human body could not. In these sequences, the camera extends perception in the manner of Dziga Vertov, giving rise to the question, what is it that a camera can do? The assistants mediate between the human and the recording technology, putting us in the place of the camera but

WILHELM NOACK OHG, 2006
PURPOSE-BUILT LOOP
MACHINE, FILM PROJECTOR
407 X 192 X 192 CM
35 MM FILM
BLACK AND WHITE, SOUND
4 MIN LOOP

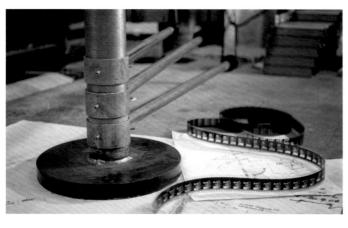

somehow changed, as though the body has been miniaturized in order to get into the gaps and corners of unremarkable space. The camera moves into corners of the workshop, sees below a shelf, peers into the space inside of a metal poll, giving form to the dead space rendered obscure by the presence of things. The hard contours of metal create another set of shapes (in the manner of Rachel Whiteread's sculptures), giving presence to what we normally regard as an absence, spaces that are ill-defined in purpose but part of experience of location.

If the camera draws attention to a form of perception that is child-like in scale and imaginative powers, it also puts us playfully in the place of a machine. The angular operation of the camera is a notable characteristic of the film as it pans sideways, stops, pans right and then left. As it glides smoothly across surfaces that are drawings, windows, corrugated metal, the eye's demand for depth of field is confused by the simple fact of seeing mechanically. Human perception, conventionally dependent on seeing in dimensions, submits to a sensation of movement. Giving in to it, the body is lulled momentarily by the smooth mechanical operations, only to be jolted out of complacency by the sound of a hammer on metal. As the camera is jerked into the air, it feels as though our bodies have been struck. At another point, the sound of winching accompanies the rising movement of the camera as it swings from a hook. We are suspended in mid air, rocking perilously. Elided with the camera, the viewer is both the machine of cinematic perception, and the raw materials of metalwork, acted upon, hammered, swung, drilled into. In this place of a double crafting-by-machine, the viewer is subjected to a becoming-thing, recalling Nietzsche when he says, 'Our working tools are also working on our thoughts.'[4]

If assistants seem to haunt the installation, it is also because people are not much in evidence in the film. They appear only in photographs, archival images of labourers in flat caps toiling over an anvil, or Edwardian men, moustached and plump, pencils hovering over a design sheet. The human figure is notably static, fixed in the chemical process of photography, captured in one posture and trapped in one moment in time. What is animated about their lives is largely achieved through sound, and it is curiously through the invisible activities of their labour that they are returned to us. From image to image, each cut is made on a chime, the quintessential sound of the workshop. Through the rhythms of making, these men and these other times are brought to life. The question of duration hovers; the lives of machines out-span their human counter-parts, whose existence is reduced to yellowing images. There are other photographs, this time of things celebrated in exhibitions, showrooms, artfully lit displays, referencing Bauhaus, the Art Deco era, and the glossy styles of post-war streamline manufacturing. The history of Berlin is in here somewhere, ragged and multi-edged traces of events as the only way of bringing to life the past of this city.

WILHELM NOACK OHG, 2006
PURPOSE-BUILT LOOP
MACHINE, FILM PROJECTOR
407 X 192 X 192 CM
35 MM FILM
BLACK AND WHITE, SOUND
4 MIN. LOOP

INSTALLATION VIEW AT
NEUGERRIEMSCHNEIDER,
BERLIN, 2006

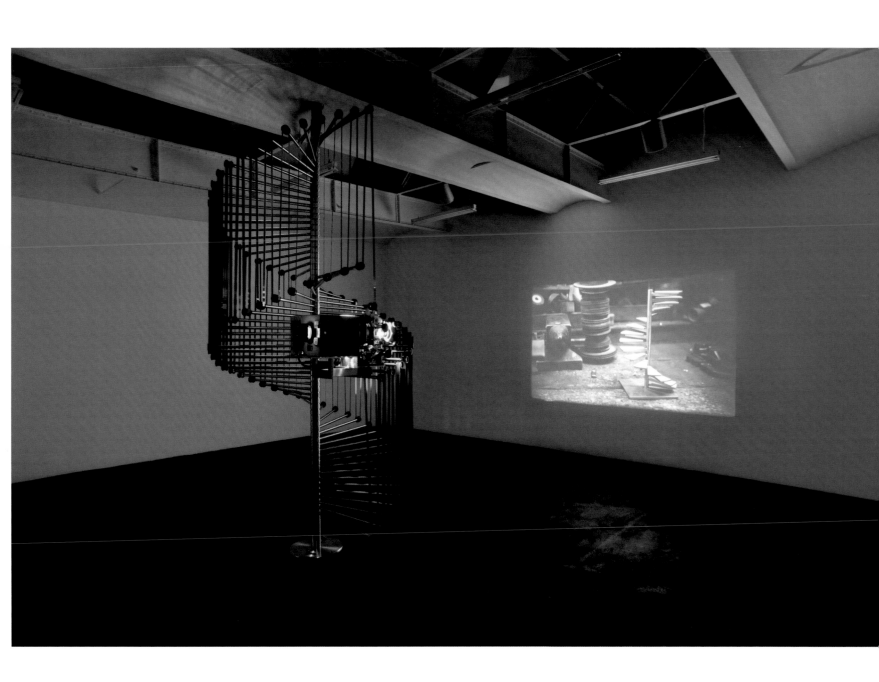

WILHELM NOACK OHG, 2006
PURPOSE-BUILT LOOP
MACHINE, FILM PROJECTOR
407 X 192 X 192 CM
35 MM FILM
BLACK AND WHITE, SOUND
4 MIN. LOOP

PRODUCTION PHOTOGRAPH

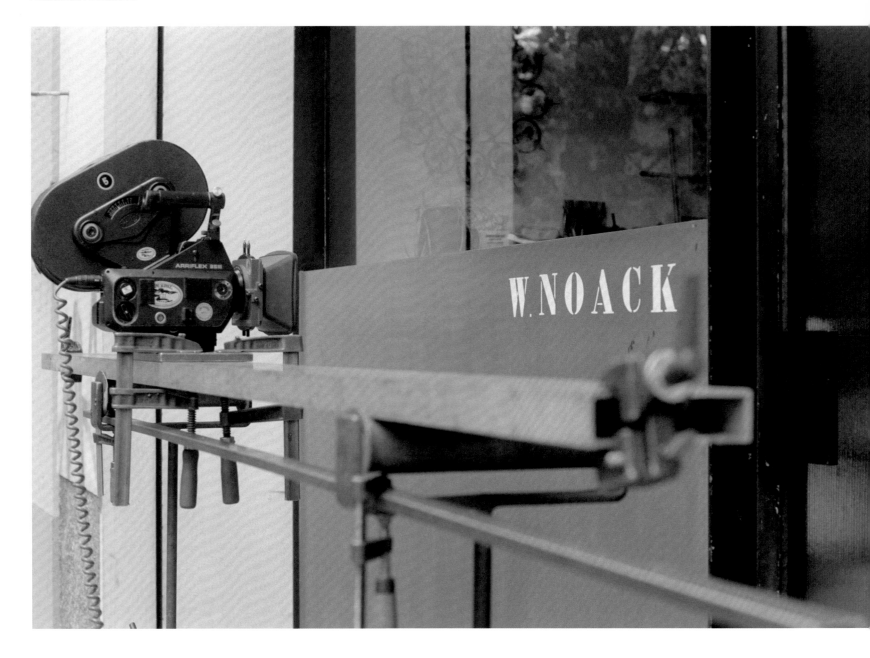

There is, in this installation, a dizzying circularity to the question of what is animating whom. One might assume that people operate machines, yet within the film the 'live' relation is a performance between a camera and other mechanical instruments. In the space of exhibition, this decentring of the human figure is reproduced; the visitor's body moves between projected image and the projector, as though a body is only more organic matter to be worked on. Caught up in the tango between the images and the machine, it is not clear to us which partner is leading, nor indeed our role in the performance. We may enter unwittingly at any point in the film's sequence. The ordinary linearity of film as a story does not apply; rather, we are in the realm of circularity, return, repetition. A looped film of approximately four minutes, there is no significant marking of the beginning or end. It rolls on just as time rolls on, with the past re-emerging anew in each instant of the present.

I like to imagine that the workshop of Wilhelm Noack, and every installation of <u>Wilhelm Noack oHG</u>, is peopled by assistants. There they go, winching up the camera, cutting celluloid into pieces left casually on the floor, smashing the worktop with hammers, attentive to the unforeseen pleasure of things. The charm of the assistants is their complete lack of utility. They do not succeed in finishing anything in their laziness; they are perfectly happy for the film to be on a self-sustaining loop. Assistants are the in-between figures of the human-machine relation, demonstrating the incomplete mastery of the world through industrial means, and the fallacy of mastery compared to chaotic play. They run amock, and for this we should be grateful, for the assistant is 'the figure of what is lost' or, rather, 'of our relation to what is lost'. They stand for everything that is unseen or rendered invisible by our narrow focus of perception. They signal an archive of the forgotten that would include not just objects but also processes of labour, and more obscurely the shapes created in the wake of labour. These 'things', discarded at each moment of the day, none the less accumulate in a great reserve of non-history. This, says Agamben, silently shapes all that remains and all that we remember. This is not an installation driven by nostalgia for a lost world of lathes and flat caps, or a weathered city, but a work of bringing into being the secret correspondence between things seen and unseen, archived and lost.

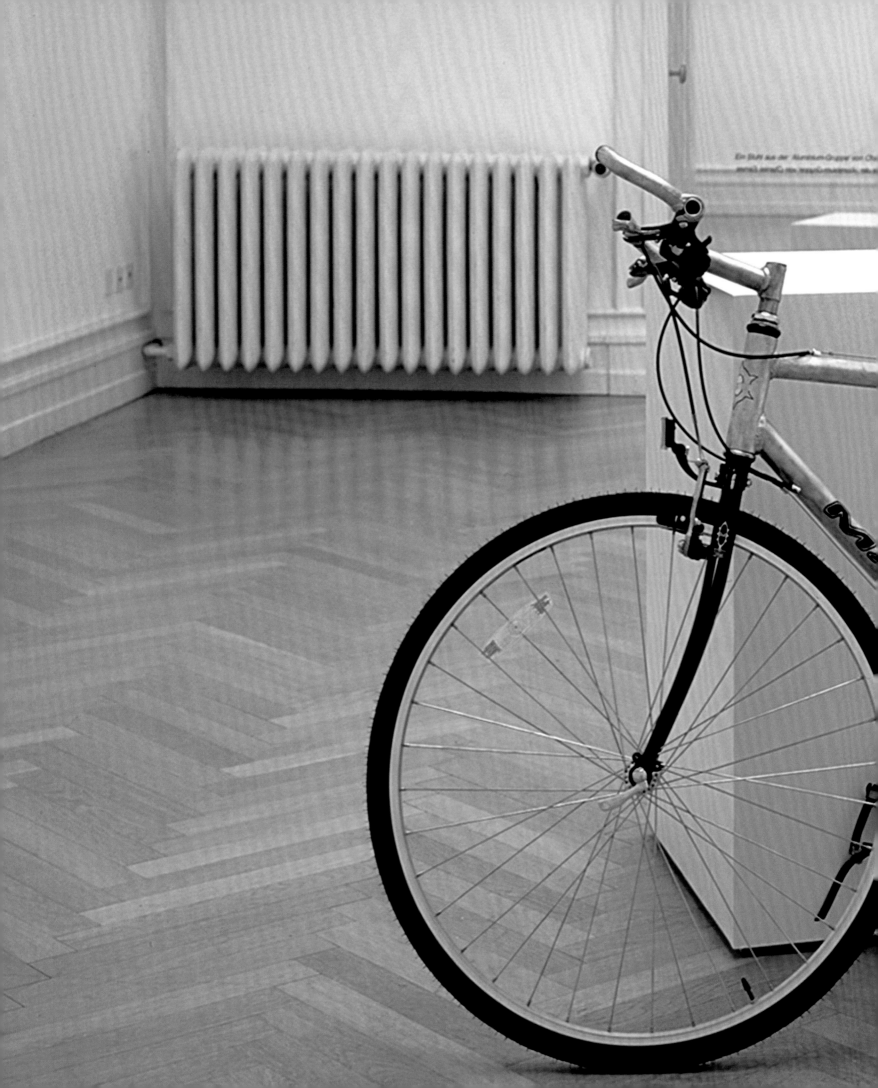

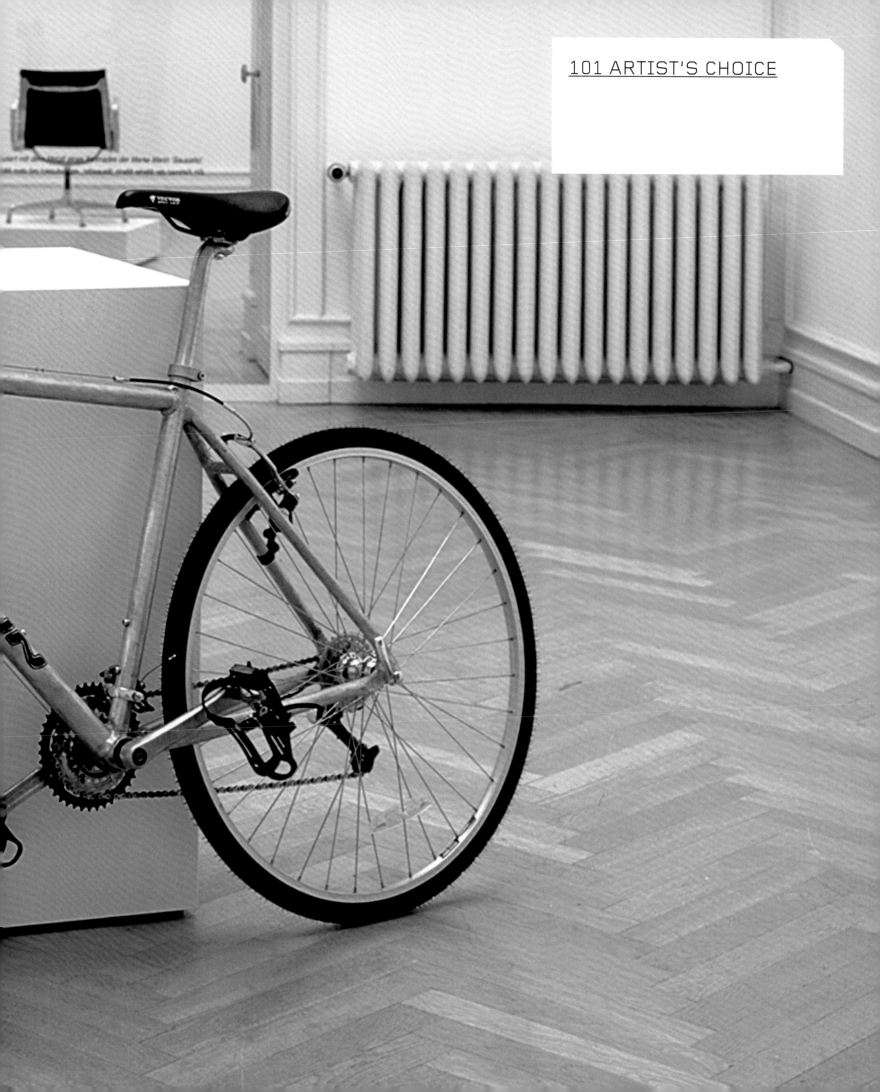

'And you would be flabbergasted at the number of bicycles that are half-human almost half-man, half-partaking of humanity.'

Apparently there is no limit, Joe remarked. *Anything can be said in this place and it will be true and will have to be believed.*

I would not mind being working this minute on a steamer in the middle of the sea, I said, coiling ropes and doing the hard manual work. I would like to be far away from here.

I looked carefully around me. Brown bogs and black bogs were arranged neatly on each side of the road with rectangular boxes carved out of them here and there, each with a filling of yellow-brown brown-yellow water. Far away near the sky tiny people were stooped at their turfwork, cutting out precisely-shaped sods with their patent spades and building them into a tall memorial twice the height of a house and cart. Sounds came from them to the Sergeant and myself, delivered to our ears without charge by the west wind, sounds of laughing and whistling and bits of verses from the old bog-songs. Nearer, a house stood attended by three trees and surrounded by the happiness of a coterie of fowls, all of them picking and rooting and disputating loudly in the unrelenting manufacture of their eggs. The house was quiet in itself and silent but a canopy of lazy smoke had been erected over the chimney to indicate that people were within engaged on tasks. Ahead of us went the road, running swiftly across the flat land and pausing slightly to climb slowly up a hill that was waiting for it in a place where there was tall grass, grey boulders and rank stunted trees. The whole overhead was occupied by the sky, serene, impenetrable, ineffable and incomparable, with a fine island of clouds anchored in the calm two yards to the right of Mr Jarvis' outhouse.

The scene was real and incontrovertible and at variance with the talk of the Sergeant, but I knew that the Sergeant was talking the truth and if it was a question of taking my choice, it was possible that I would have to forego the reality of all the simple things my eyes were looking at.

previous pages and below,
WORK, MADE-READY, KUNSTHALLE
BERN (A CHARLES EAMES
'ALUMINUM GROUP' CHAIR REMADE
USING THE METAL FROM A MARIN
'SAUSALITO' BICYCLE, A MARIN
'SAUSALITO' BICYCLE REMADE
USING THE METAL FROM A CHARLES
EAMES 'ALUMINUM GROUP' CHAIR),
1997
CHAIR
76 X 78 X 78 CM
BICYCLE
40 X 94 X 140 CM
2 PLINTHS, GLASS, VINYL TEXT
INSTALLATION VIEW AT KUNSTHALLE
BERN, 1997

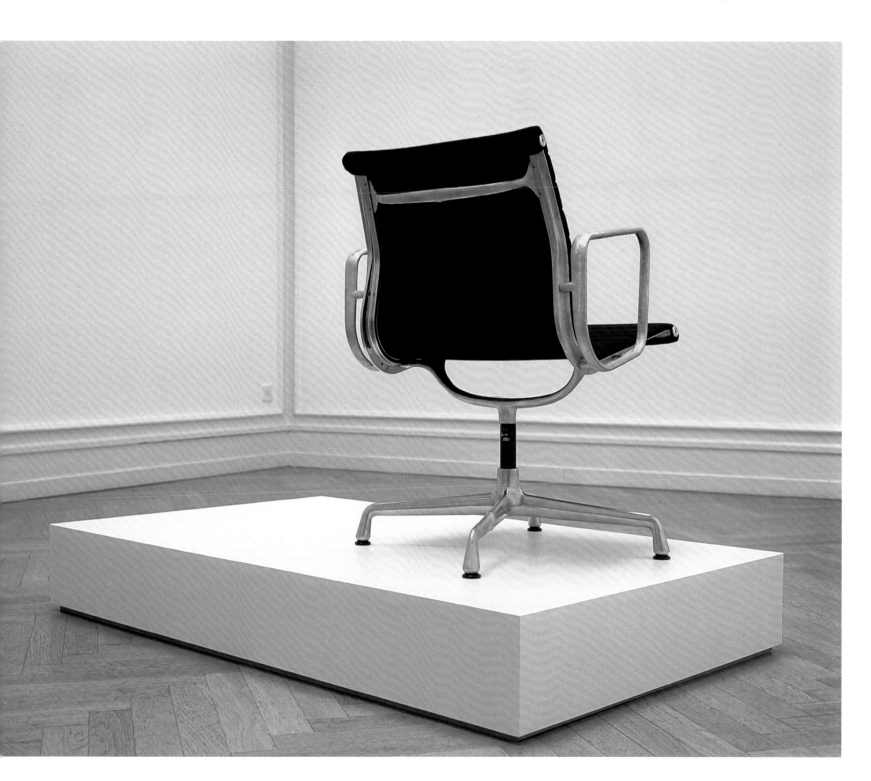

I took a sideways view of him. He was striding on with signs of anger against the County Council on his coloured face.

'Are you certain about the humanity of the bicycle?' I inquired of him. 'Is the Atomic Theory as dangerous as you say?'

'It is between twice and three times as dangerous as it might be,' he replied gloomily. 'Early in the morning I often think it is four times, and what is more, if you lived here for a few days and gave full play to your observation and inspection, you would know how certain the sureness of certainty is.'

'Gilhaney did not look like a bicycle,' I said. 'He had no back wheel on him and I did not think he had a front wheel either, although I did not give much attention to his front.'

The Sergeant looked at me with some commiseration.

'You cannot expect him to grow handlebars out of his neck but I have seen him do more indescribable things than that. Did you ever notice the queer behaviour of bicycles in these parts?'

'I am not long in this district.'

Thanks be, said Joe.

'Then watch the bicycles if you think it is pleasant to be surprised continuously,' he said. 'When a man lets things go so far that he is half or more than half a bicycle, you will not see so much because he spends a lot if his time leaning with one elbow on walls or standing propped by one foot at kerbstones. Of course there are other things connected with ladies and ladies' bicycles that I will mention to you separately some time. But the man-charged bicycle is a phenomenon of great charm and intensity and a very dangerous article.'

At this point a man with long coat-tails spread behind him approached quickly on a bicycle, coasting benignly down the road past us from the hill ahead. I watched him with the eye of six eagles, trying to find out which was carrying the other and whether it was really a man with a bicycle on his shoulders. I did not seem to see anything, however, that was memorable or remarkable.

The Sergeant was looking into his black notebook.

'That was O'Feersa,' he said at last. 'His figure is only twenty-three per cent.'

'He is twenty-three per cent bicycle?'

'Yes.'

'Does that mean that his bicycle is also twenty-three per cent O'Feersa?'

'It does.'

'How much is Gilhaney?'

'Forty-eight.'

'Then O'Feersa is much lower.'

'That is due to the lucky fact that there are three similar brothers in the house and that they are too poor to have a separate bicycle apiece. Some people never know how fortunate they are when they are poorer than each other.'

WORK, MADE-READY, LES BAUX DE PROVENCE (BAUXITE COLLECTED AT LES BAUX DE PROVENCE, FRANCE, ON THE 8th FEBRUARY 2000 USING AN ALUMINIUM BICYCLE DESIGNED BY GARY FISHER, USA), 2000-01
COLOUR PHOTOGRAPH
98 X 75 CM

obsolescence

Reyrer — Daguerotypes / Burial

Williams — tracking photographic

First print — Red River

Hybrid activity — silver → digital

James Nasmyth —

— observation → d

Etienne Jules Marie

influenced by Jules Janssen

Transit of Venus

Vitebe film archive (1 ...)

obolescence .

silver

own models

... → model → photographic image

photographic ...

... → chronophotographic device —

'Black Drop'

The Tabernas Desert in Andalucia, Spain, is the only true desert in Europe. It is a small area of undulating terrain bounded to the northeast by the Sierra de Los Filabres and to the southwest by the Sierra Nevada. The desert, which is growing in size each year due to climate change and poor land management, is home to both the film studios where Sergio Leone made many of his most celebrated Spaghetti Westerns and the Solar Platform of Almeria, a research facility developing the use of solar energy for the desalination of sea water – a possible way to stem the tide of 'desertification' in the region. One of the cacti planted as props on Leone's film sets was dug up and transported to Frankfurt in a red estate car. On its arrival in Frankfurt the engine was removed from the car and installed in Portikus, creating a temporary greenhouse for the imported cereus cactus. The thirty-metre-long extended cooling system and exhaust from the inefficient internal combustion engine provided ample heat to accommodate the highly ergonomic cactus. The following notes, originally published on the occasion of the Frankfurt exhibition in 2002 and since updated, track the evolution of the project in relation to the history of the development of glasshouse architecture, the internal combustion engine and the introduction of cacti into European cultivation.

1ST CENTURY AD
Luxurious Roman living demands the propagation of out-of-season fruits and flowers. Enterprising gardeners construct hotbeds of manure and cover the plants with frames partly glazed with mica or talc sheets. Glass panes of this kind are available only to the very wealthy.

Note: The ruins of an early forcing house were discovered at Pompeii, the structure was heated using the calidaria (a hot air system used to heat the rest of the house). A thousand years or so pass before such structures are developed further.

1493
Christopher Columbus presents a cactus from the New World to Queen Isabella of Spain.

Note: In 1484 Columbus attempts to convince King John II of Portugal to sponsor a voyage west to find a route to the Orient. Unfortunately for Columbus, Portugal is committed to discovering the sea-route to India via Africa. Having his plan rejected by King John II, Columbus then turns to Spain in 1486. His first attempt to enlist the support of the Spanish Crown is unsuccessful, but after a lengthy search for support in France and England, Queen Isabella and King Ferdinand finally agree to sponsor Columbus in 1492. This change of heart by the Spanish monarchy is due largely to Isabella's desire to spread Christianity.

1535
Gonzalo Fernández de Oviedo y Valdés publishes his book on the natural history of the West Indies including the earliest recognizable pictures of cacti to be available in Europe.

1570
The Spanish scientist Francisco Hernandez is sent on the first scientific expedition to explore the New World. Hernandez travels widely and enlists the help of native guides, herbalists and artists to seek out, draw and record the animals and plants he encounters. After seven years of Herculean toil Hernandez compiles what should have been printed as the definitive natural history of Mexico. The original manuscript is almost totally destroyed in a fire.

1611
The German Johann Conrad von Gemmingen, Prince-Bishop of Eichstätt, builds the first glasshouse bright enough to grow tropical plants. This glasshouse with its large crystal lights is developed from the 'orangerie', which had been built in order to grow citrus fruits in northern climes. He later grows a giant Opuntia tomentosa cactus with around 3,000 pads in just such a glasshouse.

1619
The Oxford Botanical Gardens introduce a system for heating their hothouses using a stove or pan of glowing charcoals, placed on a trolley that is wheeled to and fro to distribute the heat. The fumes, however, prove deadly for certain plants.

1651
Rare excerpts of Francisco Hernandez's work are published posthumously, which list for the first time the native names for various familiar cacti.

1679
Further developments in glasshouse technology in Britain are hampered by the introduction of a window tax.

1724
The first fully glazed structure appears when Stephen Switzer builds a glasshouse for the Duke of Rutland to grow grapes in at Belvoir Castle, Leicestershire, England.

1786
The Spanish botanists, Hipólito Ruiz and José A. Pavón lose one large shipment of plant specimens collected in Peru

and Chile when it is captured by the unappreciative English. Another is lost in a fire and a year later a third consignment is shipwrecked off the coast of Portugal.

1788

Steam-heated glasshouses are built for the first time.

Note: This method of heating discriminated against succulent plants that require a dry warm environment in favour of ferns, orchids and tropical foliage, which thrive in the damp air.

1799

On 16 July the German scientist Alexander von Humboldt arrives in Venezuela in the company of the French botanist Aimé Bonpland, to undertake a major expedition through Central and South America. Between them they are responsible for shipping 60,000 plant specimens back to Europe. Humboldt and Bonpland are credited with discovering and naming 15 cacti, including 11 cerei.

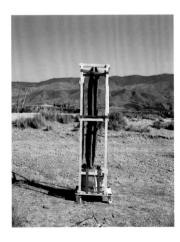

1813

The Moravian missionary Benjamin Heyne discovers the process known as crassulacean acid metabolism, or CAM,

following the observation of just such behaviour in crassulaceae. Heyne notes that the leaves of these plants have a bitter, acidic taste in the early morning and then lose their sourness by the late afternoon. He attributes this to the absorption and storage of CO_2 during the night.

Note: The ecological success of succulents and cacti relates to their unique way of breathing – how they exchange oxygen, carbon dioxide and water vapour with the environment. When the sun comes up most plants open their stomata and take up CO_2 from the atmosphere. This inevitably leads to the loss of water vapour. This water loss increases as the temperature rises. In the same way that a wet towel hung on the line at night will dry more slowly than during a warm day, cacti and other succulents conserve water by opening their stomata at night when temperatures are cooler and water loss minimal. They have developed biochemical quirks that allow them not only to take up CO_2 at night but also to store it.

1818

Experiments show how hot water pipes placed at a gentle slope in glasshouses allow convection currents to circulate the heat around the building. It is the beginning of the method still favoured today, although generally with the addition of an electric pump.

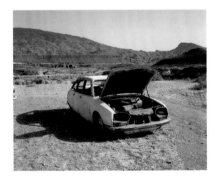

1832

The cactus playopuntias (prickly pear) are introduced into Australia. They are used as hedges for vineyards in the Hunter Valley, located 125 kilometres (80 miles) northwest of Sydney. Once introduced, the cacti become naturalized and cannot be removed by being ploughed under, which instead only creates more.

1846

The window tax of 1679 is finally abolished in Britain.

1878

Nickolaus Otto registers the first patent for an internal combustion engine.

Note: The first engine of this kind was designed by Etiene Lenoir in the early nineteenth century and ran on a mixture of gas and air. Other, mostly oil-fuelled, prototypes were built soon afterwards by Hock, Brayton, Capitaine, and Hornby during the 1860s and 1870s, but the most successful turned out to be Otto's four-stroke coal gas-fuelled horizontal engine.

1885

Gottlieb Daimler and Wilhelm Maybach make several improvements to the internal combustion engine. They patent a petrol-fuelled, light, high-speed, single-cylinder vertical engine. This basic concept for an engine remains virtually unchanged for a century during which more than a billion of them are installed, mostly in cars but also in motorcycles, trucks, airplanes, boats and in a growing range of stationary and mobile gadgets including small electricity generators and lawn mowers.

Note: Cars pollute so much because so little energy converted by internal combustion engines ends up doing the useful work of locomotion. A well-tuned engine converts just over 30% of petrol into rotary motion, but the frictional losses lower this by about 20%. Partial load factors, inevitable during urban driving, reduce this by another 20%. Accessory loss and automatic transmission may nearly halve the remainder so that the actual efficiency is no more than 10–12%, and often as low as 7–8%.

1925

The prickly pear cactus in Australia infests new rangeland at a rate of 100 hectares (250 acres) per hour. Approximately 10 million hectares, mainly in Queensland, are overwhelmed. Finally in 1925 the Larvae of the moth Cactoblastis cactorum is introduced and becomes the major

control agent for the prickly pear cacti in Australia.

1929
Sergio Leone is born in Rome, Italy.

1955
Italian designer and architect Carlo Mollino and motor racing enthusiast Mario Damonte design and build the Bisiluro to race in the 750cc class at the Le Mans 24-hour race.

Note: Although it can achieve speeds of up to 216 km/h, the Bisiluro suffers as a result of its lightweight design and is forced off the road after only two hours of racing.

1964
A Fistful of Dollars is released.

Note: The film, which stars Clint Eastwood, is based on a screenplay by Ryuzo Kikushima and Akira Kurosawa and is filmed on location near Madrid and Almeria. Leone's concern with the smallest details of dress, firearms, décor and so on lead to the introduction of various plants onto the set. These include large succulent 'cactus trees' or Agave as well as genuine cacti of various kinds, some of which are now well established in the area. Further planting occurs to satisfy expectant tourists once the film sets open to the public.

1965
For a Few Dollars More is released.

1966
The Good, the Bad and the Ugly is released.

1974
The Kalmar Volvo plant opens in Sweden. Designed by the Ultra Group and architect Gerhard Goehle in consultation with Volvo workers, the plant, which introduces the innovative 'butterfly' factory plan, revolutionizes car production methods and working conditions.

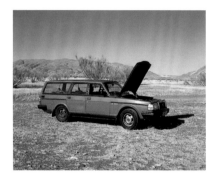

1977
American artist Chris Burden makes a seven-hour-long crossing of Death Valley, California, on an improvised moped built from a racing bicycle fitted with a tiny Japan petrol engine.

1982
The Solar Platform of Almeria opens. The Platform is a research facility developing solar energy use. As well as generating electricity, the plant has a large area dedicated to the desalination of seawater for use in agriculture etc. They also work on developing storage technology, low-cost heliostats and parabolic dishes.

1987
Portikus in Frankfurt opens to the public for the first time, in a building designed by Marie-Theres Deutsch and Klaus Drießigacker, which is attached to the facade of a former municipal library bombed in 1944.

1988
A red Volvo 240 is manufactured at the Kalmar Volvo plant, Sweden. It is 479 cm in length, 171 cm wide and 146 cm high.

It has a 4-cylinder Volvo B 230K engine, which generates 116 hp at 5100 rpm. It runs on 98 octane (4 star) unleaded fuel and has an idling speed of 15 r/s (900 rpm). It is registered in Britain (E261 XDS).

1992
16 October sees the opening of Michael Asher at the Kunsthalle Bern. Asher's installation involves the repositioning of seventeen cast-iron radiators from around the building in the entrance lobby of the Kunsthalle. The radiators are then reconnected to their original hot water supplies with hundreds of metres of copper piping.

1996
In the exhibition Zuspiel at Portikus, Frankfurt with Andreas Slominski and Ayşe Erkmen, Slominski installs a small wood-burning stove in which he burns the cut-up wooden sails from a windmill. The exhibition runs from 3 February until 24 March.

1999
On 23 January Gabriel Orozco opens at Portikus, Frankfurt am Main. Orozco has collected several tons of sand and assorted flotsam along the beach of the Chacahua Sea in Zapotalitos, Oax, in his native Mexico, out of which he creates an installation.

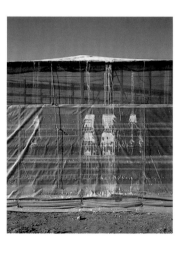

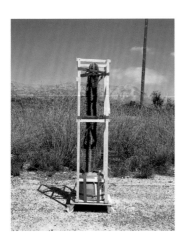

2000

Following the fatal stabbing of a local woman, a two-day riot erupts in Eljido in the Cabo de Gata, a few kilometres from the film sets in the Tabernas Desert.

Note: The Gabo de Gato is home to huge areas of plastic tents. This is what's known as Campo de Dalias, and at 64,000 acres it represents a huge economic force in the region. The polythene canopies hide vast crops of tropical fruits, vegetables and flowers grown fast and precisely to market requirements. The tented agriculture has turned a once infertile area into an agricultural goldmine. However, the water used to irrigate the crops comes from deep artesian wells, and scientists fear that the scarce resource might well be close to collapse.
The centre of this activity is El Ejido, which has grown from a modest population of 2,000 twenty years ago to some 50,000 today. Like some Wild West town, El Ejido has grown along a main highway with little or no planning restraints and with the free market in almost total control. The bonanza has lured people from all over Spain, and more recently the demand for workers willing to toil in the extreme conditions has led to the arrival of 10,000 immigrants (mostly illegal) from Morocco and other African countries, who have built shanty villages on the edges of the town. The lack of facilities for this huge population has caused massive social problems, suicides, drug addiction and mental illness.

2001

As part of his work *One Thousand Gallon Wall*, Jason Rhoades attempts to drill for ground water in the garden of Portikus, Frankfurt am Main.

Note: Rhoades installs a production facility at Portikus to manufacture Kevin Costner Essence, for which he develops the Gardenia alla Potpourri. Comprised of various ingredients such as oil, vinegar, onions, garlic, carrots, salt and water, a mixture is produced in an automated process, which – in a type of centrifuge – is exposed to the entire oeuvre of the actor Kevin Costner.

2002

In May, 12 million euros are provided by the European parliament to slow down the growth of the Tabernas Desert, Andalucia, caused by climate change and poor land use. In August a large Cereus cactus is dug up on the set of the 'Texas Hollywood Film Studio' and transported 2,145 km to Frankfurt am Main, Germany, in a red Volvo 240 Estate.

2004

On 9 September a crossing is made of the Tabernas Desert, Spain on an improvised electric bicycle. The bicycle is driven by a 900-watt electric motor that is in turn powered by electricity produced in a portable Nexa fuel cell fitted into its frame. The fuel cell is capable of producing up to 1,200 watts of power using only compressed bottled hydrogen and oxygen from the desert air.

Note: The entire journey of 41 miles over undulating terrain requires the use of two lightweight gas bottles containing 800 litres of compressed gas. The only waste product from the moped's desert crossing is pure water, of which 600ml are captured in a water bottle mounted below the fuel cell – the rest escapes as water vapour.

2006

On 28 and 29 March a replica of the radiator from the Bisiluro racing car designed by Carlo Mollino and Mario Damonte for the 750cc class at the 1955 Le Mans 24-hour race is fitted to a 1986 FIAT Panda and driven for 24 hours around the Tangenziale, Turin.

2008

In February, driven by an unprecedented surge in demand from the US, China and other Asian and Middle Eastern countries, oil prices rise above $100 a barrel for the first time. In June a mud brick structure, entitled *Plant Room*, is built within in the walls of the Kunstraum Dornbirn, Austria.[1] In October the MIT-based company Green Fuel Technologies announces a plan to build a 250-acre greenhouse for the Spanish firm Aurantia to house an algae bioreactor.[2] In November the Ford Motor Company announce losses of $2.9 billion dollars in the third financial quarter.

Note 1: Using a combination of ancient building techniques and a high-tech, low energy cooling system powered by a fuel cell, the structure provides the perfect 'archival conditions' to exhibit eight vintage photographic prints by German photographer Karl Blossfeldt.

Note 2: This huge algae farm will consume 50,000 tons of carbon dioxide a year from Aurantia's nearby concrete plant and produce 25,000 tons of biomass that will be used to produce biodiesel.

FROM KAKTEENHAUS: A BRIEF HISTORY, PORTIKUS, FRANKFURT, 2002

The Meeting, 2004

NOTES ON THE BUILDINGS
OF MR. NAUJOK AND MR.
JEANNERET, 2003
6 SLIDE PROJECTORS WITH
80 SLIDES EACH

*The following text, a fictional meeting between a dead architect and a farmer in
rural France, was conceived as a companion piece to two interrelated works:* Notes
on the Buildings of Mr. Naujok and Mr. Jeanneret *(2003) and* Carbon (Pedersen)
*(2003) and was first published in a catalogue for a two-part exhibition at the Villa
Arson, Nice, and Städtische Ausstellungshalle am Hawerkamp, Münster. In this story
of entropy and regeneration, the architect witnesses the mutation of remnants of
his own now-abandoned building project into improvized sheds and shelters for the
farmer's motley assortment of animals.* The Meeting *is accompanied by extensive
annotations by Francesco Manacorda.*

High up on the plateau of Plan d'Aups St Baume a meeting occurs.[i] One of the
two men involved is an architect up from his holiday cabin at Roquebrune Cap
Martin. He is wearing an unseasonally heavy suit and thick black-rimmed glasses
and has come to this place of pilgrimage; not to climb the hill beyond and seek
solace in its rock-bound chapel, it is already too late for him, but instead to return
to the site of an unfinished project.

He crosses the Allée des Cantons to meet the other man who is of almost identical
height and build, younger though, and dressed in typical French blue (a) workers'
overalls. Once this other man has transferred the ropes that tether two skinny
white goats grazing on the grass verge behind him, from his right to his left hand,
he greets the architect with a firm, warm handshake.

Mr. Naujok, meet Mr. Jeanneret. Jeanneret, meet Naujok.

Mr. Jeanneret has of course been dead for some 30 years.[ii] Mr. Naujok, a cook,
farmer and resident of this seemingly timeless plateau, is unperturbed by this and
greets him just as he would had he been alive.

Mr. Naujok has been observing Mr. Jeanneret for some time from his plot of
land across the street.[iii] He watched as the architect toured the little constellation
of now derelict buildings that stand opposite his farm (Naujok had guessed
the stranger's profession as much by the way he approaches his surrounding as
by the cut of his glasses). There is the main Nissen hut-type structure with its
gently undulating corrugations capped at both ends with crenellated concrete.[iv]
Flanking this is a long line of small cells with shuttered windows facing out across

i Plan d'Aups is a village in the Var region on the Côte d'Azur in southern France. Equidistant from Marseille and Toulon, the village is in the centre of the St Baume massif.

ii Charles-Edouard Jeanneret-Gris, better know as Le Corbusier, was born in La Chaux-de-Fonds, Switzerland, in 1887. After studying in his homeland and a period spent travelling, he settled in Paris in 1917. Le Corbusier spent his life trying to design models and modules to solve architectural problems and fulfil the needs of modern life. He invented the domino system, a basic building prototype consisting of a concrete structure obtained thanks to freestanding pillars and rigid floors. This skeleton had the advantage of offering different permutations for interior volume. From 1925 onwards he kept working on modules of living units, a practical application of his concept of the house as a machine to live in. The cell, as he conceived it, is a biological unit that should serve the functions of modern life with the highest efficiency. His aim was to build standardized housing 'types'. This passion developed into an interest in urban planning. Following the publication of his book Ville Radieuse (The Radiant City), Le Corbusier indulged his dream of building a perfect machine not just for the individual but for an entire community. The combinations of units could be varied according to necessity and usage: Unités d'Habitation (dwelling units); Unités de Loisir (leisure units); Unités de Camping (camping units). In 1950 Le Corbusier started working on a project called Roq involving the construction of a holiday village in Roquebrune, on the Côte d'Azur. The original project evolved into a second version, Rob, although both were finally unrealised. They can be compared to a spread-out version of the Unités d'Habitation in which the units, instead of developing vertically, would degrade over the slope of the cliff towards the sea. Failing to complete the project, Le Corbusier obtained permission to build a private holiday cabin for himself. This became the occasion for serious experimentation around essential, modular structures. Originally conceived and sketched in a few minutes, the Cabanon was studied and reworked for months afterwards together with experts such as Jean Prouvé and Charles Barberis. This very simple unit serves in fact as the experimental ground for the volume alvéolaire 226x226x226 patent, an application of the Modulor, which represents the culmination of Le Corbusier's obsession with modules derived from the monastic tradition. The Cabanon was then named 'prototype Blockhaus', and the final project for the adjacent Unités de Camping – the final version of the projects Roq and Rob – stems from the structural rigour of this model. Its structure was based on thorough research to gain the maximum ergonomic value from the building, i.e. conceived to be in tune with the occupants, fitting the needs of a human body and soul. The external skin, covered with bark, shows a clear affinity to a log hut, hiding the complicated concerns that inform the inner volumes. In 1965 Le Corbusier died while swimming in the sea in front of his holiday cabin at Roquebrune. He is buried in Roquebrune in a concrete grave that he designed himself.

iii At La St Baume, the Allée des Cantons separates the crumbling Garage Atelier (designed 1960-63 by Le Corbusier and Edouard Trouin) from Didier Naujok's farm. La St Baume is located 45 kilometres from Marseille, at the intersection of the D80 and the road to Saint Zacharie, Var.

iv The Nissen Hut, a patented invention by British Army officer and mining engineer Peter Norman Nissen (1871-1930), has become a standard English expression for a semi-circular hut with a corrugated metal roof. It dates from 1916 and was conceived for the First World War as a portable building. Simple and quick to assemble, relatively cheap and highly efficient, the Nissen hut represents one of the advanced experimental prefabricated structures originally conceived as part of the technological research originated by the army. The hut was packaged with the tools and material for its construction, effectively becoming a ready-made house to be built in four hours. The packing crates were usually preserved for firewood to heat the newly-built construction. The Nissen Hut has also been used as a housing solution. They were introduced in the UK after the First World War under the name of Nissen-Petren Houses. Eight examples – all Grade II listed – can still be seen in the Yeovil area of Somerset.

v The project called St Baume or Trouinade is an unrealized dream that Le Corbusier shared with Edouard Trouin, a landlord and surveyor native to southern France. On the site of the cave in which Mary Magdalene ended her monastic life, Trouin wanted to build an underground basilica carved in the rock as a shrine recalling the conversion of Mary Magdalene, the ex-prostitute saint. Trouin commissioned Le Corbusier to carry out the project. The church was meant to be flanked by a new permanent city, La cité permanente d'habitation, one of Le Corbusier's many attempts to realize the Ville Radieuse. The design was undertaken through the application of the modular system of alveolar cell combinations. The Permanent City was planned as a sacred centre for pilgrims and a perfect community where the houses would evoke, thanks to their vault, the cave of Magdalene. Le Corbusier was evidently fascinated and inspired by the link between her ascetic life in a cave and his own interests for the cell as a planning tool. In the plans there is only one instance of the integration of an existing building into the project. An ancient sheep fold (bergerie) was meant to become a museum that would have hosted a collection of the iconography of Mary Magdalene and a bar. This structure was to be housed beneath an exterior skin designed by Jean Prouvé. The whole project was cancelled due to a lack of funding and strong opposition from the French Catholic church, which discouraged contributions from believers.

vi After the Second World War Le Corbusier met Edouard Trouin through the Parisian avant-garde. Their friendship began in 1945, when they planned the St Baume project together on the site belonging to Trouin. The project was abandoned, but in 1960 Trouin commissioned Le Corbusier to design the Garage Atelier, adapting some already existing buildings, in Plan d'Aups St Baume. The architect drew a plan assembling the two structures that his friend had already built there: a prefabricated Wonder Building (a design by American builder Peter S. Pedersen which combined the semi-circularity of the Nissen Hut with improved arch-section panels), purchased by Trouin in 1960, and an austere tower. These two structures were meant to accommodate machinery for a new venture that Trouin wanted to start. Being illegally built, Trouin involved the famous architect to oppose the requests for demolition that the local administration was advancing. Le Corbusier added to the existing building an exterior row of six cells (226 x 236 cm). The plans he sent did not induce his friend to stop the building process in order to follow them. This suspicious attitude brought about an infuriated reaction when the architect sent a second, more refined version of the plans. Le Corbusier, exasperated, wrote a sequence of menacing letters denouncing Trouin's ambiguous attitudes. The latter in fact wanted to use Le Corbusier's plans for the museum devoted to Mary Magdalene and turn it into his personal residence (see note 5). Moreover, he deliberately changed Le Corbusier's plans for the six cells, altering the roof shape and the size. This proved utterly unacceptable to the architect, who insisted that Trouin adhere exactly

to Naujok's land and the rocky crag beyond. Rising above both of these is a tower (b), the 'up and down' to the other building's 'side to side', the sky to their land, a three-story lookout severed from its neighbours when its connecting stairs were demolished. Three shabby remnants of a once altogether more ambitious dream.[v] He surveyed them all the same, as if for the first time, crouching every now and then to look along a line or slowing to run his hand over a crumbling concrete surface. He even paused for a moment to take in the late addition to the project that caused him to disown his work all those years ago, the undulating roof, an impossible intruder. The client-turned-interfering-architect was never going to be a constructive collaborator for a man of Jeanneret's convictions.[vi]

Jeanneret invites himself in to take a closer look at Naujok's farm.

To call Naujok's little plot of land a farm is perhaps to miss the point of this constellation of improvized sheds and shelters, each of its humble structures purpose-built with particular animals in mind. For the goats grazing disinterestedly behind him are just two of some 150 animals that Mr. Naujok, his wife, and their five children sustain on their modest piece of land. Ducks, chickens, geese, turkeys, pigs (both black and piebald), sheep, cows, various small caged birds and an unnumbered cat population, all jostle for position on the Naujoks' arc. And now for a while they are joined by a raven.

What Jeanneret soon realizes is that, for Naujok, the derelict buildings and the rubbish dump hidden behind them have been a constant source of material for his model shantytown, his homemade zoo.[vii] Like the squatted inner city of Jeanneret's 'city beautiful' far off in the Punjab, Naujok's metropolis is in parasitic partnership with the struggling modernism across the street.[viii] Jeanneret quotes himself in wistful resignation of the fact that life is right and the architect wrong. It is as if here, on this exposed plateau, the kingdom of culture is giving way to the kingdom of nature. This inversion troubles the dead architect.

The self-appointed matriarch of this animal farm is a great barrel of a black, brown and beige sow (c). Her centrally positioned villa is constructed from a corrugated oil drum, surrounded to the south, east and west by a number of old bed frames, and to the north (against the wind) by a slatted wooden façade; a Jeanneret hand-me-down.[ix] Jeanneret remarks how it echoes the large metal shed

to the specifics of his plans. This strange intervention has induced some Le Corbusier commentators to trace the undulating roof shape back to a supposed Gaudi influence, and to compare the Wonder building to the rooftop gym in the Unité d'Habitation in Marseille. Le Corbusier severed any further links with the building project with the following: 'Consider as formal my prohibition to use my name without my authorization.' In recent years the local authorities have been undertaking a long research process in order to apply for the recognition of the Garage Atelier as a Le Corbusier building and therefore a piece of architectural heritage. The Le Corbusier Foundation in Paris always refused to attribute the building to Le Corbusier on the grounds of the unacceptable alterations added by Trouin. Recently, the local government bought the edifice and is planning to convert it into an exhibition space. It is currently used as a rubbish dump.

vii Le Corbusier met the Russian émigré architect Berthold Lubetkin (1901-90) in 1925 at the Exposition Universelle in Paris. The former was building his Pavilion de L'Esprit Nouveau while the latter was assisting Melnikov on the construction of the Russian Pavilion. Lubetkin allegedly turned his boundless admiration for Le Corbusier into repudiation after discovering their political and intellectual differences; Le Corbusier worshipped the machine and the compromising approach to industrialization that this brought about, the Swiss architect was also ambiguous towards the Vichy government. Lubetkin is better known for his zoological pavilions than for his radical socialist commitment. Nonetheless, his conception of architecture as a social practice does not exclude the projects that were meant to host 'animal societies' rather than human ones. Reshaping the social commitment he had embraced in his native Russia, and whose revolution he witnessed in Moscow at the beginning of the last century, his work has always been informed by the ideological belief that art and architecture were tools to reshape the future. After having worked with Auguste Peret in Paris, Lubetkin settled in London in 1931. Lubetkin's buildings at London Zoo, the ones at Whipsnade Safari in Bedfordshire and the Dudley Zoo are examples of his democratic animal housing. In every project the building's form oscillates between modern sculptural experiment and careful

consideration of the animals' needs. The spectacular penguin pool at London Zoo, with its concentric spiral slides, exemplifies Lubetkin's intention to create pavilions as showcases for animals. This idea emphasized the proximity of animal and human dwelling in the urban environment and demonstrated the ability of modern architecture to meet the needs of different species. Early visitors in the 1930s are reported to have envied the penguin's home that perfectly fulfilled both their physical and aesthetic needs. The spiral ramps are not only an elegant combination of concrete volumes but also the functionally ideal set for the penguins to play and perform on this stage in front of the visitors.

viii The traditional capital of the Punjab, Lahore, remained attached to Pakistan after the British fled India and the former colony fragmented. The new government of the Indian Punjab commissioned Le Corbusier to design its new capital in 1950. This was the occasion when he was able to put into practice all the ideas on urban planning he had been accumulating since the 1920s. The whole concept was dominated by notions of the Modulor, used as the parameters for harmonious shapes and proportions both in the single edifices and the articulation of complex urban plan. The mission Le Corbusier undertook involved social and political investments. 'The town must supply its inhabitants with all the amenities of modern life. There must be neither disorder nor sharp class distinctions. The plan aims to produce a pleasant social atmosphere, with everyone living together peacefully.' No private vehicles were permitted, as an efficient public transport system and bicycles would serve the inhabitants. Often the city plan is referred to as a human body, in which the roads represent the arteries, the government buildings the brain and the greenery the lungs. This reference to the city as the meta-version of the idea of 'modular man' makes it clear how Chandigarh was a dream come true for Le Corbusier. Although it has been defined as the 'greatest architectural achievement of the twentieth century', the artificially constructed spaces and volumes did not generate the desired effect, and the city became a beautiful, difficult to occupy, bureaucratic skeleton, burning under the merciless sun. On the outskirts of the capital, former road inspector and waste supervisor Nek Chand Saini built a Rock Garden. Since 1951 he had

participated in the construction of Le Corbusier's city; in 1958 he started collecting discarded materials found in Chandigarh. In 1965, Chand began building a spectacular sculpture garden from these found materials. His vast creation uses cement covered with discarded bits of the city such as glass bottles, broken tiles, plumbing fixtures, bicycles, wires, broken crockery and marble. The plan of the garden is in sections, and its curvy shapes are surely based on the adjacent capital's buildings and their seductive sinuosity. The garden features an extraordinary number of sculptured figures representing gods and goddesses, royal soldiers, musicians, dancers and animals. The armatures of many concrete figures have been made from bicycle parts: he has used saddles as heads, forks as legs and arms, and frames for bodies.

ix Le Corbusier's intention to create a new community with La cité permanente d'habitation in St Baume and the influence upon the inhabitants that his architecture would have had, has a strange counterpoint in the animal farm that can now be seen on the other side of the road to the Garage Atelier. Unconsciously evoking some of Le Corbusier's architecture, Didier Naujok's farm is organized in a way not unlike George Orwell's Animal Farm (1945). At the beginning of the story, after the revolt in which the animals take control of the farm, democracy is established. Akin to Le Corbusier's ideas for the classless Chandigarh, Animal Farm declares that 'all animals are equal'. One of the first 'unanimous resolutions' taken by the free animals is to decide that 'the farmhouse should be preserved as a museum. All were agreed that no animal must ever live there.' The same building would serve later as headquarter of the bureaucratic dictatorship of the pigs.

x The Pilotis. 'Si vous saviez combien je suis heureux quand je puis dire: mes idées révolutionnaires sont dans l'histoire, à toute époque et en tout pays. Les maisons des Flandres, les pilotis du Siam ou des lacustres, la cellule d'un père chartreux en pleine beatification'.

xi At the time of its construction, the Unité d'Habitation represented the most advanced use of reinforced concrete. Commissioned in 1946 just after the end of the Second World War, it embodies the enormous effort undertaken by France to modernize the new democratic republic. The construction of this immense building (140 metres long and 70 metres high) started in 1947 and

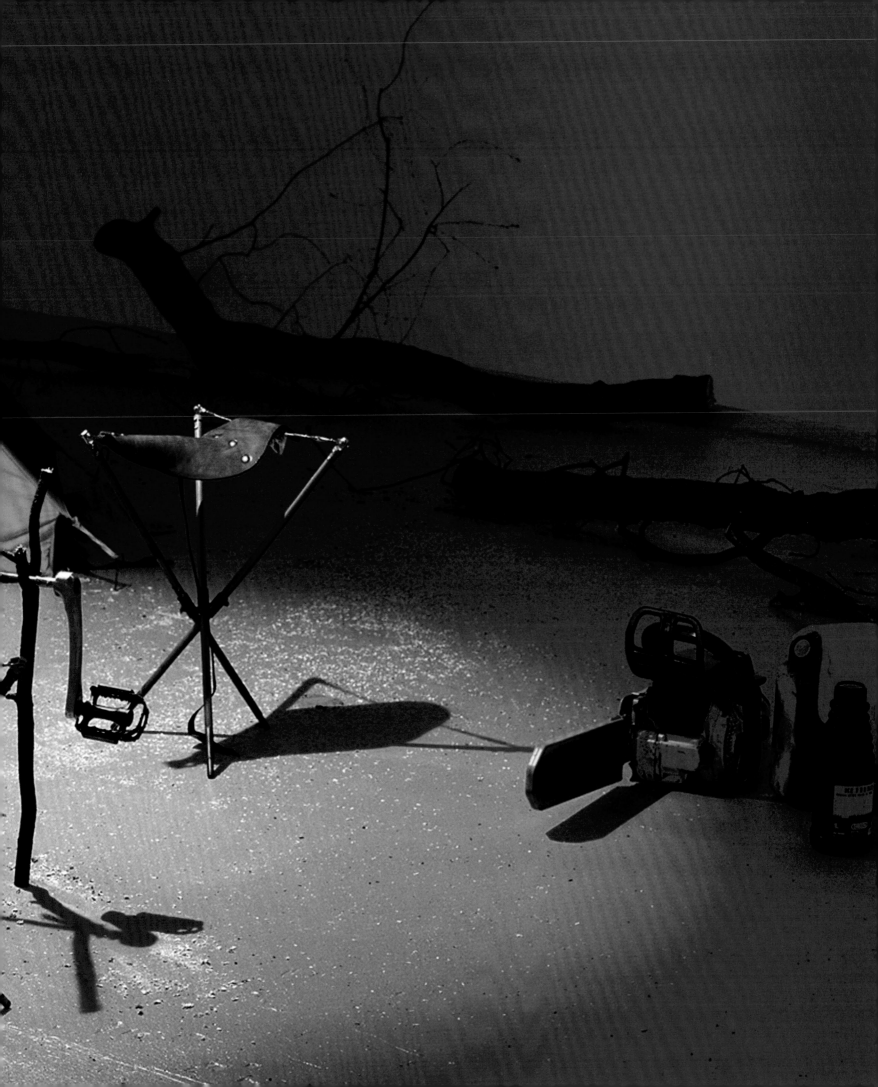

across the street. It seems to please him that this now abandoned shed has found its own functioning 'mini-me' in the yard opposite.

Jeanneret continues across the parched, stony ground. He is particularly excited by the duck's wooden shack. He notes how it reminds him, not of his ornithologically inspired concrete chapel, for there is little room for such hyperbole in Naujok's architecture, but of the farm buildings of his youth in Switzerland with their rough planked exteriors and pilotis raising them above the ground. Away from the rats, he conjectures.[x] He also thinks of the little mountain huts his father built for stranded climbers at Valsorey and Oberaletsch. However, the roof of the duck-house, a loose configuration of uneven clay tiles, brings him abruptly back from his snow-covered, high altitude reminiscences to the warm Mediterranean afternoon.

He surveys the sheep pen. A modular structure of salvaged palettes and sandy colouring (d), it brings to mind his beloved Unité d'Habitation buildings, the best of which still stridently steams along the Boulevard Michelet in Marseille. He turns again, struck by the idea that what he was trying to accomplish across the road in St Baume was not unlike the joyful concrete sculpture garden he designed for the residents on top of the Unité.[xi] He keeps this thought to himself, not realizing that Naujok's wife is Marseille born and bred, and knows the building well.

The sound of two-stroke engines momentarily interrupts their already silted conversation as what look like two deviant Solex mopeds fly past on the road behind them. Jeanneret and Naujok swing around to follow them as they pass, transfixed by these hybrid machines and their riders.[xii] The geese follow suit, turning their plump bodies in delayed response to their spinning heads. Jeanneret remarks that the bikes' fine triangulated structures are akin to the truss system he has seen utilized in many bridges.[xiii] Naujok, however, is more amused by the use of chainsaws to drive these bikes. He proposes to his new friend that this might be what was also used to cut the logs that are piled on their racks. Jeanneret can only laugh at this suggestion. Soon the exhaust fumes hanging in the still afternoon air are all that remains of these passing woodmen and their oddly improvised logging machines.[xiv]

As the fumes clear, Jeanneret remarks that he can now vaguely remember having read somewhere about a man, a Dane perhaps, who developed just such a bike with an upright riding position and loose slung saddle.[xv] More like riding a horse, suggests Naujok, nodding towards the battered brown (e) shipping container from which, from time to time, a large rusty-brown (f) head appears snorting the air and releasing a cloud of flies into the hard southern light (g). Naujok then turns back towards the dead man's buildings to point out the fast-disappearing traces of a cowboy astride what remains of his prancing horse, painted many years ago when a previous owner momentarily took the frontier-town feel of this place at face value and started a pony trekking business.

Naujok anxiously tells his new friend about the plans the mayor has for his buildings. He fears gentrification of the site might sit strangely with his animal-shanty town, but Jeanneret reassures him that no art centre could ever compete for the tourists' affections with his fine little menagerie. Smiling, the architect turns and moves quietly back across the Allée, back into the three much-plundered remnants of his buildings, leaving the farmer alone again with his comfortably housed pigs and cows and goats and chickens and ducks and geese.

previous pages and opposite,
CARBON (PEDERSEN), 2003
2 BICYCLES MAKING UP
2 THREE-LEGGED STOOLS,
TENT FRAME, COOKING SPIT,
2 CHAINSAWS, ORANGE TENT,
PLASTIC PETROL CAN, PLASTIC
OIL CAN, LEATHER GLOVES,
2 RED BIKE LAMPS, LOGS AND
TREE, CANVAS BAG, ASSORTED
BIKE AND CHAINSAW PARTS,
BLUE GELS

INSTALLATION VIEW
AT STADTISCHE
AUSSTELLUNGSHALLE AM
HAWERKAMP, MUNSTER, 2003

lasted five years. The Unité d'Habitation is an application of the model of alveolar modules in vertical form, for this reason it is also called Cité-Jardin Verticale. The assemblage of a series of preconceived combinations is brought together with particular attention to the creation of a community. Internal roads at the 7th level with shops and a market and in particular the rooftop are the most advanced experimental features. The rooftop gathers different functions together in a monumental shape that turns it almost into a sculpture. The rooftop includes a nursery, a gym, an open-air theatre, a running track and a pool. The organizational principles of this space clearly allude to Le Corbusier's humanist belief: nature and culture were meant to merge; sport, culture and leisure are conceived as the progressing activities of a perfect democracy. The cellular modules were adaptable, according to the status of the dweller (couple, family, bachelor, hotel guest). The Unité d'Habitation in Marseille served as the first of a series of four subsequent Unités: Firminy, Briey-en-Forêt, Berlin and Nantes Rezé. The one in Briey has been converted into a nursing school.

xii In 1905 Maurice Gondard and Marcel Mennesson founded the Solex Company, producing carburettors and centrifugal heaters. Nine years later Mennesson patented a design for an engine situated in the centre of a bicycle's rear wheel. In 1919 he deposited the patent for a moped, the Velosolex, with a one-piece tubular frame and an engine connected to the front wheel, but not until 1940 was the first prototype of the engine installed on a normal bicycle. The Velosolex had no transmission chain; movement was generated through friction between a rubber fly-wheel and the front tyre. Known as 'the bicycle with emergency engine' it was the only hybrid vehicle that could be used simultaneously as a bicycle and a moped. The Velosolex combines two energy transformation systems at the two extremes of efficiency. (See note 14)

xiii Squire Whipple, a nineteenth-century American engineer, is considered the pioneer of iron bridge construction. The standardized system known as the Whipple-Murphy truss allows the production of highly resistant prefabricated girders using the minimum quantity of metal. The original Whipple-Murphy truss is a subtype of the Pratt truss, a trapezoidal frame with two diagonal beams inside the panel distributing tension and weight, which was patented in the US in 1844 by Thomas and Caleb Pratt. In 1847 Whipple created a modified version, the Whipple

truss. In the 1860s the 'Bridge Company' based in Pennsylvania bought the patent, and three years later railway engineer John W. Murphy reinforced it by adding crossed diagonal beams extending between two panels of the original Pratt truss, thus rendering the truss lighter and structurally more resistant. These bridge trusses have often served as models for components in industrial design e.g. bicycle design (Pedersen) (see note 15), airplane construction (the Wright brothers' biplanes) and have been the inspiration for several innovations such as the Eiffel Tower and Le Corbusier's domino system (see note 2).

xiv For the project Carbon (Perdersen), realised at the Hawerkamphalle, Münster in 2003, Simon Starling turned two Pedersen bicycles (see note 13 and 15) into a survival kit and scooters. The bikes' frames break down into tubular sections that become the components to build a tent, two stools (featuring the bicycles' seats) and a cooking spit whose handle is formed from a pedal and supporting posts from the bike forks and a Y-shaped wooden branch. When put back together again the bikes function as scooters. Two 45cc chainsaws mounted above the front wheels creating hybrid Velosolex-type machines (see note 14). When removed, these chainsaws serve a dual function by cutting wood for the campfire. Bicycles are one of the most efficient systems for converting energy into mechanical movement; there is so little energy loss due to mechanical attrition. In contrast it is well known that the internal combustion engine converts into mechanical work only about 20 percent of the energy produced by combustion while the rest is lost as heat. The new-born scooters in Carbon (Pedersen) therefore represent a folding symbolical narrative. Their back-racks carry logs that are fire-making material for the kitchen. The engines installed are chainsaws used to cut the trees down, conflating the two actions of energy production and destruction. Thus, on the one hand, the chainsaws serve to produce potential energy, the wood, while putting an end to an energy converter, the tree. On the other hand, when driving the normally efficient bicycles the chainsaws produce a lot of pollution and wasted heat.

xv Mikael Pedersen (1855-1929), a Danish engineer, emigrated to Dursley, Gloucestershire, in 1893 after a local manufacturer of agricultural equipment hired him to set up the production of his patented cream separator, Alexandra. In Dursley, Pedersen continued

his work as an engineer, inventor of machines and musical instruments. In 1897 he patented the famous Dursley-Pedersen bicycle, a revolutionary invention with a peculiar design. Pedersen had been inspired by a well-diffused bridge truss known as the Whipple-Murphy Truss (see note 13). The Dursley-Pedersen bicycle can support a 90 kg individual while weighing just 4.9 kg and as such was at the time the lightest bicycle ever produced. The principle of the bridge truss was adapted to a new purpose, creating an odd-looking machine of the highest efficiency. Around 8,000 bicycles were built. The original prototype for the bicycle was produced in wood and is now in the collection of the City Museum, Copenhagen. Pedersen also created a folding version for the army, which was used during the Anglo-Boer War. In 1903 Pedersen experimented with the production of one of the world's first motorcycles. He fitted a single cylinder engine to the frame of his bicycle. In 1931 Le Corbusier was approached by the Swiss wallpaper manufacturer Salubra to create a new collection. The architect ended up assembling a 'keyboard', a tool to be used to select colour combinations. The keyboard consisted of twelve plates, each displaying three bands of background colours – to be used over the walls – and two series of light tones – to be used for doors, woodworks etc. Positioning the C-shaped board against the colour keyboard allowed smaller groupings to be selected. By this means Le Corbusier created a kind of linguistic system, a syntax of colours employable for stimulating personal selection. Le Corbusier firmly believed that colour expresses vitality; that it impacts strongly upon our sensitivities and acts physiologically upon us. He thought that colour classifies objects and alters their perceived volume and that colour modifies space. 'The consumer will recognize amongst these 400 colour schemes the colour equilibriums which correspond to his real nature (his temperament, his taste, his psycho-physiological sensations)'. The sections of the catalogue are evocatively titled: Sky, Landscape, Masonry, Sand etc. a) SALUBRA 32020, b) SALUBRA 32012, c) SALUBRA 4320J, 32140, 32123, d) Salubra 32082, e) Salubra 32140, f) Salubra 32110, g) Salubra 32021.

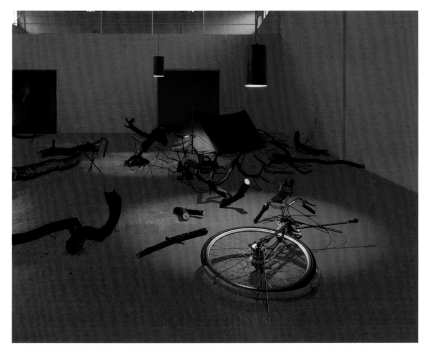

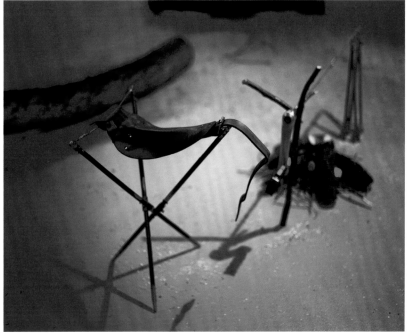

Five Thousand Years (Some Notes, Some Works), 2007

'A pre-dynastic Egyptian pot, roughly egg-shaped, the size of my hand; made thousands of years ago, possibly by a slave, it has survived in more than one sense. A humble, passive, somehow absurd object – yet potent, mysterious, sensuous. It conveys no comment, no self-expression, but it seems to contain and reflect its maker and the human world it inhabits, to contribute its minute quantum of energy made by MAN; Giacometti man; Buckminster Fuller man. It gave me a glimpse of what man is.'

HANS COPER, HANS COPER & PETER COLLINGWOOD, VICTORIA AND ALBERT MUSEUM, LONDON, 1969

'The only hope for survival lay in Time. A loophole in Time, and then maybe it would be possible to reach food, medicine, sources of energy. This was the aim of the experiments: to send emissaries in Time, to summon the Past and Future to aid the Present. But the human mind balked at the idea. To wake up in another age meant to be born again as an adult. The shock would be too great. Having sent only lifeless or insentient bodies through different zones of Time, the inventors were now concentrating on men given to very strong mental images. If they were able to conceive or to dream another time, perhaps they would be able to live in it.'

CHRIS MARKER, LA JETÉE, 1962

ALBERT RENGER-PATZSCH'S
PHOTOGRAPHS OF MUSEUM
FOLKWANG, ESSEN, 1929-32

Nachbau

The Museum Folkwang was founded by Karl Ernst Osthaus in Hagen in 1902 and was one of the first museums of its kind. After his early death in 1921 large parts of his collection were moved to Essen. From 1929 they were exhibited in the new Museum Folkwang in Essen, which was comprised of two existing buildings, the Goldschmidt Villas, as well as a significant extension by the architect Eduard Körner on the Folkwang's present site. In 1944/45 both the Villas and Körner's building were destroyed by bombing.

The photographer Albert Renger-Patzsch (1897-1966) worked in and for the Museum Folkwang, for a number of years before the outbreak of the Second World War. Best known for his work documenting the industrialization of the Ruhr in the 1920s and 1930s and for his book *Die Welt ist Schon* (The World is Beautiful, 1928)[1], Renger-Patzsch was given a studio at the Folkwang in return for his occasional work as museum photographer. For almost ten years he regularly photographed objects from the collection as well as documenting the various installations within the museum. Because Renger-Patzsch never signed a contract formalizing this arrangement, the largely unknown body of work made for the museum is now under the control of the owners of his estate. *Nachbau* (Reconstruction, 2007), conceived in relation to the impending demolition of the newest part of one of the oldest modern art museums in Europe, was developed as a partial corrective to this situation and involved the rebuilding of a part of the 1930s Museum Folkwang and the subsequent re-installation of the 1930s period-hang.

The 'stage set', which eventually facilitated the 'remaking' of Renger-Patzsch's images, was built in large part by stripping out and reconfiguring the mobile wall system in the museum's so called 'Neubau' (New Building, 1983), for which this exhibition was the last. *Nachbau* also involved the 'faking' of a number of works from the collection that had been confiscated under National Socialism – a De Chirico now in Switzerland, a Franz Marc and a Erich Heckel both in the US. Apart from some speculative use of colour and a single missing sculpture, the reconstruction was exact in every detail, even, it was observed, down to its smell. What will remain of *Nachbau*, once the 'Neubau' is demolished to make way for a building designed by David Chipperfield Architects, are about sixteen seconds of diffused light captured, as if in a rare moment of reverse time travel, on four sheets of film some sixty-five years after Renger-Patzsch himself clutched at his cable release and gazed into the 'ineffably luminous eyes'[2] of Paula Modersohn-Becker's self-portrait (1906).

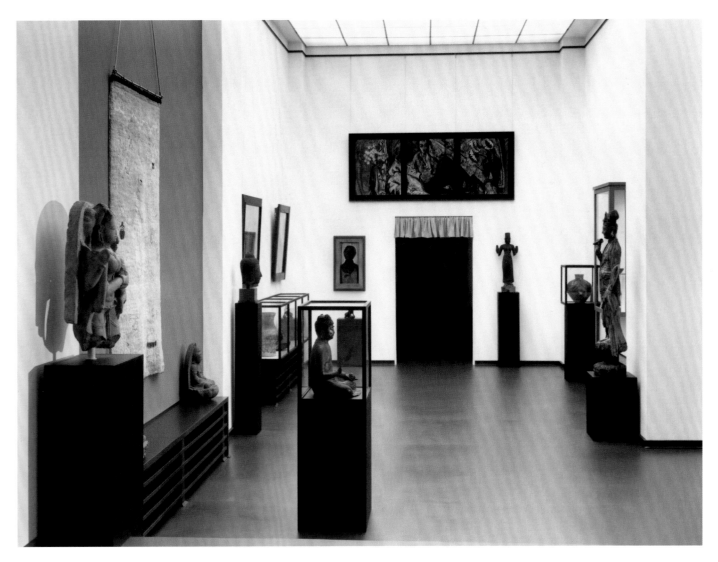

NACHBAU, 2007
SILVER GELATIN PRINT
23 CM X 17 CM

In 1988 a short-lived and somewhat superficial interest in white witchcraft took me to the very cusp of Cornwall, to its most easterly reaches where Devon gives way to its altogether more magical neighbour. The purpose of my visit was to meet and photograph Bernie Skuse, a man who had been brought to my attention through a series of meetings with people connected to Britain's small but flourishing white witch community, who had in turn come to my attention through the photographic historian Philip Stokes. Bernie, a short gnome-like man with piercing eyes and a seemingly theatrical beard, lived with his wife in a small cottage on the edge of the Saltash Estate. Apart from the witchcraft, or 'technicoloured magic' as he preferred, Bernie had been a merchant seaman, coalminer, poet, carpenter, sign-writer and 'wall of death' motorcyclist. His wife, Jeannie, showed me a scrapbook of newspaper clippings of Bernie as a young man who, on seeing an early Tarzan film, had taken to the trees for some years dressed only in a loincloth. He was known for a while as 'Tarzan of Bitterwell Lake'.

I photographed him on a number of occasions over a period of a few days. On one occasion he showed me his special chair. He used the chair as what I understood to be a kind of psycho-geographic tool, a folksy teleportation system that allowed him access to the world beyond Saltash. The chair, a clunky looking piece made of knotted and twisted vine wood, was the sort of thing you might not have given a second glance to in a junk shop. He had a stick to match, a kind of compass, a channel for his psyche on its various ventures into the wider world. His wife, a firmly grounded ex-teacher, told me how he could impose himself through space, great chunks of space in fact. Northern Scandinavia was not beyond his reach it seemed. She recounted the occasion on which due to ill health Bernie had been unable to attend his daughter's wedding in Sweden, but with the aid of his chair, his stick and a map had, from the confinement of his living room, shattered a glass at the table laid in preparation for the wedding feast. Its stem, as Bernie's finger in the photograph seems to attest, remained standing.

BERNIE SKUSE, SALTASH,
CORNWALL, 1988
BLACK AND WHITE
PHOTOGRAPH

Speed

In Jeremy Millar's and Michiel Schwarz's 1998 exhibition 'Speed' at the Whitechapel Gallery, London, a Joseph Beuys *Sled* (1969) sat side-by-side with an Eames fibreglass rocking chair (1950). Ed Ruscha's film *Miracle* (1975), in which car maintenance meets quantum physics, was playing in a nearby cinema. A painting by Henri Matisse, *Windshield on the Villacoublay Road*, that captures all the energy of an automobile ride in 1917, hung nearby. Duchamp's snow shovel, *In Advance of a Broken Arm* (1915/63) adorned another wall, and John McCracken's flash of minimal red, *Mach 2* (1992), pushed the envelope on the floor above. By placing the Eames, an aspirational, forward-looking piece of West Coast 1950s American design, next to the Beuys, a shaman's sled with its survival kit of felt and fat and a torch to light the way, 'Speed' activated both objects in a compelling new way. It was as if they'd collided trying to traverse a wormhole in space-time, the bullish rocker forcing its way into the future, the sled, makeshift headlamp blazing, hurtling back into the past.

The Apprentice

The evolution of Duchamp's first ready-made, the *Bicycle Wheel* (1911), the collision between a draftsman's stool and a straight-forked front wheel, seems to have been far from our contemporary understanding of this object as an artwork. Duchamp describes the genesis of the wheel as something closer to his *Rotoreliefs* (1935) than to the other ready-mades. For him it started life as a producer of hallucinations, a kind of trippy, escapist executive-toy. He writes, 'to watch this wheel revolving is very relaxing, very comforting, a kind of opening of avenues to other things remote from the material, everyday world. I liked the idea of having a bicycle wheel in my studio. I enjoyed it in the same way that I enjoy watching the flames in the hearth'.[3]

BICYCLE WHEEL (FAILED), 2003-04
PLATINUM/PALLADIUM PRINT
32 X 26 CM

Work, Made-Ready

Work, Made-Ready, Kunsthalle Bern (1997) inverts the notion of the ready-made in a simple but labour-intensive act of transmutation. Two aluminium objects were reconstructed using the metal from the other. What resulted were two handcrafted, degraded mutations of their former manufactured selves, scarred from their genetic transfer and separated by a sheet of glass that supported a recto/verso text, a recipe for the work.

Mobile Seating

'Approaching the subject of seating-in-motion from any starting point, we soon find ourselves in a world where many of the rules, traditions, preconceptions associated with seating-as-furniture, i.e., anchored more or less permanently in a room, are largely invalidated. The main reason for this lies in a variety of constraints so powerful that the designer has no choice but to put aside much of his painfully accumulated knowledge and start from scratch.'

While the American designer George Nelson clearly establishes the design parameters for seating in motion through space, he also hints at the possible understanding of the design object as a type of time machine 'which instantly transports us back to the situation when [it was] created'. George Kubler's landmark book *The Shape of Time* (1962) inverts that thought, arguing that such objects similarly project into the future. Kubler elaborates on this idea by referencing various quotations of Toltec-Maya craftsmen by modernist architects and artists. He writes,

'Frank Lloyd Wright renewed an experimentation with Maya corbel-vaulted compositions that had lapsed since the fifteenth century in the Yucatan, and he resumed it with the technical resources of his time at the point where the Toltec-Maya builders of Chichen Itza desisted (Barnsdall House, Los Angeles, 1920). Henry Moore, the modern British sculptor, likewise returned to variations upon the theme of angular recumbent figures, based upon a Toltec-Maya tradition of about the twelfth century. [...] These twentieth-century continuations of the unfinished classes of the fifteenth-century American Indian art can be interpreted as an inverted colonial action by stone-age people upon modern industrial nations at a great chronological distance.'

Western saddle. Courtesy H. Kauffman & Son, New York City.

116

ILLUSTRATION FOR GEORGE NELSON'S
ESSAY 'MOBILE SEATING', 1974, COURTESY
OF H. KAUFFMAN & SON, NEW YORK[4]

As Pamela M. Lee writes in *Chronophobia: On Time in the Art of the 1960's*, 'For Kubler history is at once progressive and deformative, a system that unfolds in time only to circle back endlessly on itself. Works of art cycle throughout history, they are implicated in a progress of deepening regression, as if the system of history was both evading itself and swallowing its own tale'.

In 1969 Robert Smithson, an artist whose art work and writing were both hugely influenced by Kubler's ideas, visited the Yucatan to see the Mayan temples buried in the Mexican jungle. Like a tourist returning from paradise with 'nothing but a lousy T-shirt', Smithson returned to New York with a set of slides of the crumbling Hotel Palenque, a building that in its shambling, entropic way, its 'rise into ruins,'[5] in its state of simultaneously being built and falling down, came to embody so eloquently much of Kubler's take on historical process.

Kintsugi

While some would argue that its origins are as much in hygiene as they are in aesthetics, the ancient Japanese art of *Kintsugi* is above all a celebration of the irreversible nature of time and of entropy. It is the methodical and yet somehow joyful process of covering cracks in broken porcelain with black and then red lacquer and finally a dusting of gold powder or coating of gold leaf. Each repaired vase, cup or bowl is shot through with gold veins that map and exalt a moment of impact.

Plečnik, Union

Plečnik, Union (2000) is a 'counter-entropic' work, originally produced in 2000 for Manifesta 3, Ljubljana, which attempted to reverse a destructive act. The starting point for the piece was the discovery of a shattered glass lamp in the park opposite the Moderna Galerija. The lamp was one of many that line the paths of the park and was designed by the Slovenian modernist architect Josef Plečnik (1872-1957). Typically for that park the lamp had been smashed with a beer bottle, of the local 'Union' brand, hurled by a well-oiled arm. The broken fragments of both the bottle and the lamp were collected together and then painstakingly rebuilt – two relics of a violent moment in Ljubljana's park life.

PLEČNIK, UNION, 2000
GLASS, GLUE, PLINTHS
BOTTLE 26 X 8 CM
LAMP 34 X 33 CM

'Later on they are in a garden. He remembers there were gardens. She asks him about his necklace, the combat necklace he wore at the start of the war that is yet to come. He invents an explanation. They walk. They look at the trunk of a redwood tree covered with historical dates. She pronounces an English name he doesn't understand. As in a dream, he shows her a point beyond the tree, hears himself say, "This is where I come from…"'.

CHRIS MARKER, LA JETÉE, 1962

CHRIS MARKER
LA JETÉE, 1962
FILM
28 MIN.

The Galerie für Zeitgenössische Kunst (Gallery of Contemporary Art), Leipzig is housed in a large, late-nineteenth-century villa built for the Gotha-born geologist Carl Hermann Credner (1841-1913)[6]. Unlike his neighbours whose villas sit in neat rows perpendicular to the street, Credner's home, designed by the architects Bruno Eelbo and Karl Weichardt, was built slightly askew in order to avoid destroying a large oak tree that already occupied the plot. When work began on the restoration of the building in the mid 1990s it was discovered that the roots of this ancient oak had begun to tear the foundation of the building apart. Sinuous sections of root were visible in the basement. The tree was sacrificed and its vast trunk laid to rest adjacent to the newly restored gallery. On cutting into the tree, patches of purple stain were discovered in the oak. If you patiently counted back on the tree rings it was possible to speculate that these purple stains, the result of metal slowly dissolving in the acidic wood, were in fact fragments of shrapnel that lodged in the tree during skirmishes towards the end of the Second World War.

Carl Hermann Credner's library, now housed in part at the Grassi Museum, Leipzig, contained a stray copy of issue 1 of the then avant-garde design journal *Dekorative Kunst* (Munich, 1898), an issue featuring the work of the British Arts and Crafts designer and architect Charles Francis Ainsley Voysey, who was at the time of publication designing a house for the writer H. G. Wells, a house paid for in large part by the proceeds from the publication of his best-selling novel *The Time Machine* (1895). One interior photograph in *Dekorative Kunst* shows a chair, the 'Swan Chair' (1885), which, while simplifying Victorian decorative styles, makes clear reference to ancient Egyptian ceremonial furniture. While being a determined exponent of English vernacular architecture and design, like many designers in the later half of the nineenth century and early twenieth century, Voysey appears to have been influenced by the increasing availability of Ancient Egyptian artefacts. In 1884 Liberty's in London started selling reproductions of various Ancient Egyptian pieces, including a much-copied stool that found its way into the design language of both Adolf Loos and Josef Frank. As well as furniture designs, Josef Frank also borrowed decorative patterns from the Ancient Egyptians. His fabric design Borealis (c. 1940) appears directly related to the leopard-skin pattern taken from an ebony and ivory stool found in the tomb of Tutankhamen (1358-1350 BC)[8].

H.C/H.G.W, 1999
OAK TREE SECTION
PRODUCTION PHOTOGRAPH

'For example, one important way of retaining the products of the past occurs in the elaborate tomb furniture of some peoples, whose firm belief in an after-life was of course a main motive for the immense funeral deposits in Eygptian, Eutruscan, Chinese or Peruvian burial grounds. We are at liberty to suppose that the craftsmen in these societies were excessively numerous in relationship to princely demands upon their skill. The corollary is that the production of precious things far exceeded the rate of their disappearance by normal wear and breakage.'

GEORGE KUBLER, THE SHAPE OF TIME: REMARKS ON THE HISTORY OF THINGS, 1962

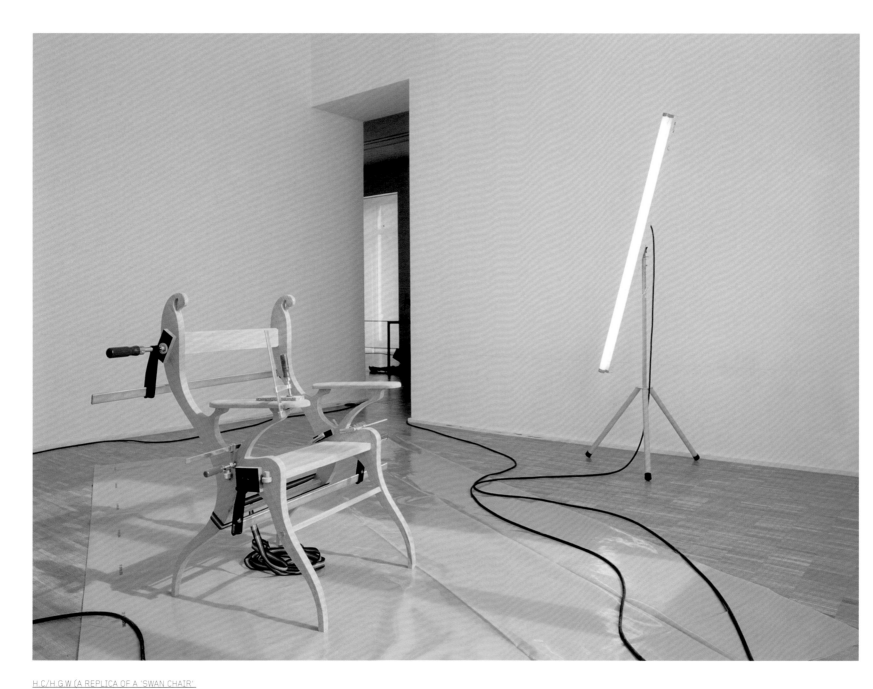

H C/H G W (A REPLICA OF A 'SWAN CHAIR'
DESIGNED IN ENGLAND IN 1885 BY CHARLES
FRANCIS AINSLEY VOYSEY, BUILT USING THE
WOOD FROM AN OAK TREE FROM THE GROUNDS
OF THE VILLA AT 11 KARL-TAUCHNITZ-STRASSE,
LEIPZIG, DESIGNED IN 1892 BY BRUNO EELBO
AND KARL WEICHARDT FOR THE GEOLOGIST CARL
HERMANN CREDNER), 1999
OAK CHAIR
97 X 62 X 60 CM
CLAMPS, STRAPS, PLASTIC SHEET, OAK PLANKS,
VINYL TEXT

INSTALLATION VIEW AT GALERIE FUR
ZEITGENÖSSISCHE KUNST, LEIPZIG, 1999

Beyond Mortal Use

'As a Chinese of rank adorns his mausoleum during his lifetime, so I am preparing – in this late maturity of mine – a corridor in my home, as a kind of sunset road, with a succession of photographs and other souvenirs of my life, most or all of them beautiful.'[9]

CARLO MOLLINO, 1973

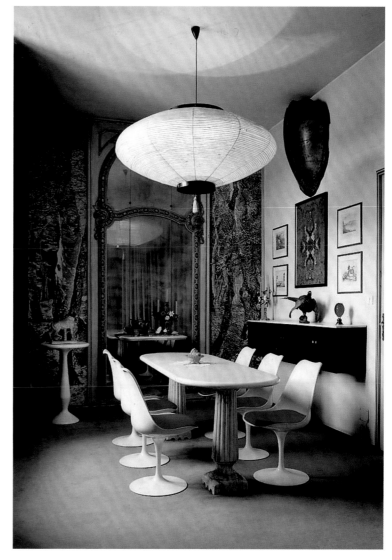

CARLO MOLLINO'S DINING ROOM, VILLA ADOVA, TURIN, 1960-73

Perhaps the design for Carlo Mollino's apartment in Villa Adova, Turin, which he began in 1960 and to which he devoted much of his time in the last thirteen years of his life, could be understood as his masterpiece. What he created there but never inhabited is a *gesamtkunstwerk* of dizzying complexity. It is his legacy. Mollino (1905-73) was for much of his eclectic life preoccupied by his own place in history, an obsessive documenter of his own flamboyantly performative existence – an editor, retoucher and re-cropper of photographs. For this dynamic man, the son of a futurist engineer, a student of the baroque, a skier, a pilot, a racing car builder, a designer of curvaceous furniture, complex architectural spaces, with a post-Einstein/post-Boccioni plastic sense of time and space, his apartment stood as it does today as a complex projection of his thoughts. A tomb of near Egyptian ambitions[10] conceived, one might speculate, to carry his spirit into the afterlife surrounded by his earthly chattels, born away on a deep blue carpet safe in his carefully chosen 'litbateau' with its serpentine decoration and pharaonic pretensions, surrounded by a mummified harem of butterflies. Mollino shared with the Pharaohs a sense that furniture is beyond mortal use, its value was rather symbolic or ritualistic. It is perhaps little surprise that Mollino had very little interest in manufacturing or design for the mass market. Like the Pharaohs he employed craftsmen to smooth his passage into the afterlife into eternity perhaps. He was a designer of time machines – curvaceous, energetic, thrusting furniture that spoke to a baroque, as well as neo-classical, preoccupation with the extrapolation of form in space as much as it did to modernism and to the future.

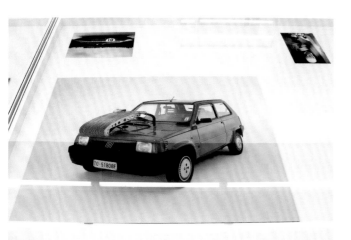

24 HR. TANGENZIALE: VITRINES (A REPLICA OF THE RADIATOR FROM THE BISILURO DESIGNED BY CARLO MOLLINO AND MARIO DAMONTE FOR THE 750CC CLASS AT THE 1955 LE MANS 24 HOUR RACE, FITTED TO A 1986 FIAT PANDA AND DRIVEN FOR 24 HOURS ON THE 28TH AND 29TH OF MARCH 2006 AROUND THE TANGENZIALE, TURIN), 2006
PHOTOGRAPHIC PRINTS, DRAWINGS, CARDBOARD, WOOD, BRASS RADIATOR PARTS, CARDBOARD RADIATOR COVER, PHOTOCOPIES, PLANTS, TRESTLES, 3 VITRINES
SIZES VARY FROM 140 X 100 CM TO 140 X 280 CM

La Jetée

Chris Marker's low-budget 1962 film *La Jetée* evolved at a time of political anxiety in France and the wider world. The film is haunted with images of concentration camps, with echoes of the end of the Algerian war and the exposé of the French authorities' use of torture in that conflict and with the tense unfolding of the Cuban missile crisis. The film is set in a post-apocalyptic future present and imagines a Paris of 1962 as fragments of a distant memory. It is the story of one man's attempt to escape time.

Perhaps what is most remarkable about the film is its use of still images. It breaks the fundamental rules of film: the impression of movement through twenty-four-frames-per-second projection. But despite its almost exclusive use of still images, but for one blink of an eye, it is tantalizingly cinematic. As Catherine Lupton has pointed out in her study on Marker, *Memories of the Future*,[11] the director, who made the images for the film on a simple thirty-five-millimetre SLR camera, uses all of the tricks of cinema but for the illusion of movement – deploying 'establishing shots, eyeline matches, shot and counter shot, close-ups and so forth'. It feels, fittingly perhaps because of its subject matter, 'like a memory of a film'. For, as Roland Barthes has argued in *The Rhetoric of the Image*, if motion pictures give us a 'sense of being there', then stills surely depict a sense of 'having been there'. But for one brief moment of movement the film is paced, somewhat like a comic book, according to a relationship between still image and a spoken or subtitled narrative. The speed and transition of the images goes hand in hand with the trajectory of the narrative. As the film reaches its inevitable climax and Marker's time traveller attempts to break causality and escape time itself, the images start to appear more and more rapidly, as if at any moment, reaching twenty-four images a second, the film will break into illusory movement.

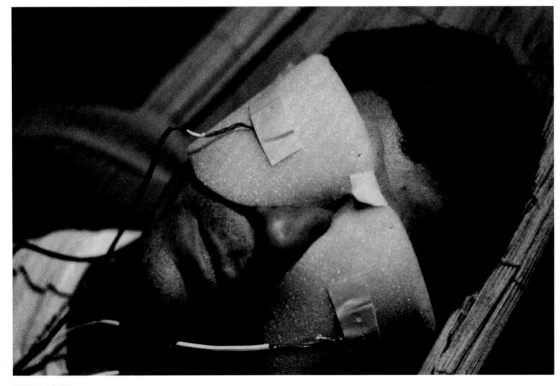

CHRIS MARKER
LA JETÉE, 1962
FILM
28 MIN

The Time Machine in *La Jetée* is a simple hammock slung from some pipes in the subterranean 'empire of rats' – an underground network of galleries. A roughly fashioned mask of foam and crude wires and the injection of an unspecified drug aid the process. The time traveller is prone, slumped in the formless hammock, a passive participant in a journey beyond his control. Marker's rough hammock is a far cry from H. G. Wells' portrayal of the time machine, in that the original novel is described as having a saddle and being made of brass rails, nickel bars and quartz rod. In film it has generally been depicted as a collision between a traditional Victorian arm chair and a brightly illuminated Tivoli-style ride – a hybrid contraption, part curving Thonet rocker, part Breuer 'Wassily' chair, part Ron Arad 'Rover Chair' and part dodgem car with space for a dynamic pilot at the controls. In *La Jetée*'s closing sequence the time traveller finds himself unable to escape from time – from the image that has haunted him, the image of his own death on the jetty at Orly Airport.

Le Jardin Suspendu was developed for an exhibition at the Museum of Modern Art at Heide, Melbourne, formerly the home of the art patrons and collectors John and Sunday Reed. Their house, Heide II, completed in 1967 in the International Style by David McGlashan and Neil Everist, is an eloquent structure of limestone, glass and terrazzo. In the garden not far from the house is a large indigenous River Red Gum tree that still bears the scar inflicted on it by an ancient aboriginal boat builder, a large canoe-shaped section of bark having been removed. This is one of the few trees that existed on the site before the construction of the house. The Reeds planted large quantities of European and American exotics, most notably the large Mexican oak that stands close to the Heide II.

Three years after the completion of Heide II, the Spanish explorer Vital Alsar arrived at Mooloolaba on the East Coast of Australia following an 8,600-mile journey from Ecuador on a simple raft built from seven balsa logs, with a mangrove mast sporting a sail decorated by none other than Salvador Dalí. His journey, like Thor Heyerdahl's less emphatic Kontiki voyage of 1947, set a strong precedent for, if not proof of, the cross-pollination of ideas, goods and people among the ancient cultures of the Pacific.

LE JARDIN SUSPENDU (A 1 6 5 SCALE MODEL
OF A 1920S FRENCH FARMAN MOSQUITO, BUILT
USING THE WOOD FROM A BALSA TREE CUT ON
THE 13TH OF MAY 1998 AT RODEO GRANDE,
BABA, ECUADOR, TO FLY IN THE GROUNDS
OF HEIDE II DESIGNED IN 1965 BY DAVID
MCGLASHAN AND NEIL EVERIST), 1998
C-PRINT
78 X 101 CM

TORBEN SKOV
ILLUSTRATION FOR H G WELLS' TIDSMASKINEN
(THE TIME MACHINE), 1970
CARL ANDERSEN FORLAG, 1970

Quick Realities

It was reported on the 1st of April this year that a man wearing 'a bow tie and rather too much tweed for his age'[12] was arrested in Switzerland as he attempted to sabotage operations at the Large Hadron Collider.[13] The arrested man, who insisted he was from the future, was reportedly spotted rooting around in the bins where he claimed to be looking for fuel to power his 'time machine power unit'. While this elegantly orchestrated piece of April foolery, a hoax as insightful institutional critique, clearly came from outside the physics establishment, there are respected voices from within who claim that the troubled collider might genuinely be being sabotaged by the future. It has been suggested that the Higgs Boson (the hypothetical particle that physicists hope to create in the collider), might be so abhorrent to nature that its creation would ripple backwards through time and stop the collider before it could produce the sought-after particle – like a time traveller journeying backwards through time to kill his own grandfather. What Buckminster Fuller hailed as the 'quick realities'[14] of contemporary physics, that have, until now, become most traumatically manifest in the two bombs dropped on Hiroshima and Nagasaki in 1945, seem to generate an ever-growing sense of temporal uncertainty. From its humble beginnings (in a subterranean former rackets court on the campus of Chicago University), the Manhattan Project culminated catastrophically in the bombs dropped on Japan: the first an explosion and the second a baffling implosion, like some tormented cartoon character quite literally turning itself inside-out, generating temperatures unknown on earth – about ten billion degrees within less than a millionth of a second. The events that occurred in that unimaginably brief moment caused a fundamental rupture in our relationship with time but perhaps most significantly in our understanding of the future which 'became something to be anticipated precisely and feared'.[15]

Such anxiety-inducing traumas are just one aspect of an ongoing sense of temporal instability. The sense that our increasingly unanchored, fluid lives are at odds with the artificial construct of a linear chronology, of course, pre-dates the atom bomb and is perhaps as old as the construct of time itself. Indeed, as Borges writes in *The Garden of Forking Paths*, 'In contrast to Newton and Schopenhauer, your ancestor did not believe in a uniform, absolute time. He believed in an infinite series of times, in a growing, dizzying net of divergent and convergent and parallel times'. The banks of Heraclitus' river of time[16], to which the title of the exhibition eludes, have, as W. G. Sebald's *Austerlitz* so elegantly attests in the Observation Room in Greenwich, been continually breached and redefined. Empirical science, has, for a few centuries, seemingly held back the fold waters of our temporal uncertainty, but if the Hadron Collider is any indicator, it now appears to be swelling their source.

The Meeting

Comprised of works that themselves push and pull at an understanding of linear time – often restaging or reiterating ideas, images or forms from the past or projecting them into the future – 'Never The Same River' conflates works already exhibited at Camden Arts Centre throughout its history into a single exhibition while, in an attempt to break the strangle-hold of history, simultaneously juxtaposing them with moments from a possible future programme. By restaging the display of works from different periods of the galleries' history in the exact position they occupied the first time they were exhibited, 'Never The Same River' aims to create a kind of temporal polyphony or even, at times, cacophony, orchestrating a series of collisions between, until now, spatially and historically remote works, all of which worry at the borders of our understanding of time – the probable past and possible future of Camden Arts Centre momentarily coming together in an unstable present.

'Never The Same River' attempts to map an artistic preoccupation with a renewed understanding of that 'growing, dizzying net of divergent and convergent and parallel times'. While this was in part inspired by the works that I encountered both on numerous visits to Camden Arts Centre over the last twenty years and when back-tracking through the Centre's archives in the somewhat temporally dislocated reading rooms of the Holborn Library, its genesis might be found most specifically in the events surrounding the installation of a work I made in 2000, rather melodramatically titled *Burn-Time*. Like an increasing number of my works, it had its origins in a rejected public proposal, in this case for the German city of Bremen. The work as it existed in London consisted of a by-then well-used henhouse built in Scotland to the plans of a neo-classical prison-turned-museum dedicated to work of the Bremen-born Bauhaus-trained designer Wilhelm Wagenfeld, as well as a number of similarly well-used egg-coddlers (Wagenfeld, 1933) and a roughly built stove fashioned from bricks extracted from one of the Centre's walls. The stove, fuelled by wood cut as required from the decommissioned henhouse, facilitated the cooking of the eggs (previously laid in the henhouse/prison/museum) in Wagenfeld's patented poacher. During the exhibition, work began on plans to refurbish Camden Arts Centre, and the architects, not knowing that it was a temporary addition, included my brick stove in their drawings of Gallery 3. This misplaced addition to the architectural plans is particularly serendipitous in view of the fact that the architect of the original library building that is now Camden Arts Centre, Arnold S. Tayler ARIBA, is a blood-relative. This meeting across time with my great-great uncle planted the seed of 'Never The Same River' and I suspect inspired the invitation to select it.

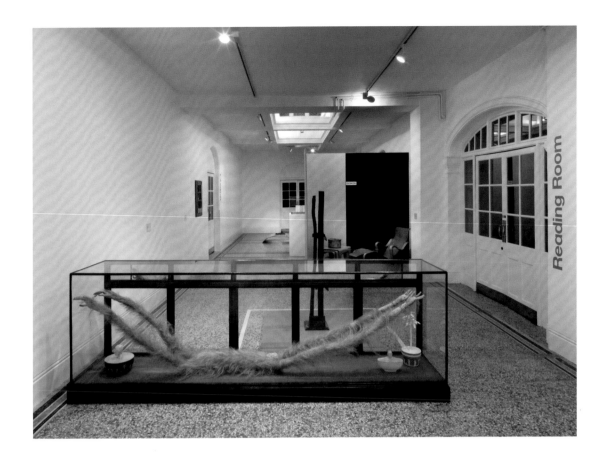

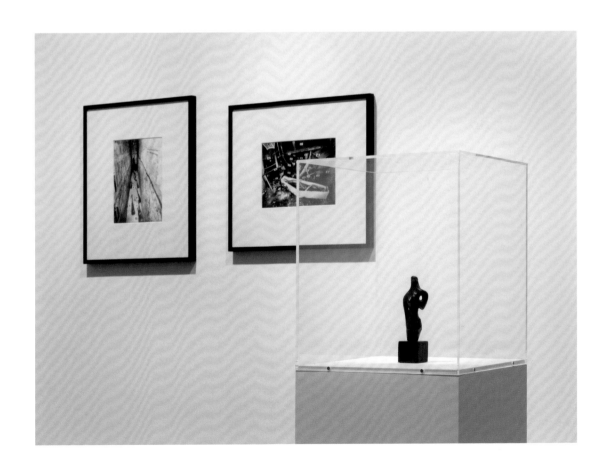

Space Time

While each work has been assembled from remote moments in the history of the exhibition space, each work also has its own speed, its own internal sense of temporal trajectory, and thus an encounter with the space of the exhibition involves an encounter with what might best be imagined as an impossibly interlocking series of moving walkways all running at different speeds and on different trajectories. As we move from work to work, from one era to another, we are pushed and pulled through time, sometimes gradually and sometimes at breathtaking velocity, sometimes through the briefest moments in time and, at others, through vast chunks of the stuff.

A man is filmed crossing a bridge into the future – again – his actions marking frame by frame a false start to the cinematic future of the twentieth century (Matthew Buckingham). An eighth of a second of 1976 and an eighth of a second of 1977 fuse in a single photographic exposure, a joyous midnight moment turned indecisive – then and now (Douglas Huebler). Close by, a chicken and egg drama unfolds in a photograph restaging the events depicted in a painting which was in turn based on a photograph made by that same photographer (Christian Boltanski /Jacques Monory). A twentieth-century sculptor (Henry Moore) reinvents a long-dead category of English sculpture with recourse to pre-Columbian and ancient-Egyptian precedents sent into the future by the craftsmen of those civilizations – their ancient, pebble-like forms in turn tossed back onto the beach via the bronze foundry by another sculptor (Des Hughes). Two modest canvases testify to an artistic dilemma – their maker, who once cast himself as a corpse laid out in a pyramidal tomb, finds himself caught between the desire to sustain tradition (timeless) and the instinct to subvert (timely) (Paul Thek). An early twentieth-century purveyor of 'séance-fiction' pre-empts the Blitz – her painterly premonitions, once excluded from their present, deemed fit only for the future by their maker (Hilma Af Klint). A magic lantern summons voices from the grave (Susan Hiller), the here and now of its interlocking circles of coloured light seeming to both echo and contradict the faded painted circles tracked on a Galician seawall – remnants of a broken-hearted hermit's life, whose fable-like story triggers musing on the fallacies of prediction (Michael Stevenson).

If it is true that the future is always set in the present and is always misremembered,[17] then what of that crab caught in the glare of a flash as it retreats beneath a redeployed car body-press – this improvised anchor a submerged remnant of Irish entrepreneurship turned Hollywood time machine, Delorean's failed dream (Sean Lynch)? Some works seem to have been generated at almost glacially slow speeds, the medium of the moment, newsprint, petrified (Tony Carter). A sloth hangs in museological stasis (Francis Upritchard) while nearby a bullish chaise longue fires its reclining passenger into the future (Marcel Breuer) and a broken sapling is immortalized in bronze (Keith Coventry). We tread on temporarily unstable ground – step by dizzying step.

Space and time are constantly confused and become interchangeable terms. A black and white film ripples out from the once-shabby corner of one of the Centre's galleries, mapping the institution and its surrounding infrastructure until the camera settles on a newsstand heralding Man's first steps on the moon, the map growing suddenly bigger as members of the public speculate and fantasize about a future in space (David Lamelas). An absurdist crossing of the Mexican/US border via a circumnavigation of the globe is at once in defiance of a political stasis and an attempt to operate outside the norms of contemporary life – a detour par excellence (Francis Alÿs). A hooded hawk (Stefan Gec), its tiny bell fashioned from brass salvaged from a defunct Russian submarine, is recorded flying around the vaulted space once occupied by the aforementioned brick stove and now dominated by, in what is perhaps the exhibition's most disorientating moment of déjà-vu, a restaged, backstage view of an artist in residence – all self-parody and projection – existing at 'the thinnest of interfaces between the past and the future'[18] (Mike Nelson). The hawk's looping flight seeming to cut right through this phantom studio – redoubling the sense that the whole elaborate apparatus is only a mirage. Another studio floor – a deeply stratified, sedimentary conflation of paint, photographs, newspaper clippings, and torn-out book illustrations – creates the unstable bedrock from which contemporary images appear. A painted scream, the open mouth a 'shadowy abyss', voices the 'diabolical powers of the future' (Francis Bacon).

An Afterword

In its making 'Never The Same River' has asked all sorts of questions about the relationship between artworks and their documentation, between photography and memory and between the objects that haunt the Centre's history and the ideas that evolve around them. Artists' and curators' memories are of course fallible or coloured by concerns of the present and aspirations for the future. Works shift in significance, are reappraised, remade or simple decay. Some exhibitions are just never recorded – the 'installation view', as the archives attest, is a relatively recent invention – a work's relationship to the others around it or to the space it occupied lost forever. 'Never The Same River' is thus by nature a collage of hard fact, rigorous research, hazy memory, word-of-mouth rumour and speculation that amounts to a kind of collective memory of a possible future and probable past.

I would like to acknowledge the importance of Daniel Birnbaum's essay 'Chronology' (2005), Peter Eleey's exhibition and catalogue 'The Quick and the Dead' (2009) and Michael Asher's exhibition 'Santa Monica Museum of Art' (2008) to the formulation of 'Never The Same River'. I would also like to thank Rasmus Nielsen for his input and support; all the artists (both living and dead) for their generosity and cooperation in making this difficult installation possible; and Gina Buenfeld and the team at Camden Arts Centre for their extraordinary commitment to the cause.

FROM NEVER THE SAME RIVER (POSSIBLE FUTURES, PROBABLE PASTS), CAMDEN ARTS CENTRE, LONDON, 2010

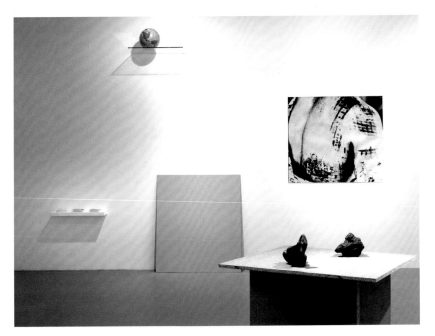

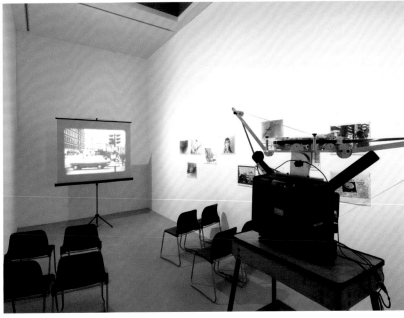

EXHIBITION VIEW OF 'NEVER
THE SAME RIVER (POSSIBLE
FUTURES, PROBABLE PASTS)'
CURATED BY SIMON STARLING,
AT CAMDEN ARTS CENTRE,
LONDON, 2011

FRANCIS ALŸS,
THE LOOP (A ROUTE AROUND
THE GLOBE FOLLOWING THE
PACIFIC ROUTE – JUNE 1 TO
JULY 5, 1997), 1997

ANDREA FISHER
DISPLACEMENT I
(HIROSHIMA), 1993

ANDREA FISHER
DISPLACEMENT III
(HIROSHIMA), 1993

DES HUGHES
NORFOLK FLINT (WITH
BORING), 2007

EXHIBITION VIEW OF 'NEVER
THE SAME RIVER (POSSIBLE
FUTURES, PROBABLE PASTS)'
CURATED BY SIMON STARLING,
AT CAMDEN ARTS CENTRE,
LONDON, 2011

DAVID LAMELAS,
A STUDY OF RELATIONSHIPS
BETWEEN INNER AND OUTER
SPACE, 1969

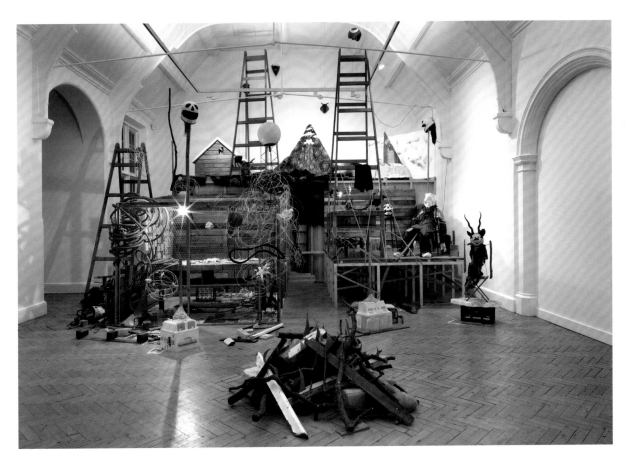

EXHIBITION VIEW OF 'NEVER
THE SAME RIVER (POSSIBLE
FUTURES, PROBABLE PASTS)'
CURATED BY SIMON STARLING,
AT CAMDEN ARTS CENTRE,
LONDON, 2011

MIKE NELSON
A STUDIO APPARATUS FOR CAMDEN ARTS
CENTRE; AN INTRODUCTORY STRUCTURE.
INTRODUCTION, A LEXICON OF PHENOMENA AND
INFORMATION ASSOCIATION, FUTUROBJECTICS.
(IN THREE SECTIONS), MYSTERIOUS ISLAND*, OR
TEMPORARY MONUMENT, 1998-2010

INTERVIEW: PAGES 007–039

1 Carlo Mollino (1905-73), Italian visionary architect, designer, photographer and artist, is regarded as a modern version of a Renaissance intellectual.

2 Winfried Georg Maximilian Sebald (1944-2001) was a German writer and academic based in England. His books include *The Rings of Saturn: An English Pilgrimage* (Harville Press, London, 1999).

3 Haruki Murakami, *Kafka on the Shore* (Harville Press, London, 2005).

4 Albert Renger-Patzsch (1897-1966) was a German photographer who specialized in industrial landscapes and mass-produced object portraits. His archives were destroyed during the Second War World. See Albert Renger-Patzsch, *Die Welt ist schön* (The World is Beautiful, 1928, republished by Harenberg Edition, Munich, 1999).

5 Bruno Haas, 'Institution and Place', in *Simon Starling: Nachbau*, (Museum Folkwang, Essen, Germany, 2007).

6 Mark Godfrey, 'Simon Starling's Regenerated Sculpture', in *Simon Starling: Cuttings* (Hatje Cantz, Ostfildern, Germany, 2005).

7 Hiroshi Sugimoto, *Noh Such Thing as Time* (Koyanagi Gallery, Tokyo, 2001).

8 Lilly Reich (1885–1947) was a German modernist designer and close collaborator of Ludwig Mies van der Rohe.

9 See Charles Darwin, *On the Origin of Species* (John Murray, London, 1859, reprinted by Wordsworth Editions, Ware, England, 1998).

10 Herbert Lang (1879-1957) was a German zoologist who made many field expeditions to Africa between 1906 and 1935.

SURVEY: PAGES 041–087

1 1967 was the year in which Richard Long made *A Line Made By Walking*; in which the painters Daniel Buren, Olivier Mosset, Michel Parmentier and Niele Toroni formed the BMPT collective to deliver their epochal anti-painting manifesto; and in which Robert Morris published his *Notes on Sculpture*, Sol Lewitt his *Paragraphs on Conceptual Art*, and Dan Graham his *Homes for America*. It also saw the founding of the Italian Arte Povera movement, as well as the opening of Konrad Fischer Gallery in Düsseldorf, a key portal for the entry of American Conceptual art into Europe. 1967 also marked, finally, the Beatles' *Sergeant Pepper's Lonely Hearts Club Band* – the year pop music grew up.

2 His maternal great-great-uncle was the architect of the building (originally intended to be a library) that is now home to the Camden Arts Centre, London, which hosted a solo exhibition of Starling's work in 2000, as well as a group show curated by the artist in 2011.

3 Glasgow's role in this new sculptural *réveil*, which had (tellingly perhaps) relatively little to do with the mainstream success of New British Sculpture as such (Tony Cragg, Richard Deacon, Anthony Gormley, Anish Kapoor, et al.), is habitually associated with the Modern Institute (among others), founded by Toby Webster in 1998. Some of the key names in the Modern Institute, alongside Starling, are those of Martin Boyce, Jim Lambie and Cathy Wilkes. Other key players in the Glasgow scene of the time were Roderick Buchanan, Douglas Gordon, Jonathan Monk, David Shrigley and Ross Sinclair.

4 This exhibition was also important for another reason, suggested in the work's self-explanatory title: it highlighted the artist's programmatic interest in the history of design (Bauhaus, Pensi) as well as a love of what one could call 'metamorphology' – a neologism worth sticking to if only because it describes Starling's basic

procedure so well. Finally, it is worth emphasizing the fact that the Showroom's 1:1 replica was constructed and installed inside a disused industrial building (demolished shortly after the project took place there), a recurring feature in Starling's extensive exhibition history.

5 I very consciously echo one of the basic tenets or leitmotifs of Documenta 12 here, namely that 'modernity is our antiquity' – a fine way of capturing the spirit of quasi-archaeological curiosity with which Starling has scrutinized some of modernity's most devoutly adored relics, such as the Eames office chair (*Work, Made Ready*, 1997), the egg timers and table lamps of Wilhelm Wagenfeld (*Burn-Time*, 2000, and *300:1 (After Wilhelm Wagenfeld)*, 2010, respectively), or Lilly Reich and Ludwig Mies van der Rohe's designs for the German engineering pavilion at the 1929 Barcelona world fair (*Exposition*, 2004). Charles Esche wrote an early essay, appropriately titled 'Undomesticating Modernism', that dealt with Starling's modest subversions of the type of modernist domesticity signified by these status symbols: *Afterall*, no. 1, winter 2000.

6 As Francis McKee put it: 'like the tip of an iceberg, this description only hints at Starling's epic sequence of preparations for the flight of his model plane: the discovery of a gum tree with a canoe-shaped scar in its trunk in the grounds of the museum [the Heide Museum of Modern Art in Victoria, Australia]; his journey to Quayaquil, Ecuador, to select a balsa wood tree; and the making of the model by hand. Likewise, the title barely suggests the hinterland of research for the project, which touched on the 8,565 mile voyage of explorer Vita Alsar from Quayaquil to Brisbane; Le Corbusier's interest in "flying machines" as models for his buildings; indigenous Australian technologies; and the Modernist origins of the museum at Heide.' Francis McKee, 'Chicken or Egg?', *Frieze*, no. 56, January-February 2001.

7 In 'Kakteenhaus: A Brief History' (2002, see in this volume pp. 108-11), a timeline-style addendum to the catalogue published on the occasion of *Under Lime*, an exhibition organized at the Temporary Kunsthalle in Berlin that featured Starling's bright red Volvo 240 as an actual sculptural/structural component, we are informed that the year 1974 sees the opening of the Kalmar Volvo plant in Sweden: 'designed by the Ultra Group and architect Gerhard Goehle in consultation with Volvo workers, the plant, which introduces the innovative 'butterfly' factory plan, revolutionizes car production methods and working conditions.' *Simon Starling: Under Lime*, Walther König, Cologne, 2009, p. 111. Interestingly, the very same Volvo factory also makes an appearance in the work of another British artist whose practice deals with questions of production, post-production and new and old labour (no pun intended), namely Liam Gillick.

8 The twentieth-century patron saints of this doctrine are Joseph Beuys and Marcel Duchamp, who despite their opposite artistic temperaments share an interest in alchemy that helps to shed some light on certain aspects of Starling's practice – the 'alchemistic' impulse of which is primarily concentrated in his photographic work involving the extraction of certain chemical elements from historical photographs (see the discussion of *The Nanjing Particles* at the end of this essay). The ghost of Duchamp could be said to haunt several of Starling's works, beginning with the bicycle-themed *Work, Made Ready* (1997). The spectral contours of Beuys are perhaps not so easily discerned, but – leaving aside a shared interest in the allegorical potency of entropic geological and chemical processes – the collaborative nature of many of Starling's projects (which very

often remain rooted in the language of sculpture) does bring the notion of Beuys' *Sozialplastik* into play.

9 Steering clear of the language of pathology, Michel Gauthier has coined the phrase 'the transporting art of the loop' to describe Starling's practice (see *Simon Starling: THEREHERETHENTHERE*, MAC/VAL, Vitry-sur-Seine, 2009). The paradoxical effect of movement resulting in stasis, on the one hand, and immobility generating *dunamis* (energy), on the other, reiterates an age-old philosophical quarrel, first articulated in fifth-century BC Greece, that pitted the Eleatics against Heraclitus and his followers. A school of pre-Socratic philosophers centred around Elea, a sixth-century Greek colony in present-day Sicily, and the Eleatics opposed the then (and now!) fashionable philosophical view, attributed to Heraclitus, according to which perpetual change ('becoming') is the only permanent quality of being. Not surprisingly, Heraclitus is much better remembered today for allegedly having observed that we never step in the same river twice – half the title, incidentally, of a group show curated by Starling at the Camden Arts Centre in 2011. Another element that plays into this oxymoronic complex of deliberately fruitless motion is the Bataillan notion of *dépense* or waste: Starling has called *The Accursed Share*, the closest Georges Bataille ever came to developing a coherent theory of anti-economy, a 'handbook for artists'. Starling's interest in Bataillan wastefulness is articulated most emphatically in *Drop Sculpture (Atlas)* (2008), a project developed for the Rijksmuseum in Amsterdam that involved the destruction (by the artist) and painstaking reconstruction (by the museum's team of restorers) of three terracotta replicas of an original terracotta sculpture depicting the god Atlas.

10 Conversation with the author, July 2011.

11 *Island for Weeds (Prototype)*, first exhibited at the Scottish Pavilion during the 2003 Venice Biennale, is directly related to *Rescued Rhododendrons* in that the cluster of rhododendrons of which the work actually consists was originally conceived as a public sculpture to be floated around Loch Lomond near Glasgow. In an interview in *The Guardian* published on the occasion of his being awarded the Turner Prize in 2005, Starling explains the work's genesis and outlines the reasons for its ultimate failure as a public project: 'You see, the Rhododendron Ponticum is regarded as the scourge of Scotland. It was originally from southern Spain, but was imported, I think, by a Swedish botanist. It was planted in gardens and then spread until it became a real problem. A lot of money has been spent trying to eradicate it from Scotland. [...] Originally, I drove to Spain with seven of these plants and planted them with their ancestors. [...] I decided I wanted to grow them in Loch Lomond on a thing called Island for Weeds. One of the funders was going to be Scottish National Heritage. Then someone realized that Scottish National Heritage had spent £5 million trying to eradicate the rhododendrons, so it seemed to be a bad idea for them to fund a project that involved growing more. It became this whole political thing and it didn't happen.' Stuart Jeffries, 'Simon Starling: I got a lovely poem from a lady in St Albans about sheds', *The Guardian*, 7 December 2005.

12 The Portikus exhibition space was opened in 1987; it originally consisted of a new building tucked away behind the neo-classical facade of a former municipal library destroyed in an air raid in 1944. It is connected to Frankfurt's famed Städelschule, one of Germany's leading art academies, where Starling has taught since 2003.

13 On the website of North Adams's MASS MoCA (www.massmoca.org, accessed 16 July 2011), where this canoe was shown in a solo

INVERTED RETROGRADE
THEME, USA: HOUSE FOR
A SONGBIRD (1:5 SCALE
MODELS OF NO. 2 AND NO.
4 CALLE VICTORIA, VILLA
CONTESSA, BAYAMÓN, PUERTO
RICO DESIGNED IN 1964
BY SIMON SCHMIDERER
FOR THE INTERNATIONAL
BASIC ECONOMY HOUSING
CORPORATION, USA,
INSTALLED UP-SIDE DOWN
TO ACT AS CAGES FOR SONG
BIRDS), 2002
2 PARTS
EACH 338 X 210 X 356 CM

following pages,
LA SOURCE (DEMI-TEINTE),
2009
BLACK GLASS BALLS AND BLACK
AND WHITE PHOTOGRAPH IN
LIGHT BOX
BALL DIAMETERS VARY FROM
3 TO 25 CM

INSTALLATION VIEW AT PARC
SAINT LÉGER, POUGUES-LES-
EAUX, FRANCE, 2009

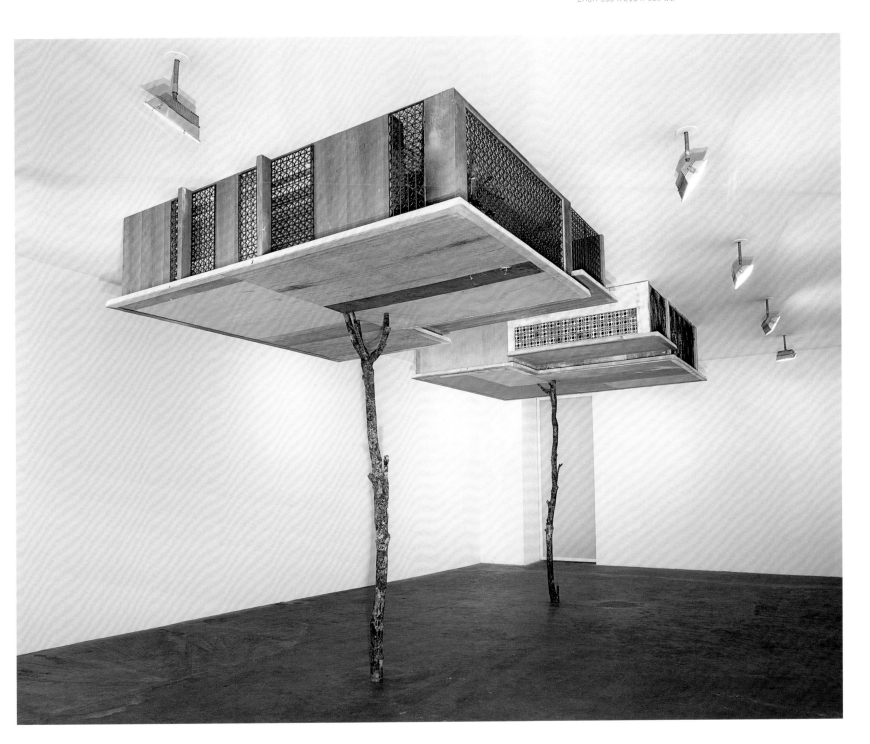

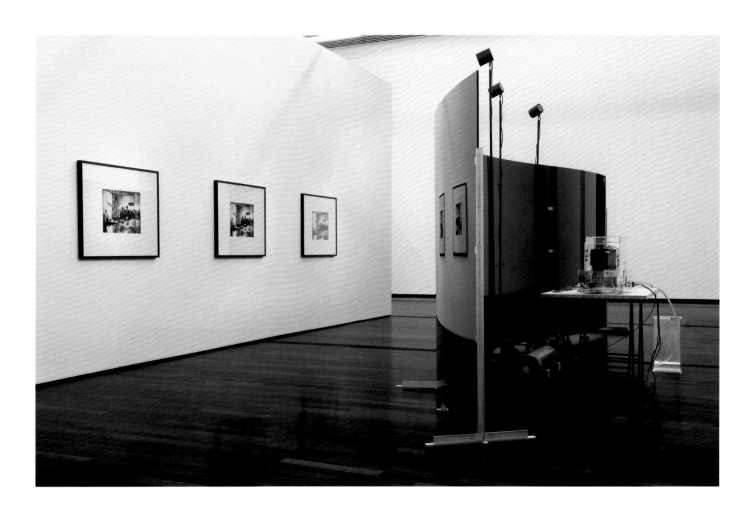

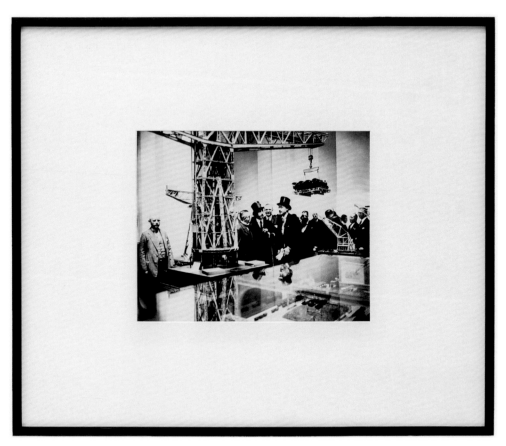

EXPOSITION (THREE CONTEMPORARY
PLATINUM PRINTS MADE FROM
A PHOTOGRAPH OF THE GERMAN
ENGINEERING EXHIBIT AT THE 1929
BARCELONA EXPOSITION DESIGNED BY
LILLY REICH AND MIES VAN DER ROHE,
ILLUMINATED USING ENERGY GENERATED
IN A FUEL CELL FOLLOWING THE REACTION
BETWEEN HYDROGEN AND OXYGEN ON A
PLATINUM CATALYST), 2004
3 PLATINUM/PALLADIUM PRINTS
EACH 63 X 86 CM
FUEL CELL, DC/DC CONVERTER, HYDROGEN
GAS, PERSPEX, TRESTLES, TABLE
EACH 72 X 31 X 45 CM
GLASS, STEEL
200 X 640 CM

INSTALLATION VIEW AT MUSÉE D'ART
CONTEMPORAIN DU VAL-DE-MARNE
(MAC/VAL), PARIS, 2004

exhibition in 2009, we read how 'Starling's voyage was made in a purpose-built strip canoe of the type made in North America since the 1880s and originally based on the Native American birch bark canoe. This hybrid canoe was fashioned from dark brown African Walnut interspersed with ash, mimicking the Okapi's stripes, and when carried overhead by two canoeists the boat became a kind of pantomime animal.' Here, the spirit of recycling ('full circle') that animates much of Starling's work on a thematic or conceptual level is put to the test of actual application. A handmade canoe first exhibited in a New York gallery show in 2007 was put on display again in the exhibition at MASS MoCA in 2009, only to be taken out of the museum to be put to practical use in a boating trip that brought the artist back to New York – or rather, more appropriately given the Red Rivers project's historical backbone, to the island of Mannahatta, as it was known to its original inhabitants, the Lenape.

14 Indeed, it is worth considering to what extent the various milestones in the life of Charles Darwin and his theories overlap with the various giant steps made throughout the nineteenth century as a whole in the adjoining fields of printing, photography and cinematography – endeavours in the realm of human knowledge that essentially circle around notions of reproduction and reproducibility. Darwin's voyage aboard the Beagle spanned the five years during which much of photography's foundations were laid, and his first forays into the theory of evolution are almost exact contemporaries of such pre-cinema devices as the phenakistoscope, stroboscope, and zootrope. Darwin lived long enough to see Eadweard Muybridge embark on his first experiments with the so-called zoopraxiscope, but died too early (in 1882) to witness the projection of the first actual motion picture (in 1889).

15 One journey in particular – really more of a pilgrimage, if we consider Brancusi's well-publicized cultivation of his own oriental-mystic persona – allegedly saw the Romanian artist walk all of the 1,700 kilometres that separated his native Targu Jiu from the then-capital of the art world, Paris.

16 Even though a two-ton sheet of rusting steel may be named after a Brancusi sculpture, the first name that will come to mind upon encountering it is undoubtedly that of Richard Serra. In a disconcerting twist of art-historical irony, it later turned out that the firm that delivered Starling's *Bird in Space, 2004* to his Chelsea gallery was the same one that, back in 1969, had lost a worker to a deadly accident involving a Serra installation piece, *One Ton Prop* (which had as its lugubrious subtitle *House of Cards*): another modern art folk tale revolving around the irreducible materiality of sculpture.

17 Bush presumably introduced this tax with Tony Blair's support, since this was a moment of tightening trans-Atlantic friendship bonds. Significantly, Blair plays a not-so-minor part in *Bird in Space*'s wildly spiralling narrative. The steel used to 'make' the New York sculpture came from a Romanian company that had been bought up by the Indian-born steel magnate Lakshmi Mittal, whose acquisition of the aforementioned state company had been made considerably easier after Blair personally intervened on Mittal's behalf just a month after the tycoon had donated a whopping £125,000 to the Labour party. As Joe Murphy noted in *The Daily Telegraph*, 'Mr Blair later told MPs [in his defence] that Mr Mittal's company was British. In fact, LNM Holdings is based in a Caribbean tax haven. It operates almost entirely overseas and competes against British steelmakers that have shed 6,000 jobs in the past year.' (Joe Murphy, 'Blair pushed through deal for Indian billionaire who gave Labour £125,000', *The Telegraph*, 10 February 2002.)

18 Conversation with the author, July 2011.

19 The quasi-Freudian character of Starling's relationship with Moore is borne out by one work in particular: the aptly titled *Self Portrait (as Henry Moore)* (2011). Moore's name also pops up in the following works: *Moore Maquette* (2008), *Mossed Moore* (2009–11) and *Silver Particle/Bronze (After Moore)* (2008).

20 For an artist whose work so often deals with industrial design, labour and (post-)Fordist production cycles, Starling has been especially fortunate to exhibit in a number of art spaces housed in disused industrial buildings with rich local histories, from the Glaswegian site that sheltered 'half' of *An Eichbaum Pils beer can …* (see note 4) and the machine-assembly hall in Dornbirn (the original site of *Plant Room*) to a derelict bottling plant in the French town of Pougues-les-Eaux (now home to the Parc Saint Léger Centre d'Art Contemporain, where Starling realized *La Source* in 2009) and an abandoned textile printing factory in North Adams, Massachusetts, home of MASS MoCA and the site of Starling's 2010 solo exhibition 'The Nanjing Particles'.

21 See note 7. In the 2009 exhibition in Berlin, *Plant Room* was shown in relation to *Kakteenhaus*.

22 Starling's *Nachbau* project was realized in the 1983 extension to the Folkwang's 'Altbau' (old building), itself only built in 1960, just before the former wing's destruction, to make way for the highly acclaimed extension by David Chipperfield in 2010.

23 See Simon Starling, 'Replication: Some Thoughts, Some Works', *Tate Papers*, autumn 2007 (http://www.tate.org.uk/research/tateresearch/tatepapers/07autumn/starling.htm).

24 Bruno Haas, 'Institution and Place' in *Simon Starling: Nachbau*, Museum Folkwang and Steidl, Essen and Göttingen, 2007, p. 45.

25 On the subject of this early work, which consisted of 300 prints of the titular gun piled beneath a plastic cover, Stuart Morgan noted the following in a review published in *Frieze* in 1995: 'Starling's main talent is his command of the shaggy dog story; he makes us so interested in the circumstances of his discoveries that we forget the oddity of the scenario. Why was he there? Whose pistol was it? Why 300 prints? Are there 300 prints? Does it matter? What connects the false teeth and the museum? A relic is a relic, Starling seems to imply, but does that make it art? Then he goes one step further and suggests that it may not matter.' Made in the early days of Starling's career, this observation continues to hold much truth: in the end, the reason why Starling was there (in Stuttgart, in Solnhofen, in Ecuador, in Andalusia) matters little. (Stuart Morgan, 'The Future's not what it used to be', *Frieze*, March-April 1995)

26 Theodor Adorno, *Aesthetic Theory*, Continuum, London and New York, 1997, p. 120. This quote is taken from the chapter titled 'Enigmaticalness, Truth Content, Metaphysics'.

27 See note 25.

FOCUS: PAGES 089–099

1 Henri Bergson, *Creative Evolution*, Random House, New York, 1944, p. 138.

2 Hollis Frampton, 'The Invention without a Future' in *On the Camera Arts and Consecutive Matters: the writings of Hollis Frampton* (Bruce Jenkins, ed.), MIT Press, Cambridge, Massachusetts, and London, 2009, p. 177.

3 Giorgio Agamben, 'The Assistants' in *Profanations*, Zone Books, New York, 2006, pp. 29-36.

4 Friedrich Nietzsche, cited in Friedrich A. Kittler, *Gramophone, Film, Typewriter*, Stanford University Press, Stanford, California, 1986-99.

ARTIST'S WRITINGS: PAGES 107–141

1 Albert Renger-Patzsch's original title for the book had been *Die Dinge* (Things), but his publisher forced him to change it for fear a book with that title would not sell.

2 See Bruno Haas, *Institution and Place: Nachbau*, Museum Folkwang, Essen, and Steidel, Göttingen, 2007.

3 See Juan Antonio Ramirez, *Duchamp, Love and Death, Even*, Reaktion Books, London, 1998.

4 George Nelson, *On Design*, Architectural Association, London, 1980.

5 See Robert Smithson, 'A Tour of the Monuments of Passaic, New Jersey' (1967) in Jack Flam (ed.), *Robert Smithson: The Collected Writings*, University of California, Berkeley, 1996.

6 In 1870 Credner was appointed professor of geology in the University of Leipzig, and in 1872 director of the Geological Survey of Saxony. He is author of numerous publications on the geology of Saxony, and of *Elemente der Geologie* (1891), regarded as the standard text among German geologists.

7 The culmination of German interest in the English Arts and Crafts movement came with the publication of Hermann Muthesius' book *Das Englische Haus* in 1904.

8 See Kristina Wängberg-Eriksson, *Josef Frank, Textile Designs*, Bokförlaget Signum, Lund, Germany, 1999.

9 Carlo Mollino, in a letter to his friend Giuseppe Erda, 18 April 1973.

10 See Fulvio Ferrari, 'Mollino's Apartment in Via Napione', in Giovanni Brino (ed.), *Carlo Mollino: Architecture as Autobiography*, Thames and Hudson, London, 2005.

11 Catherine Lupton, *Chris Marker: Memories of the Future*, Reaktion Books, London, 2005.

12 Nick Hilde, CNET.UK.

13 The Large Hadron Collider is a twenty-seven-km-long particle accelerator that runs across the French-Swiss border near Geneva, designed to investigate the forces and particles that reigned during the first trillionth of a second of the Big Bang.

14 Cited in Peter Eleey, 'Thursday', *The Quick and The Dead*, Walker Art Center, Minneapolis, 2009.

15 Ibid.

16 From a lecture by Normann Klein, Dundee, 2010.

17 Jaki Irvine in Mike Nelson, *Extinction Beckons*, Matt's Gallery, London, 2007.

18 Gilles Deleuze, *The Logic of Sensation*, Continuum, London, 2003.

SELECTED <u>EXHIBITIONS AND PROJECTS</u>
1986-96

SELECTED <u>ARTICLES AND INTERVIEWS</u>
1988-96

museum piece, specimen of art, manufacture
etc., fit for a museum, (derog.) old-fashioned or
quaint person, machine, etc.

Paul Maguire and Simon Starling, Mackintosh Museum, Glasgow School of Art, May 1991

Kabinett für Zeichnung:
Simon J. Starling

„Kabinett für Zeichnung"

Ausstellung vom 20.10. bis 18.11.95

Zur Eröffnung der Ausstellung am
19.10.95 um 20 Uhr sind Sie und
ihre Freunde herzlich eingeladen.

KX/Kampnagel, Jarrestraße 20
22303 Hamburg, Tel: 040/279 23 94
Öffnungszeiten: Do-Sa, 16-20 Uhr

Gefördert durch die Kulturbehörde Hamburg und
The
British
Council

1986-1987
Simon Starling attends Maidstone College of Art, England

1987-1990
Simon Starling attends Nottingham Polytechnic.

1990-1992
Simon Starling attends Glasgow School of Art.

1991
'Museum Piece' (with Paul Maguire),
MACKINTOSH MUSEUM, Glasgow (solo)

1991
Palmer, Roger, 'There is no museum in the exhibition at present',
<u>Alba</u>, July

1992
'Invisible Cities',
FRUITMARKET GALLERY, Edinburgh (group)

'Three New Works',
TRANSMISSION GALLERY, Glasgow (group)

'Gesture No. 5',
POST WEST GALLERY, Adelaide (group)

1993
'BT New Contemporaries 1993-94',
THE MAPPIN GALLERY, Sheffield, toured to CORNERHOUSE,
Manchester; ORCHARD GALLERY, Derry, Northern Ireland; CITY
MUSEUM AND ART GALLERY, Stoke-on-Trent, England (group)

'Matter and Fact',
COLLECTION GALLERY, London (group)

1994
'Modern Art',
TRANSMISSION GALLERY, Glasgow (group)

'Institute of Cultural Anxiety',
INSTITUTE FOR CONTEMPORARY ART (ICA), London (group)

'Oriel Mostyn Open',
ORIEL MOSTYN, Llandudno, Wales (group)

'Die Zweite Wirklichkeit. Aktuelle Aspekte des Mediums Kunst'
WILHELMSPALAIS, Stuttgart (group)

1995
'An Eichbaum Pils Beer Can...',
THE SHOWROOM, London (solo)

'Kabinett für Zeichnung',
KAMPNAGEL, Hamburg (solo)

'Maikäfer Flieg',
HOCHBUNKER KÖLN-EHRENFELD, Cologne (group)

'About Place',
COLLECTIVE GALLERY, Edinburgh (group)

1995
Morgan, Stuart, 'The future's not what it used to be', <u>Erkz~</u>,
March-April

Currah, Mark, 'Simon Starling at The Showroom', <u>Time Out
London</u>, 7 July

Hunt, Ian, 'Simon Starling at The Showroom, London', <u>Frieze</u>,
no. 24, September-October

Jaio, Miren, 'Simon Starling at The Showroom, London', <u>Lapiz</u>,
no. 115

1996
'Kilt ou Double',
LA VIGIE-ART CONTEMPORAIN, Nîmes, France (group)

'City Limits',
STAFFORDSHIRE UNIVERSITY GALLERY, Stoke-on-Trent,
England (group)

1996
Feldman, Melissa, 'Matters of Fact: New Conceptualism in
Scotland', <u>Third Text</u>, no. 37, winter

Glasgow Kunsthalle Bern
Nathan Coley Louise Hopkins
Fanni Niemi-Junkola Ross Sinclair
Simon Starling Smith/Stewart
15. März – 20. April 1997

1996 (cont.)
'Fishing for Shapes',
PROJEKTRAUM VOLTMERSTRASSE, Hannover, traveled to
KUNSTLERHAUS BETHANIEN, Berlin (group)

1997
'Blue Boat Black',
TRANSMISSION GALLERY, Glasgow (solo)

'Sick Building',
TRANSMISSION GALLERY at GLOBE GALLERY, Copenhagen
(group)

'Wish You Were Here Too',
83 HILL ST, Glasgow (group)

'Glasgow',
KUNSTHALLE BERN (group)

'Nerve: Glasgow Projects',
ARTSPACE, Sydney (group)

'L'Automne dans toutes ses collections',
MUSÉE D'ART CONTEMPORAIN, Marseille (group)

'B.C.C',
CLEVELAND AND THE TANNERY, London (group)

1997
Sinclair, Ross, 'Blue Boat Black', <u>Frieze</u>, no. 38, January-February

1998
'Le Jardin Suspendu',
THE MODERN INSTITUTE, Glasgow (solo)

'Moderna Museet Projekt',
MODERNA MUSEET, Stockholm (solo)

'Strolling: The Art of Arcades, Boulevards, Barricades',
MUSEUM OF MODERN ART AT HEIDE, Melbourne (group)

'Bad Faith',
THREE MONTH GALLERY, Liverpool, traveled to WAYGOOD
GALLERY, Newcastle (group)

'Reconstructions',
SMART PROJECT SPACE, Amsterdam (group)

'Family',
INVERLEITH HOUSE, Edinburgh (group)

1999
'Blinky Palermo Prize',
GALERIE FÜR ZEITGENÖSSICHE KUNST, Leipzig (solo)

'If I Ruled the World',
THE LIVING ART MUSEUM, Reykjavik, traveled to CENTRE FOR
CONTEMPORARY ARTS, Glasgow (group)

'Prime',
DUNDEE CONTEMPORARY ARTS, Scotland (group)

'Dummy',
CATALYST ARTS PROJECT, Belfast (group)

'Thinking Aloud',
CAMDEN ARTS CENTRE, London (group)

'Fireworks',
DE APPEL, Amsterdam (group)

'Un Certain',
ATA CONTEMPORARY ART CENTRE, Sofia (group)

1999
Shepeard, Paul, 'Edgeless, Modeless', <u>Afterall</u>, no. 1

Tazaki, Anni L., 'Ready-Made Made-Ready', <u>Flyer</u>, no. 5

Kowa, Günter, 'Der wundersame Fischzug mit der
Museumsvitrine', <u>Mitteldeutsche Zeitung</u>, 4 June

Sommer, Tim, 'Vieldeutiges Spiel um Erinnerungen', <u>Leipziger
Volkszeitung</u>, 4 August

'Leipziger Premiere furs Palermo-Stipendium', <u>Leipziger
Volkszeitung</u>, 1 November

SELECTED <u>EXHIBITIONS AND PROJECTS</u>
2000-01

SELECTED <u>ARTICLES AND INTERVIEWS</u>
2000-01

2000
'Method 1: Simon Starling',
SIGNAL, Malmö, Sweden (solo)

STUDIO 2000, Cologne (solo)

'Open Studio',
CAMDEN ARTS CENTRE, London (solo)

'Robieres/Roberies',
MARRES-CENTRE FOR CONTEMPORARY ART, Maastricht,
Netherlands (group)

'Micropolitique',
LE MAGASIN, Grenoble (group)

'Spacecraft',
BLUECOAT DISPLAY CENTRE, Liverpool (group)

'The British Art Show 5',
HAYWARD GALLERY, London, toured to TALBOT RICE and CITY
ART CENTRE, Edinburgh; SOUTHAMPTON CITY ART GALLERY
and CENTRE FOR VISUAL ARTS, Southampton, England;
CHAPTER ARTS CENTRE, FOTOGALLERY and NATIONAL
MUSEUM AND GALLERY, CARDIFF; BIRMINGHAM MUSEUM
AND ART GALLERY (group)

'What If/Tänk om: Art on the Verge Architecture and Design',
MODERNA MUSEET, Stockholm (group)

'Artifice',
DESTE FOUNDATION, Athens (group)

MANIFESTA 3, Ljubljana (group)

'Future Perfect',
CENTRE FOR VISUAL ARTS, Cardiff (group)

'Play-Use',
WITTE DE WITH, Rotterdam (group)

2001
'Burn-Time',
LICHTHAUS PLUS NEUE KUNST, Bremen, Germany (solo)

'Burn-Time/Reading Room',
GALERIE FÜR GEGENWARTSKUNST BARBARA CLAASSEN-
SCHMAL, Bremen, Germany (solo)

'Poul Henningsen & Simon Starling',
COOPER GALLERY, Dundee, Scotland (solo)

'Simon Starling'
JOHN HANSARD GALLERY, Southampton, England (solo)

'Burn-Time',
NEUGERRIEMSCHNEIDER, Berlin (solo)

'Inverted Retrograde Theme',
SECESSION, Vienna (solo)

'CMYK/RGB',
FRAC LANGUEDOC-ROUSSILON, Montpellier, France (solo)

'Work, Made-Ready, Les Baux de Provence',
KUNSTVEREIN HAMBURG (solo)

'East Doors (North)',
HARRIS MUSEUM AND ART GALLERY, Preston, England (solo)

'Open Country: Contemporary Scottish Artists',
MUSÉE CANTONAL DES BEAUX-ARTS, Lausanne (group)

2000
Schultz, Deborah, 'The Office of Misplaced Events (Temporary
Annex)', <u>Art Monthly</u>, January

Paulli, Luca, 'A Project for a Space'; Henry Hughes, 'Manifesta 3',
<u>Tema Celeste</u>, March

Hedberg, Hans, 'Simon Starling', <u>NU The Nordic Art Review</u>, May

Mullholland, Neil, 'If I Ruled the World', <u>Frieze</u>, no. 54, September

Eichler, Dominic, 'The Work in this Space is a Response to the
Existing Conditions and/or Work Previously Shown within the
Space', <u>Frieze</u>, no. 54, September-October

Esche, Charles, 'Undomesticating Modernism', <u>Afterall</u>, October

Meyric Hughes, Henry; 'Manifesta 3', <u>Tema Celeste</u>, October

Griese, Horst; 'Umwege Machen das Leben Interessanter',
<u>Weser Kurier</u>, 7 December

2001
Mckee, Francis, 'Chicken or Egg', <u>Frieze</u>, no. 56, January-
February

Asthoff, Jens, 'Simon Starling', <u>Kunstmagazin</u>, no. 4

Stange, Raimar, 'Public Relations', <u>Kunstbulletin</u>, May

Ebner, Jorn, 'Briten landen in Berlin', <u>Frankfurter Allgemeine
Zeitung</u>, 5 May

Weinrautner, Ina, 'Werke mit doppeltem Boden', <u>Handelsblatt</u>,
3 May

Rosenberg, Angela, 'Simon Starling: Variations On A Theme',
<u>Flash Art</u>, July-September

Asthoff, Jens, 'Simon Starling im Kunstverein', <u>Kunstbulletin</u>,
October

Simon Starling

FLAGA, (1972-2000)

23 Aprile - 1 Giugno 2002

Martedì - Sabato, 15.00 - 19.30

Galleria Franco Noero

Via Mazzini 394, I 10123 Torino
Tel/fax: 0039 011 882208
e-mail: galleriafranconoero@libero.it

2001 (cont.)
'Circles º4',
ZENTRUM FÜR KUNST UND MEDIENTECHNOLOGIE (ZKM),
Karlsruhe, Germany (group)

'The Silk Purse Procedure',
SPIKE ISLAND and ARNOFINI, Bristol (group)

'Squatters/Ocupações',
MUSEU SERRALVES, Porto, toured to WITTE DE WITH, Rotterdam
(group)

'Strategies Against Architecture II',
FONDAZIONE TESECO, Pisa (group)

'Let's Get to Work',
SUSQUEHANNA ART MUSEUM, Harrisburg, Pennsylvania (group)

'Total Object Complete With Missing Parts',
TRAMWAY, Glasgow (group)

'Here and Now: Scottish Art 1990-2001',
DUNDEE CONTEMPORARY ARTS, GENERATOR PROJECTS, and
MCMANUS GALLERIES, Dundee, Scotland; PEACOCK VISUAL
ARTS and ABERDEEN ART GALLERY, Scotland (group)

'Words and Things',
CENTER FOR CONTEMPORARY ART, Glasgow (group)

'The Larsen Effect: Progressive Feedback in Contemporary Art',
O.K. CENTRUM FÜR GEGENWARTSKUNST, Linz, Austria, toured to
CASINO LUXEMBOURG (group)

2002
'Inverted Retrograde Theme, USA',
CASEY KAPLAN, New York (solo)

'Flaga (1972-2000)',
GALLERIA FRANCO NOERO, Turin (solo)

'Djungel',
DUNDEE CONTEMPORARY ARTS, Scotland, traveled to SOUTH
LONDON GALLERY, London (solo)

'Hammer Projects: Simon Starling',
HAMMER MUSEUM, Los Angeles (solo)

'Kakteenhaus',
PORTIKUS, Frankfurt (solo)

'Mathew Jones/Simon Starling',
MUSEUM OF CONTEMPORARY ART, Sydney (solo)

'Wrong Time, Wrong Place',
KUNSTHALLE BASEL (group)

'No Return: Positionen aus der Sammlung Haubrok',
MUSEUM ABTEIBERG, Mönchengladbach, Germany (group)

'Exchange and Transform',
KUNSTVEREIN, Munich (group)

'That Place',
THE MOORE SPACE, Miami (group)

'My Head is on Fire But My Heart is Full of Love',
CHARLOTTENBORG MUSEUM, Copenhagen (group)

'Happy Outsiders',
ZAÇHETA GALLERY, Warsaw, toured to KATOWICE CITY GALLERY,
Poland; PRO ARTE INSTITUTE, St Petersburg (group)

2002
Gebbers, Anna-Catharina, 'Zusammenhänge herstallen', <u>Artist
Kunstmagazin</u>, March

Levin, Kim, 'Voice Choices: Simon Starling', <u>Village Voice</u>,
1-3 March

'Art Reviews: Simon Starling', <u>The New Yorker</u>, 18 March

Burton, Johanna, 'Simon Starling', <u>Time Out New York</u>,
21-28 March

Meredith, Michael, 'Simon Starling', <u>Artforum</u>, May

Gioni, Massimiliano, 'New York Cut Up', <u>Flash Art</u>, no. 224,
May-June

Monaghan, Helen, 'Labours of Love', <u>The List</u>, 20 June-4 July

Mansfield, Susan, 'A Wing and a Prayer', <u>The Scotsman</u>, 22 June

Stewart, Claire, 'Simon Starling', <u>Press and Journal</u>, 22 June

'Pick of the week: Art Djungel', <u>Scotland on Sunday</u>, 23 June

Jeffrey, Moira, 'Simon Starling: He's Such a Material Guy',
<u>Herald</u>, 28 June

'Living in a material world', <u>The Courier and Advertiser</u>, 28 June

Sutherland, Giles, 'A New Leaf from an Old Book', <u>Sunday Herald</u>,
30 June

Gale, Iain, 'The Resurrection Man', <u>Sunday Herald</u>, 30 June

Leffingwell, Edward, 'Simon Starling at Casey Kaplan', <u>Art in
America</u>, July

SELECTED <u>EXHIBITIONS AND PROJECTS</u>
2002-03

SELECTED <u>ARTICLES AND INTERVIEWS</u>
2002-03

2002 (cont.)
'Zusammenhänge herstellen',
KUNSTVEREIN HAMBURG (group)

'Barby Asante, Journey into the East',
THE SHOWROOM, London (group)

'Der Globale Komplex: Continental Drift',
GRAZER KUNSTVEREIN, Graz, Austria (group)

'Sphere',
SIR JOHN SOANE'S MUSEUM, London (group)

'Still Life/Naturaleza muerta: Arte contemporáneo británico
y peruano',
MUSEO NACIONAL DE BELLAS ARTES, Santiago, toured to
MUSEO DE BELLAS ARTES, Caracas; CARRILLO GILL, Mexico
City; BIBLIOTECA LUIS ÁNGEL ARANGO, Bogotá; MUSEO DA
ARTE MODERNA, Guatemala; NITERO, Rio de Janeiro (group)

'Inter.Play',
THE MOORE SPACE, Miami, toured to MUSEO DE ARTE DE
PUERTO RICO, San Juan (group)

MANIFESTA 4, Frankfurt (group)

2002 (cont.)
Gardner, Belinda Grace, 'Die Tiere beten jeden Tag zum lieben
Tofu', <u>Die Welt</u>, 1 July

Klaas, Nicole, and Heiko Klaas, 'West-östliche Vereinigung', <u>Kieler
Nachrichten</u>, 6 June

Mahoney, Elisabeth, 'Into Dundee's Arty Jungle: Simon Starling',
<u>Guardian</u>, 11 July

Keil, Frank: 'Schwimmtofu an Schweineporträt', <u>Frankfurter
Rundschau</u>, 7 August

Hohmann, Silke, 'Die Überlegenheit des Unwegs', <u>Frankfurter
Rundschau</u>, 14 September

Mahoney, Elisabeth, 'Simon Starling: Djungel', <u>Modern Painters</u>,
Autumn

Danicke, Sandra, 'Cereus, Kaktus aus Spanien', <u>Neue Zürcher
Zeitung</u>, 4 October

Low, Lenny Ann, 'Matthew Jones/Simon Starling', <u>Sydney Morning
Herald</u>, 17 October

Hill, Peter: 'Double Vision', <u>Sydney Morning Herald</u>, 25 October

Römer, Stefan, 'Zusammenbiegen, was das Zeug halt', <u>Texte zur
Kunst</u>, December

2003
'Carbon',
KUNSTHALLE MÜNSTER, Germany (solo)

'Simon Starling'
VILLA ARSON, Nice, France (solo)

'Work, Made-Ready, In Light of Nature',
MUSEO D'ARTE CONTEMPORANEA ROMA, Rome (solo)

'Imperfect Innocence: Debra and Dennis Scholl Collection',
CONTEMPORARY MUSEUM, Baltimore, toured to PALM BEACH
INSTITUTE OF CONTEMPORARY ART, Lake Worth, Florida (group)

'Moderna Museet c/o Malmö Konsthall',
MALMÖ KONSTHALL, Sweden (group)

'False Innocence',
FUNDACIÓN JOAN MIRÓ, Barcelona (group)

'Special Dédicace Rochechouart',
MUSÉE D'ART CONTEMPORAIN, Rochechouart, France (group)

'Faking Real',
LEROY NEIMAN GALLERY, New York (group)

'I Moderni/The Moderns',
CASTELLO DI RIVOLI, Turin (group)

'Independence',
SOUTH LONDON GALLERY, London (group)

50th VENICE BIENNALE (group)

'GNS (Global Navigation System)',
PALAIS DE TOKYO, Paris (group)

4th MÜNSTERLAND SCULPTURE BIENNIAL, Marktplatz Beckum,
Germany (group)

2003
McLaren, Duncan, 'Simon Starling', <u>Art Review</u>, January 2003

Tufnell, Rob, 'Made in Scotland', <u>Tema Celeste</u>, January-February

Prince, Mark, 'Southfork Ranch, Romania', <u>Art Monthly</u>, March

Madoff, Steven Henry, 'One for All'; Tom Vanderbilt, 'A Thousand
Words: Simon Starling', <u>Artforum</u>, May

Menin, Samuele, and Valentina Sansone, 'Sculpture Forever',
<u>Flash Art</u>, no. 230, May-June

Brevi, Manuela, 'Arte eventi', <u>Arte</u>, June

Dunn, Melissa, 'The Venice Biennale: Slouching Toward Utopia',
<u>Flash Art</u>, no. 231, July-September

Lorch, Catrin, 'La Biennale di Venezia', <u>Kunst Bulletin</u>, August

Arms, Inke, 'Individuelle Systeme', <u>Kunstforum</u>, no. 166, August-
October

Fox, Dan, '50th Venice Biennale'; Bruce Haines, '50th Venice
Biennale', <u>Frieze</u>, no. 77, September

Vetrocq, Marcia, 'Venice Bienniale: Every Idea But One', <u>Art in
America</u>, September

Jansen, Gregor, 'Münsterland : Skulptur Biennale', <u>Kunst Bulletin</u>,
September

Ehlers, Fiona, 'Sieben Rhododendren reisen nach Hause',
<u>Kulturspiegel</u>, October

Selvaratnam, Troy, 'The Starling Variations', <u>Parkett</u>, no. 67

Richardson, Craig, 'Zenomap', <u>Contemporary</u>, no. 51

2003 (cont.)
'Hands up, baby, hands up!',
OLDENBURGER KUNSTVEREIN, Oldenburg, Germany (group)

'Moving Pictures',
GUGGENHEIM MUSEUM, Bilbao (group)

'Outlook: International Art Exhibition',
BENAKI MUSEUM, Athens (group)

2004
'Tabernas Desert Run',
THE MODERN INSTITUTE, Glasgow (solo)

'One Ton',
NEUGERRIEMSCHNEIDER, Berlin (solo)

'Simon Starling',
CASEY KAPLAN, New York (solo)

'Exposition',
FUNDACIÓN JOAN MIRÓ, Barcelona (solo)

'Five-Man Pedersen (Ikast-Strelze)',
HERNING KUNSTMUSEUM, Denmark (solo)

26th SÃO PAULO BIENNIAL (group)

'Strange, I've Seen that Face Before',
GALLERY OF MODERN ART, Glasgow, traveled to MUSEUM
ABTEIBERG, Mönchengladbach, Germany (group)

'LAB',
KRÖLLER-MÜLLER MUSEUM, Otterlo, Netherlands (group)

'Socle du monde',
HERNING KUNSTMUSEUM, Denmark (group)

28th PONTEVEDRA BIENNIAL, Spain (group)

'The Birthday Party',
COLLECTIVE GALLERY, Edinburgh (group)

'Prototype: Contemporary Art from Joe Friday's Collection',
CARLETON UNIVERSITY ART GALLERY, Ottawa (group)

'Schöner Wohnen, kunst van heden voor alle dagen',
BE-PART PLATFORM VOOR ACTUELE KUNST, Waregem, Belgium
(group)

2004
Birnbaum, Daniel, 'Transporting Visions: Daniel Birnbaum on the
Art of Simon Starling', <u>Artforum</u>, February

Vogel, Carol, 'Inside Art: Boss Prize Finalists', <u>New York Times</u>,
6 February

Kimmelman, Michael, 'Art in Review: Simon Starling', <u>New York
Times</u>, 12 March

Nicolin, Paola, 'Simon Starling', <u>Abitare</u>, June

Gioni, Massimiliano, 'Simon Starling: The Bricoleur', <u>Carnet</u>, June

2005
'CAM: Crassulacaen Acid Metabolism',
VOID GALLERY, Derry, Northern Ireland (solo)

'Simon Starling: 'Cuttings,'
KUNSTMUSEUM BASEL and MUSEUM FÜR GEGENWARTSKUNST,
Basel (solo)

'The Failure',
KORRIDOR, Berlin (group)

'Universal Experience: Art, Life and the Tourist's Eye',
MUSEUM OF CONTEMPORARY ART, Chicago, toured to
HAYWARD GALLERY, London; MUSEO DI ARTE MODERNA E
CONTEMPORANEA DI TRENTO E ROVERETO, Italy (group)

'The Hugo Boss Prize 2004',
GUGGENHEIM MUSEUM, New York (group)

'En/Of',
MUSEUM KURHAUS KLEVE, Cleves, Germany (group)

2005
Godfrey, Mark, 'Image Structures: Photography and Sculpture',
<u>Artforum</u>, February

Manacorda, Francesco, 'Entropology', <u>Flash Art</u>, no. 241,
March-April

Kley, Elisabeth, 'Goodbye Fourteenth Street: A Review',
<u>Artnews</u>, May

Birnbaum, Daniel, 'Simon Starling: Museum für Gegenwartskunst',
<u>Artforum</u>, May

Labille, Sandra, 'Turner Prize Surprise: Painter is Favorite',
<u>Guardian</u>, 3 June

Fenton, Ben, 'Bottom Painter Makes Turner Prize Shortlist',
<u>Daily Telegraph</u>, 3 June

Reust, Hans Rudolf, 'Simon Starling at Museum für
Gegenwartskunst', <u>Artforum</u>, October

SELECTED EXHIBITIONS AND PROJECTS
2005-06

SELECTED ARTICLES AND INTERVIEWS
2005-06

2005 (cont.)

'Bidibidobidiboo',
FONDAZIONE SANDRETTO RE REBAUDENGO, Turin (group)

'The Forest: Politics, Poetics and Practice',
NASHER MUSEUM OF ART, Durham, North Carolina (group)

'Paralleles Leben/Parallel Life',
FRANKFURTER KUNSTVEREIN, Frankfurt, Germany (group)

'Ambiance: Des Deux Côtés Du Rhin',
MUSEUM LUDWIG, Cologne, and K21 KUNSTSAMMLUNG
NORDRHEIN-WESTFALEN, Düsseldorf (group)

'Turner Prize 2005',
TATE BRITAIN, London (group)

'Lichtkunst aus Kunstlicht',
ZENTRUM FÜR NEUE KUNST UND MEDIENTECHNOLOGIE,
Karlsruhe, Germany (group)

'Drive: Cars in Contemporary Art',
GALLERIA D'ARTE MODERNA, Bologna, Italy (group)

'36x27x10',
WHITE CUBE at THE FORMER PALAST DER REPUBLIK, Berlin
(group)

Simon Starling is awarded the Turner Prize, Tate Britain, London

2006

'24 hr. Tangenziale',
GALLERIA FRANCO NOERO, Turin (solo)

'Autoxylopyrocycloboros',
COVE PARK, Scotland (solo)

'Wilhelm Noack oHG',
NEUGERRIEMSCHNEIDER, Berlin (solo)

'Simon Starling',
HEIDELBERGER KUNSTVEREIN (solo)

'Casa aberta',
INHOTIM CENTRO DE ARTE CONTEMPORANEA, MINAS GERAIS,
Brazil (group)

1st BUSAN BIENNIAL, South Korea (group)

'NowHere Europe: Trans:it. Moving Culture Through Europe',
NATIONAL MUSEUM OF CONTEMPORARY ART, Bucharest (group)

'If it didn't exist you'd have to invent it: a partial Showroom
history',
THE SHOWROOM, London (group)

7th PERIFERIC BIENNIAL, Iași, Romania (group)

'Objet à part',
LA GALERIE CENTRE D'ART CONTEMPORAIN, Noisy-le-Sec,
France (group)

'On the Move II: Verkehrskultur',
WESTFÄLISCHER KUNSTVEREIN, Münster, Germany (group)

'Transformation',
KUNSTMUSEUM LIECHTENSTEIN, Vaduz (group)

'Wo bitte geht's zum Öffentlichen?',
ÖFFENTLICHER RAUM WIESBADEN, Germany (group)

2005 (cont.)

Schwabsky, Barry: 'Simon Starling', Map, no. 3, October

Godfrey, Mark, 'Simon Starling at Kunstmuseum Basel & Museum
für Gegenwaartskunst', Frieze, no. 94, October

Lubbock, Tom, 'Turner Prize: The Good, The Dull and The Bland',
Independent, 18 October

Jeffrey, Moria, 'A Shed-Load of Success', Herald, 18 October

Van Gelder, Lawrence, 'Arts, Briefly: Turner Prize Finalists',
New York Times, 19 October

'The Approval Matrix', New York Magazine, 31 October

Gordon, Margery, 'Bulking Up', Art & Auction, November

Sharp, Jasper, 'Man vs. Nature', Art Review, December

Jury, Louise, 'Just an Old Nike? Or is it a Poetic Narrative? Either
Way, Starling Flies to Turner Prize', Independent, 6 December

Higgins, Charlotte, 'It's a Shed, It's Collapsible, It Floats, and
(with the help from a bike), It's the Winner', Guardian,
6 December

Van Gelder, Lawrence, 'Arts Briefly: Simon Starling Wins Turner
Prize', New York Times, 6 December

2006

Li, Pi, 'Flash Art News: Prizes', Flash Art, no. 246, January-
February

Jones, Dafydd, 'Turner Prize', Art Review, February 2006

Duffy, Damien: 'C.A.M', Circa, no. 115

Robecchi, Michele, 'Simon Starling', Contemporary, no. 85

Stange, Raimar, 'The Dialectrician', Spike Art, no. 7

Spiegler, Marc, 'Five Theories on Why The Art Market Can't
Crash', New York Magazine, 3 April

Smith, Roberta, 'The Natural World, in Peril and in Its Full Glory',
New York Times, 13 September

Stern, Steven, 'Ecotopia: The Second ICP Triennial', Time Out New
York, 26 October-1 November

Simon Starling
[24 hr. Tangenziale]

29 Marzo - 15 Maggio 2006
Martedì - Sabato, 15.00 - 19.30

Galleria Franco Noero

Via Giolitti 52 A, I-10123 Torino
Tel 0039 011 882208
Fax 0039 011 19703024
www.franconoero.com
info@franconoero.com

--

2006 (cont.)
2nd ICP TRIENNIAL OF PHOTOGRAPHY AND VIDEO,
International Center of Photography, New York (group)

'Blind Date Passau',
MUSEUM MODERNER KUNST STIFTUNG WÖRLEN, Passau,
Germany (group)

--

2007
'Simon Starling',
CASEY KAPLAN, New York (solo)

'Particle Projection (Loop)',
WIELS, Brussels (solo)

'László Moholy-Nagy & Simon Starling',
PRESENTATION HOUSE GALLERY, Vancouver (solo)

'Nachbau/Reconstruction',
STÄDTISCHEN KUNSTMUSEUM ZUM MUSEUM FOLKWANG,
Essen, Germany (solo)

'Simon Starling: Autoxylopyrocycloboros',
MUSEE D'ART CONTEMPORAIN DU VAL-DE-MARNE (MAC/VAL),
Vitry-sur-Seine, France (solo)

'Kintsugi, Simon Starling',
AKTUELLE KUNST IM SCHAUKASTEN HERISAU, Switzerland
(solo)

2nd MOSCOW BIENNIAL (group)

'Art Futures 2007',
BLOOMBERG SPACE, London (group)

8th SHARJAH BIENNIAL, United Arab Emirates (group)

'Held Together With Water: Art from the Sammlung Verbund
Collection',
MUSEUM FÜR ANGEWANDTE KUNST, Vienna (group)

'ZPC Volet #3 entreprises singulières',
MUSÉE D'ART CONTEMPORAIN DU VAL-DE-MARNE, Vitry-sur-
Seine, France (group)

'Made in Germany: Young Contemporary Art from Germany',
KESTNERGESELLSCHAFT, KUNSTVEREIN HANNOVER and
SPRENGEL MUSEUM, Hannover (group)

'Des Mondes Perdus',
CAPC MUSÉE D'ART CONTEMPORAIN, Bordeaux (group)

'Visiones del Paraiso: Utopias, Distopias, Heterotopias',
ESPACIO 1414, Santurce, Puerto Rico (group)

'Rouge baiser',
FRAC PAYS DE LA LOIRE, Carquefou, France (group)

'Out of Art',
CENTRE PASQUART, Biel, Switzerland (group)

9th LYON BIENNIAL (group)

'Nachvollziehungsangebote',
KUNSTHALLE EXNERGASSE, Vienna (group)

'Immagini, Forme e Natura delle Alpi',
FONDAZIONE GRUPPO CREDITO VALTELLINESE, Sondrio, Italy
(group)

'Turner Prize: A Retrospective 1984-2006',
TATE BRITAIN, London (group)

2007
Starling, Simon, 'Simon Starling', <u>Domus</u>, July-August

Lockett, Alex, 'Alex Lockett Examines The Process of
Transformation and Reconstruction In The Work of Brian Jungen
and Simon Starling', <u>Miser and Now</u>, no. 10, August

Starling, Simon, 'Replication: Some Thoughts, Some Works', <u>Tate
Papers</u>, Autumn

Downey, Anthony, 'Simon Starling: Sustainable Photography', <u>Next
Level</u>, no. 12

SELECTED <u>EXHIBITIONS AND PROJECTS</u>
2007-08

SELECTED <u>ARTICLES AND INTERVIEWS</u>
2007-08

2007 (cont.)
'Wenn Handlungen Form werden',
NEUES MUSEUM, Nuremberg (group)

2008
'The Nanjing Particles',
MASSACHUSETTS MUSEUM OF CONTEMPORARY ART, North
Adams (solo)

'Cuttings (Supplement)',
THE POWER PLANT, Toronto (solo)

'Three Birds, Seven Stories, Interpolations and Bifurcations',
GALLERIA FRANCO NOERO, Turin (solo)

'Three Birds, Seven Stories, Interpretations and Bifurcations',
LUDWIG MUSEUM, Budapest (solo)

'Project for a Public Sculpture (After Thomas Annan)',
THE MODERN INSTITUTE, Glasgow (solo)

'Plant Room',
KUNSTRAUM DORNBIRN, Austria (solo)

'Simon Starling: Concrete Light',
LIMERICK CITY GALLERY OF ART, Ireland (solo)

'Richard Long and Simon Starling',
SPIKE ISLAND, Bristol, England (solo)

'P2P',
CASINO LUXEMBOURG (group)

'Gravity: Colección Ernesto Esposito',
ARTIUM CENTRO MUSEO VASCO DE ARTE, Vitoria-Gasteiz, Spain
(group)

'Greenwashing. Environment: Perils, Promises and Perplexities',
FONDAZIONE SANDRETTO RE RABAUDENGO, Turin, toured to
PALAZZO DUCALE DI LAURINO, Salerno, Italy (group)

'Martian Museum of Terrestrial Art',
BARBICAN ART GALLERY, London (group)

''Italia, Italie, Italien, Italy, Wlochy',
MUSEO D'ARTE CONTEMPORANEA SANNIO (ARCOS),
Benevento, Italy (group)

'La marge d'erreur',
CENTRE D'ART CONTEMPORAIN LA SYNAGOGUE DE DELME,
France (group)

'Of this tale, I cannot guarantee a single word',
ROYAL COLLEGE OF ART, London (group)

'Amateurs',
CCA WATTIS INSTITUTE FOR CONTEMPORARY ARTS,
San Francisco (group)

'History in the Making',
MORI ART MUSEUM, Tokyo, traveled to MOSCOW MUSEUM OF
MODERN ART (group)

'Master Humphrey's Clock',
DE APPEL, Amsterdam (group)

1st RENNES BIENNIAL, France (group)

'Peripheral Vision and Collective Body',
MUSEION, Bozen, Italy (group)

'Compromised Places: Topography and Actuality',
MUSEO COLECCIONES (ICO), Madrid (group)

2008
Birnbaum, Daniel , 'Simon Starling: The Power Plant', <u>Artforum</u>,
January

Rehberg, Vivian, 'Lyon Biennial', <u>Frieze</u>, no. 112, January-
February

'Provision', <u>Modern Painters</u>, March

Bonaspetti, Edoardo, 'Simon Starling', <u>Mousse</u>, no. 13, March

Enright, Robert, 'Artist a master of "now you see it, now you
don't"', <u>The Globe and Mail</u>, 1 March

Sandals, Leah, 'Avenue Questions & Artists: Henry Moore and
more', <u>Toronto National Post</u>, 6 March

McLaughlin, Bryne, 'Simon Starling in Review: 21st-century
Colonialism', <u>Canadian Art</u>, 27 March

'Making-of: Simon Starling Shedboatshed (Moblie Architecture
No. 2), 2005', <u>Monopol</u>, June

'Simon Starling', <u>Art in America</u>, Summer

Vegh, Stephanie, 'Toronto: Simon Starling', <u>Map</u>, no. 114

Myers, Julian, 'Amateurs', <u>Frieze</u>, no. 117

Drake, Cathyrn, 'Simon Starling at Galleria Franco Noero',
<u>Artforum</u>, October

Mahoney, Elisabeth, 'Richard Long/Simon Starling', <u>Art Monthly</u>,
November

Wainwright, Jean, 'Richard Long and Simon Starling', <u>Art World</u>,
December-January

'The Nanjing Particles', <u>Metroland</u>, 11-17 December

2008 (cont.)
'What is Life: Christine Borland, Graham Fagen, Simon Starling',
ROYAL BOTANIC GARDEN, Edinburgh (group)

'Reality Check',
STATENS MUSEUM FOR KUNST, Copenhagen (group)

'Scotland and Venice: 2003, 2005, 2007',
PIER ARTS CENTRE, Orkney, Scotland (group)

'The Greenroom: Reconsidering the Documentary and
Contemporary Art',
BARD CENTER FOR CURATORIAL STUDIES, Annandale-on-
Hudson, New York (group)

1st BRUSSELS BIENNIAL (group)

'Close-Up',
FRUITMARKET GALLERY, Edinburgh (group)

'Cronostasi: Filmic Time and Photographic Time',
GALLERIA D'ARTE MODERNA, Turin (group)

'Mexico: Expected/Unexpected Collection Isabel et Agustin
Coppel',
LA MAISON ROUGE, Paris, toured to TENERIFE ESPACIO DE
LAS ARTES, Spain (group)

'Free Radicals',
ARTNEWS PROJECTS, Berlin (group)

'Objects of Value',
MIAMI ART MUSEUM (group)

2009
'Under Lime',
TEMPORÄRE KUNSTHALLE, Berlin (solo)

'Black Out' (with Superflex),
KUNSTHALLEN BRANDTS, Odense, Denmark (solo)

'The Long Ton',
NEUGERRIEMSCHNEIDER, Berlin (solo)

'Inverted Retrograde Theme, USA (House for a Song Bird)',
BASS MUSEUM OF ART, Miami (solo)

'Thereherethenthere (La Source)',
PARC SAINT LÉGER CENTRE D'ART CONTEMPORAIN, Pougues-
les-Eaux, France, traveled to MUSÉE D'ART CONTEMPORAIN DU
VAL-DE-MARNE, Vitry-sur-Seine, France (solo)

'Red White Blue',
CASEY KAPLAN, New York (solo)

'The Space of the Work and the Place of the Object',
SCULPTURE CENTER, New York (group)

4th TATE TRIENNIAL, London (group)

'The Quick and the Dead',
WALKER ART CENTER, Minneapolis (group)

'Radical Nature: Art and Architecture for a Changing Planet
1969-2009',
BARBICAN ART GALLERY, London (group)

53rd VENICE BIENNALE (group)

'Capturing Time',
KADIST ART FOUNDATION, Paris (group)

'Free as Air and Water',
THE COOPER UNION, New York (group)

2009
Viliani, Andrea, 'The Exotic', <u>Kaleidoscope</u>, January-February

Cotton, Michelle, 'Close-Up', <u>Frieze</u>, no. 120, January-February

Starling, Simon, 'A Concerted Overview', <u>Kaleidoscope</u>, March-
April

Smee, Sebastian, 'A very laborious production', <u>Boston Sunday
Globe</u>, 15 March

Gabler, Jay, '"The Quick and the Dead" at the Walker: A Beautiful
Madhouse', <u>Twin Cities Daily Planet</u>, 25 April

Pil and Galia Kollectiv, 'Altermodern: Tate Triennial 2009, London',
<u>Artpapers</u>, May-June

Yablonsky, Linda, 'You Had to Be There', <u>ArtNews</u>, June

Campbell-Johnston, Rachel, 'Radical Nature at the Barbican',
<u>Times</u>, 16 June

Kennedy, Randy, 'Curious (New York) Natives Greet a Canoe From
Afar', <u>New York Times</u>, 29 July

Beasley, Stephen, 'Radical Nature', <u>Frieze</u>, no. 126

'InBerkshires Notes: Mass MoCA film', <u>The Advocate</u>, 22 October

Jackson, Matthew Jesse, 'The Quick and the Dead', <u>Artforum</u>,
November

Gopnik, Blake, 'Head north and follow the signs of contemporary
times', <u>Washington Post</u>, 22 November

West, Richard: 'Autoxylopyrocycloboros', <u>Source</u>, no. 58

Jacobson, Alex, 'Boston: Simon Starling', <u>Map</u>, no. 19

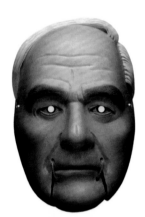

2009 (cont.)
'Space as Medium',
MIAMI ART MUSEUM (group)

2010
'Red Rivers',
KAMEL MENNOUR, Paris (solo)

'Project for a Masquerade (Hiroshima): The Mirror Room',
THE MODERN INSTITUTE/TOBY WEBSTER LTD, Glasgow (solo)

'Recent History',
CAC MÁLAGA, Spain, traveled to TATE ST IVES, England (solo)

'Fall Out',
MALMÖ KONSTHALL, Sweden, and GL. HOLTEGAARD, Holte,
Denmark (group)

'Les Lendemains d'Hier',
MUSÉE D'ART CONTEMPORAIN DE MONTRÉAL (group)

'A Place Out of History',
MUSEO TAMAYO ARTE CONTEMPORANEO, Mexico City (group)

'Never the Same River (Possible Futures, Probable Pasts)'
(organized by Simon Starling),
CAMDEN ARTS CENTRE, London (group)

2010
Saunders, Wade, and Annet Rochette, 'Simon Starling Making
Connections', <u>Art in America</u>, February

Jones, Jonathan, 'Simon Starling: Recent History', <u>Guardian</u>,
23 February

Bedford, Christopher, 'New Images of the Old Man', <u>Art in
America</u>, October

'Best of 2010: The Artists' Artists', <u>Artforum</u>, December

Starling, Simon: 'Micheal Stevenson: On How Things Behave',
<u>Artforum</u>, December

2011
'F as in Foglia',
GALLERIA FRANCO NOERO, Turin (solo)

'Project for a Masquerade (Hiroshima)',
HIROSHIMA CITY MUSEUM OF CONTEMPORARY ART (solo)

'Simon Starling',
KUNSTHAL CHARLOTTENBORG, Copenhagen (solo)

'The Inaccessible Poem',
FONDAZIONE MERZ, Turin (solo)

'E. G.' (with Superflex),
KUNSTHAUS GRAZ, Austria (solo)

'Ostalgia',
NEW MUSEUM OF CONTEMPORARY ART, New York (group)

'Carlo Mollino: Maniera Moderna',
HAUS DER KUNST, Munich (group)

'Found in Translation Chapter L',
CASINO LUXEMBOURG (group)

2011
Degen, Natasha, 'Simon Starling', <u>Frieze</u>, no. 137, March

Gavin, Francesca, 'Never The Same River (Possible Futures,
Probable Pasts)', <u>Dazed & Confused</u>, no. 196, April

Starling, Simon, 'A Nuclear Masquerade', <u>Tate etc</u>., no. 21

Starling, Simon, 'Project for a Masquerade (Hiroshima): From
Hard Graft to Happy Accident', <u>Texte Zur Kunst</u>, no. 82, June

Gronlund, Melissa, 'Simon Starling', <u>Catalogue</u>, no. 6

Doubal, Rosalie, 'Visual Art Reviews', <u>The List</u>, 25 August

Gambari, Olga, 'Simon Starling', <u>Flash Art</u>, no. 298,
December-January

Daldanise, Nicoletta, 'Le libere associazioni di Simon Starling',
<u>Arte Critica</u>, no. 69, December-February

2012
KUNSTHALLE MOLOUSE, France (solo)

CASEY KAPLAN, New York (solo)

NEUGERRIEMSCHNEIDER, Berlin (solo)

'Plus de croissance: un capitalisme idéal',
CENTRE D'ART CONTEMPORAIN DE FERME DU BUISSON,
France (group)

'Camera Work',
ADAM ART GALLERY at VICTORIA UNIVERSITY, Wellington,
New Zealand (group)

'When Attitudes Became Form, Become Attitudes',
CCA WATTIS INSTITUTE FOR CONTEMPORARY ARTS,
San Francisco (group)

BIBLIOGRAPHY

MONOGRAPHS, EXHIBITION CATALOGUES AND SURVEYS

Ardenne, Paul, and Christine Macel, Micropolitique, Le Magasin, Grenoble, France, 2000

Backstein, Joseph, Daniel Birnbaum, Iara Boubnova, Nicolas Bourriaud, Fulya Erdemci, Gunnar B. Kvaran, Rosa Martínez and Hans Ulrich Obrist, Footnotes on Geopolitics, Market and Amnesia, Moscow Biennale, 2007

Basualdo, Carlos, and Monica Amor, Mexico: Expected/Unexpected, the Isabel and Agustin Coppel Collection, La Maison Rouge, Paris, and Museum of Contemporary Art, San Diego, 2008

Berg, Stephan, Martin Engler, Eveline Bernasconi, et al., Made in Germany: Young Contemporary Art from Germany, Haje Cantz, Ostfildern, Germany, 2007

Bier, Rolf, After You Made Me Soft Again, Galerie Barz, Hannover, Germany, 1996

Birnbaum, Daniel, Making Worlds, Venice Biennale and Marsilio, Venice, 2009

Bonacossa, Ilaria, Max Andrews and Mariana Cánepa Luna, Greenwashing: Environment. Perils, Promises and Perplexities, The Bookmakers, Berlin, and Fondazione Sandretto Re Rebaudengo, Turin, 2008

Bonami, Francesco, Ole Bouman, Maria Hlavajová and Kathrin Rhomberg, Manifesta 3, Moderna Galerija, Ljubljana, 2000

Bonami, Francesco, Dreams and Conflicts: The Dictatorship of the Viewer, Venice Biennale and Skira, Milan, 2003

Bonami, Francesco, Carol Becker, Alain de Boton, Lucy Lippard, Susan Sontag, Nancy Spector and Robert Fitzpatrick, Universal Experience: Art, Life, And The Tourist's Eye, D.A.P., New York, and Museum of Contemporary Art, Chicago, 2005

Bonami, Francesco (ed.), Bidibidobidiboo: Works from Collezione Sandretto Re Rebaudengo, Skira, Milan, 2005

Bourriaud, Nicolas, Altermodern, Tate, London, 2009

Bradley, Fiona, Scotland & Venice 2003, 2005, 2007, Beith Printing, Glasgow, 2008

Bradley, Will, Project for a Modern Museum, Moderna Museet, Stockholm, 1998-99

Carey-Thomas, Lizzie, Martin Myrone, and Robert Tant, Turner Prize 2005, Tate, London, 2005

Cattelan, Maurizio, Bettina Funcke, Massimiliano Gioni and Ali Subotnick, Charley 01, Les Presses Du Réel, Lyon, 2002

Christov-Bakargiev, Carolyn, I Moderni/The Moderns, Castello di Rivoli, Turin, 2002

Coles, Pippa, Matthew Higgs and Jacqui Poncelet, The British Art Show 5, Hayward Gallery, London, 2000

Delany, Max, Morning Star Evening Star, 200 Gertrude Street & Museum of Modern Art at Heide, Melbourne, 1998

Demos, T. J., Mark Godfrey, et al., Vitamin PH: New Perspectives in Photography, Phaidon, London, 2006

Demos, T. J., Francesco Manacorda and Jonathan Porritt, Radical Nature: Art and Architecture for a Changing Planet 1969-2009, Barbican Art Gallery, London, and Walther König, Cologne, 2009

Denis-Morel, Barbara, Écosystèmes: Biodiversité et Art Contemporain, Espace Fernand Pouillon de l'Université de Provence, 2010

Dennison, Lisa, Nancy Spector and Joan Young, Moving Pictures, Guggenheim Museum Bilbao, 2003

Dercon, Chris (ed.), Carlo Mollino: Maniera Moderna, Haus der Kunst, Munich, and Walther König, Cologne, 2011

Diserens, Corinne, Yehuda Safran and Letizia Ragaglia, Peripheral Vision and Collective Body, Museion, Bozen, Italy, 2008

Doherty, Willie, Caroline Russell and Stuart Morgan, BT New Contemporaries 1993-94, Cornerhouse Gallery, Manchester, 1993

Eccher, Danilo, Immagini, Forme e Natura Delle Alpi, Fondazione Gruppo Credito Valtellinese, Sondrio, Italy, 2007

Ellegood, Anne, Sally O'Reilly, et al., Vitamin 3-D: New Perspectives in Sculpture and Installation, Phaidon, London, 2009

Esche, Charles, Sugar Hiccup, Tramway, Glasgow, 1997

Faivovich, Guillermo, Nicolas Goldberg, Daniel Birnbaum and Simon Starling, The Campo del Cielo Meteorites, Hatje Cantz, Ostfildern, 2011

Gallagher, Ann, and Katerina Gregos, Artificie, Deste Foundation, Athens, 2000

Goncharov, Kathleen, The Forest: Politics, Poetics, and Practice, Duke University, Durham, North Carolina, 2005

Grosenick, Uta, and Burkhard Riemschneider, Art Now: 137 Artists at the Rise of The New Millennium, Taschen, Cologne 2002

Grosenick, Uta, Art Now Vol. 2, Taschen, Cologne, 2005

Heartney, Eleanor, Art & Today, Phaidon, London, 2008

Hug, Alfons, Free Territory, São Paulo Biennial, 2004

Keller, Christoph, Circles, Zentrum für Kunst und Medientechnologie, Karlsruhe, Germany, 2001

Klein, Bettina (ed.), Objet à part, Galerie, Centre d'art Contemporain de Noisy-le-Sec, France, 2006

Kliege, Melitta, Wenn Handlungen Form werden: Ein neuer Realismus in der Kunst seit den fünfziger Jahren, Verlag für moderne Kunst, Berlin, 2008

Koh, Germaine (ed.), Prototype: Contemporary Art From Joe Friday's Collection, Carleton University Art Gallery, Ottawa, 2006

König, Kaspar, and Julian Heynen, Ambiance: Des Deux Cotes Du Rhin, K21 Kunstsammlung, Düsseldorf, and Ludwig Museum, Cologne, 2005

Joachimides, Christos M. (ed.), Outlook: International Art Exhibition, Hellenic Culture Organization, Athens, 2003

Johnstone, Lesley, Yesterday's Tomorrows, Musée d'Art Contemporain de Montréal, 2010

Lepdor, Catherine, Caroline Nicod, Rob Tufnell and Francis McKee, Open Country: Contemporary Scottish Artists, Edipresse Imprimeries Reunies and Musée Cantonal des Beaux-Arts de Lausanne, 2001

Lind, Maria, What If: Art on the Verge, Architecture and Design, Moderna Museet, Stockholm, 2000

Lind, Maria, and John Calcutt, Here+Now: Scottish Art 1990-2001, Dundee Contemporary Arts, Scotland, 2001

Loock, Ulrich, and Charles Esche, Glasgow, Kunsthalle Bern, 1997

Lowndes, Sarah, Social Sculpture: The Rise of the Glasgow Art Scene, Luath, Edinburgh, 2007

MaCabe, Eamonn, Artists & Their Studios, Angela Patchell Books, London, 2008

Manacorda, Francesco, Lydia Yee and Tom McCarthy, Encyclopedia of Terrestrial Life: Martian Museum of Terrestrial Art, Barbican Art Gallery, London, 2008

Maraniello, Gianfranco, Drive: Cars in Contemporary Art, Damiani, Bologna, 2005

Mari, Bartomeu, João Fernandes, Vicente Todolí and Miguel Von Haffe Perez, Squatters, Serralves Foundation, Porto, and Witte de With, Rotterdam, 2001

Martínez Goikoetzea, Enrique Gravity: Colección Ernesto Esposito, Artium, Vitoria-Gasteiz, Spain, 2008

Millar, Jeremy (ed.), Institute of Cultural Anxiety, Institute of Contemporary Arts, London, 1994

Morgan, Stuart, Matter and Fact, Collection Gallery, London, 1993

Nedkova, Iliyana, Spacecraft, Bluecoat Design Centre, Liverpool, 2000

Obrist, Hans Ulrich, and Stéphanie Moisdon, The History of a Decade that has Not yet Been Named, Lyon Biennial and JRP Ringier, Zurich, 2007

Park, Manu, A Tale of Two Cities, Busan Biennial, 2006

Perica, Blazenka, Karin von Maur, Robert Fleck, Franz Pomassi, Simon Starling, Hermann Nitsch, Daniel Libeskind, Otto Breicha, Christian Meyer and Ferdinand Zehentreiter, The Visions of Arnold Schönberg, Hatje Cantz, Ostfildern, Germany, 2002

Pietromarchi, Bartolomeo, The (Un) Common Place: Art, Public Space and Urban Aesthetics in Europe, Actar, Barcelona, 2005

Pontbriand, Chantal (ed.), Muations: Perspectives on Photography, Paris Photo and Steidl, Göttingen, Germany, 2011

Price, Elizabeth, Small Gold Medal, Hackney Museum and Book Works, London, 2001

Qasimi, Hoor Al, Jack Persekian, Mohammed Kazem, Eva Scharrer and Jonathan Watkins, Still Life: Art, Ecology and the Politics of Change, Sharjah Biennale, 2007

Richardson, Craig, Scottish Art since 1960: Historical Reflections and Contemporary Overviews, Ashgate, Farnham, England, 2011

Rückert, Genoveva, Christa Schneebauer, Martin Sturm, and Rainer Zendron, Der Globale Komplex: Continental Drift, Grazer Kunstverein and OK Centrum für Gegenwartskunst, Graz, Austria, 2002

Schor, Gabriele (ed.), Held Together with Water: Art from the Sammlung Verbund, Hatje Cantz, Ostfildern, Germany, 2007

Sigg, Pablo, Microhistorias y Macromundos, Museuo Tamayo and Instituto Nacional de Bellas Artes y Literatura Reforma y Campo Marte, Mexico City, 2010

Sinclair, Ross, and Radek Váňa, Maikäfer Flieg, Bunker Köln-Ehrenfeld, Cologne, 1995

Smith, Nick, Invisible Cities, Fruitmarket Gallery, Edinburgh, 1992

Spector, Nancy, Michael Rush, James Rondeau and Gary Sangster, Imperfect Innocence: Debra and Dennis Scholl Collection, Contemporary Museum, Baltimore, and Palm Beach Institute of Contemporary Art, 2003

Starling, Simon, An Eichbaum Pils Beer Can..., The Showroom, London, 1995

Starling, Simon, and Francis McKee, Blue Boat Black, Transmission Gallery, Glasgow, 1997

Starling, Simon, and Maria Lind, Simon Starling, Moderna Museet, Stockholm, 1998

Starling, Simon, and Hinrich Sachs, Le Jardin Suspendu, The Modern Institute, Glasgow, 1998

Starling, Simon, and Charles Esche, Simon Starling: Undomesticating Modernism, Galerie Fur ZeitgenOssische Kunst, Leipzig, Germany, 1999

Starling, Simon, and Juliana Engberg, Simon Starling: Front to Back, Camden Arts Centre, London, 2000

Starling, Simon, East Door (North), Harris Museum and Art Gallery, Preston, England, 2001

Starling, Simon, and Ami Barack, Simon Starling CMYK/RGB, FRAC Languedoc Roussillon, Montpellier, France, 2001

Starling, Simon, Matthias Herrmann and Jeremy Millar, Inverted Retrograde Theme, Secession, Vienna, 2001

Starling, Simon, and Rob Tufnell, Poul Henningsen and Simon Starling, Cooper Gallery, University of Dundee, Scotland, 2001

Starling, Simon, and Katrina Brown, Simon Starling: Djungel, Dundee Contemporary Art, 2002

Starling, Simon, and Rob Tufnell, Flaga (1972-2000), Galleria Franco Noero, Turin, 2002

Starling, Simon, and Danilo Eccher, Simon Starling, Museum of Contemporary Art, Rome, 2003

Starling, Simon, and Jochen Volz, Simon Starling: Kakteenhaus, Portikus Frankfurt, 2003

Starling, Simon, Five-Man Pedersen (Ikast-Streize), Socle du Monde, Kunstmuseum and Ikast Kedelhal, Herning, Denmark, 2004

Starling, Simon, Laurence Gateau, Gail Kirkpatrick and Francesco Manacorda, Simon Starling, Villa Arson, Nice, France, and Städtische Ausstellungshalle am Hawerkamp, Münster, Germany, 2004

Starling, Simon, Fulvio Ferrari and Napoleone Ferrari, Simon Starling [24 hr. Tangenziale], Galleria Franco Noero, Turin, 2006

Starling, Simon, Daniel Kurjakovic, Reid Shier and Philipp Kaiser, Simon Starling: Cuttings, Hatje Cantz, Ostfildern, Germany, 2006

Starling, Simon, and Nathalie Zonnenberg, Drop Sculpture (Atlas), Rijksmuseum, Amsterdam, 2007

Starling, Simon, and Bruno Haas, Simon Starling: Nachbau I & II, Städtischen Kunstmuseum zum Museum Folkwang, Essen, 2007

Starling, Simon, and Julie David (ed.), Autoxylopyrocycloboros, MAC/VAL, Vitry-sure-Seine, France, 2007

Starling, Simon, Bärbel Vischer, Ulriche Meyer Stump and Hans Dunser, Simon Starling: Plant Room, Kunstraum Dornbirn, Austria, 2008

Starling, Simon, Gregory Burke, Mark Godfrey, Reid Shier and Sarah Stanners, Simon Starling: Cuttings, Power Plant, Toronto, 2008

Starling, Simon, Susan Cross and Anthony Lee, Simon Starling: The Nanjing Particles, Massachusetts Museum of Contemporary Art, North Adams, 2009

Starling, Simon, Three Birds, Seven Stories, Interpolations and Bifurcations, Galleria Franco Noero, Turin, 2009

Starling, Simon, Angela Rosenberg, Julian Heynen and Dominic Eichler, Simon Starling: Under Lime, Temporäre Kunsthalle, Berlin, and Walter König, Cologne, 2009

Starling, Simon, Frank Lamy and Michel Gauthier, Simon Starling: Thereherethenthere, MAC/VAL, Vitry-sure-Seine, France, 2010

Starling, Simon, and Nathalie Zonnenberg, Simon Starling: Drop Sculpture Atlas, Yale University, New Haven, 2010

Starling, Simon, Montse Badia and Laura A. E. Suffield (ed.), Simon Starling: Recent History, CAC Malaga, Spain, 2011

Starling, Simon, Mariano Boggia, Maria Centonze, Guillermo Faivovich, Nicolás Goldberg, Hernán Pruden and Jacob Lillemose, The Inaccessible Poem, Fondazione Merz, Turin, 2011

Storer, Russell, Mathew Jones & Simon Starling, Museum of Modern Art, Sydney, 2002

Terraioli, Valerio (ed.), 2000 and Beyond: Contemporary Tendencies (Art of the Twentieth Century), Skira, Milan, 2010

Titz, Susanne, and Toby Webster (eds.), Strange I've Seen that Face Before, Museum Abteiberg, Mönchengladbach, Germany, 2006

Van Oldenborgh, Lennaart, and Thomas Peutz, Reconstructions, Smart Project Space, Amsterdam, 1998

Vanderlinden, Barbara (ed.), 1st Brussels Biennial for Contemporary Art, Walther König, Cologne, 2008

Volpato, Elena, Cronostasi: Filmic Time and Photographic Time, Hopefulmonster, Turin, 2009

Webster, Toby, Will Bradley and Henriette Bretton-Meyer, My Head is on Fire But My Heart is Full of Love, Charlottenburg Museum, Copenhagen, 2002

Young, Joan, Marcella Beccaria, Rosa Martínez, Francis McKee, Molly Nesbit, Hans Ulrich Obrist, and Jan Tumlir, Hugo Boss Prize 2004, Solomon R. Guggenheim Museum, New York, and Hatje Cantz, Ostfildern, Germany, 2004

ARTICLES AND REVIEWS

'Art Reviews: Simon Starling', The New Yorker, 18 March 2002

Arms, Inke, 'Individuelle Systeme', Kunstforum, no. 166, August-October 2003

Asthoff, Jens, 'Simon Starling', Kunstmagazin, no. 4, 2001

Asthoff, Jens, 'Simon Starling im Kunstverein', Kunstbulletin, October 2001

Beasley, Stephen, 'Radical Nature at the Barbican', Frieze, no. 126, 2009

Bedford, Christopher, 'New Images of the Old Man', Art in America, October 2010

'Best of 2010: The Artists' Artists', Artforum, December 2010

Birnbaum, Daniel, 'Transporting Visions: Daniel Birnbaum on the Art of Simon Starling', Artforum, February 2004

Birnbaum, Daniel, 'Simon Starling: Museum für Gegenwartskunst', Artforum, May 2005

Birnbaum, Daniel , 'Simon Starling at the Power Plant', Artforum, January 2008

Bonaspetti, Edoardo, 'Simon Starling', Mousse, no. 13, March 2008

Brevi, Manuela, 'Arte eventi', Arte, June 2003

Burton, Johanna, 'Simon Starling', Time Out New York, 21-28 March 2002

Campbell-Johnston, Rachel, 'Radical Nature at the Barbican', Times, 16 June 2009

Cotton, Michelle, 'Close-Up', Frieze, no. 120, January-February 2009

Currah, Mark, 'Showroom', Time Out London, 7 July 1995

Daldanise, Nicoletta, 'Le libere associazioni di Simon Starling', Arte Critica, no. 69, December 2011-February 2012

Danicke, Sandra, 'Cereus, Kaktus aus Spanien', Neue Zurcher Zeitung, 4 October 2002

Degen, Natasha, 'Simon Starling', Frieze, no. 137, March 2011

Doubal, Rosalie, 'Visual Art Reviews', The List, 25 August 2011

Downey, Anthony, 'Simon Starling: Sustainable Photography', Next Level, no. 12, 2007

Drake, Cathyrn, 'Simon Starling: Galleria Franco Noero', Artforum, October 2008

Duffy, Damien: 'CAM', Circa, no. 115, 2006

Dunn, Melissa, 'The Venice Biennale: Slouching Toward Utopia', Flash Art, no. 231, July-September 2003

Ebner, Jorn, 'Briten landen in Berlin', Frankfurter Allgemeine Zeitung, 5 May 2001

Ehlers, Fiona, 'Sieben Rhododendren reisen nach Hause', Kulturspiegel, October 2003

Eichler, Dominic, 'The Work in this space is a response to the existing conditions and/or work previously shown within the space', Frieze, no. 54, September-October 2000

Enright, Robert, 'Artist a master of "now you see it, now you don't"', The Globe and Mail, 1 March 2008

Esche, Charles, 'Undomesticating Modernism', Afterall, October 2000

Feldman, Melissa, 'Matters of Fact: New Conceptualism in Scotland', Third Text, no. 37, winter 1996-97

Fenton, Ben, 'Bottom Painter Makes Turner Prize Shortlist', Daily Telegraph, 3 June 2005

Fox, Dan, '50th Venice Biennale', Frieze, no. 77, September 2003

Gabler, Jay, '"The Quick and the Dead" at the Walker: A Beautiful Madhouse', Twin Cities Daily Planet, 25 April 2009

Gale, Iain, 'The Resurrection Man', Sunday Herald, 30 June 2002

Gambari, Olga, 'Simon Starling', Flash Art, no. 298, December 2011-January 2012

Gardner, Belinda Grace, 'Die Tiere beten jeden Tag zum lieben Tofu', Die Welt, 1 July 2002

Gavin, Francesca, 'Never The Same River (Possible Futures, Probable Pasts)', Dazed & Confused, no. 196, April 2011

Gebbers, Anna-Catharina, 'Zusammenhänge herstallen', Artist Kunstmagazin, March 2002

Gioni, Massimiliano, 'New York Cut Up', Flash Art, no. 224, May-June 2002

Gioni, Massimiliano, 'Simon Starling: The Bricoleur', Carnet, June 2004

Godfrey, Mark, 'Image Structures: Photography and Sculpture', Artforum, February 2005

Godfrey, Mark, 'Simon Starling at Kunstmuseum Basel Museum für Gegenwaartskunst, Switzerland', Frieze, no. 94, October 2005

Gopnik, Blake, 'Head north and follow the signs of contemporary times', Washington Post, 22 November 2009

Gordon, Margery, 'Bulking Up', Art & Auction, November 2005

Griese, Horst; 'Umwege Machen das Leben Interessanter', Weser Kurier, 7 December 2000

Gronlund, Melissa, 'Simon Starling', Catalogue, no. 6, 2011

Haines, Bruce, '50th Venice Biennale', Frieze, no. 77, September 2003

Hedberg, Hans, 'Simon Starling', NU The Nordic Art Review, May 2000

Higgins, Charlotte, 'It's a shed, it's collapsible, it floats, and (with the help from a bike), it's the winner', Guardian, 6 December 2005

Hill, Peter: 'Double Vision', Sydney Morning Herald, 25 October 2002

Hohmann, Silke, 'Die Überlegenheit des Unwegs', Frankfurter Rundschau, 14 September 2002

Hughes, Henry, 'Manifesta 3', Tema Celeste, March 2000

Hunt, Ian, 'Simon Starling at the Showroom, London', Frieze, no. 24, September-October 1995

'InBerkshires Notes: Mass MoCA film', The Advocate, 22 October 2009

Jackson, Matthew Jesse, 'The Quick and the Dead', Artforum, November 2009

Jacobson, Alex, 'Boston: Simon Starling', Map, no. 19, 2009

Jaio, Miren, 'Simon Starling at the Showroom, London', Lapiz, no. 115, 1995

Jansen, Gregor, 'Münsterland: Skulptur Biennale', Kunstbulletin, September 2003

Jeffrey, Moira, 'Simon Starling: He's Such a Material Guy', Herald, 28 June 2002

Jeffrey, Moria, 'A Shed-Load of Success', Herald, 18 October 2005

Johnson, Ken, 'Aesthetic Withdrawal in the Quest for Ideas', New York Times, 23 January 2009

Jones, Dafydd, 'Turner Prize', Art Review, February 2006

Jones, Jonathan, 'Simon Starling: Recent History', Guardian, 23 February 2011

Jury, Louise, 'Just an Old Nike? Or is it a Poetic Narrative? Either Way, Starling Flies to Turner Prize', Independent, 6 December 2005

Keil, Frank: 'Schwimmtofu an Schweineporträt', Frankfurter Rundschau, 7 August 2002

Kennedy, Randy, 'Curious (New York) Natives Greet a Canoe From Afar', New York Times, 29 July 2009

Kimmelman, Michael, 'Art in Review: Simon Starling', New York Times, 12 March 2004

Klaas, Nicole, and Heiko Klaas, 'West-östliche Vereinigung', Kieler Nachrichten, 6 June 2002

Kley, Elisabeth, 'Goodbye Fourteenth Street: A Review', Artnews, May 2005

Kowa, Gunter, 'Der wundersame Fischzug mit der Museumsvitrine', Mitteldeutsche Zeitung, 4 June 1999

Labille, Sandra, 'Turner Prize Surprise: Painter is Favorite', Guardian, 3 June 2005

Leffingwell, Edward, 'Simon Starling at Casey Kaplan', Art in America, July 2002

'Leipziger Premiere furs Palermo-Stipendium', Leipziger Volkszeitung, 1 November 1999

Levin, Kim, 'Voice Choices: Simon Starling', Village Voice, 1-3 March 2002

Li, Pi, 'Flash Art News: Prizes', Flash Art, no. 246, January-February 2006

'Living in a material world', The Courier and Advertiser, 28 June 2002

Lockett, Alex, 'Alex Lockett examines the process of transformation and reconstruction in the work of Brian Jungen and Simon Starling', Miser and Now, no. 10, August 2007

Lorch, Catrin, 'La Biennale di Venezia', Kunstbulletin, August 2003

Low, Lenny Ann, 'Matthew Jones/Simon Starling', Sydney Morning Herald, 17 October

Lubbock, Tom, 'Turner Prize: The Good, The Dull, and The Bland', Independent, 18 October 2005

'Making-of: Simon Starling Shedboatshed (Moblie Architecture No 2), 2005', Monopol, June 2008

Madoff, Steven Henry, 'One for All', Artforum, May 2003

Mahoney, Elisabeth, 'Into Dundee's Arty Jungle: Simon Starling', Guardian, 11 July 2002

Mahoney, Elisabeth, 'Simon Starling: Djungel', Modern Painters, Autumn 2002

Mahoney, Elisabeth, 'Richard Long/Simon Starling', Art Monthly, November 2008

Manacorda, Francesco, 'Entropology', Flash Art, no. 241, March-April 2005

Mansfield, Susan, 'A Wing and a Prayer', The Scotsman, 22 June 2002

Meredith, Michael, 'Simon Starling', Artforum, May 2002

Meyric Hughes, Henry, 'Manifesta 3', Tema Celeste, October 2000

McKee, Francis, 'Chicken or Egg', Frieze, no. 56, January-February 2001

McLaughlin, Bryne, 'Simon Starling in Review: 21st-Century Colonialism', Canadian Art, 27 March 2008

McLaren, Duncan, 'Simon Starling', Art Review, January 2003

Menin, Samuele and Valentina Sansone, 'Sculpture Forever', Flash Art, no. 230, May-June 2003

Monaghan, Helen, 'Labours of Love', The List, 20 June-4 July 2002

Morgan, Stuart, 'The future's not what it used to be', Erkz~, March-April 1995

Mullholland, Neil, 'If I Ruled the World', Frieze, no. 54, September 2000

Myers, Julian, 'Amateurs', Frieze, no. 117, 2008

Nicolin, Paola, 'Simon Starling', Abitare, June 2004

Palmer, Roger, 'There is no museum in the exhibition at present', Alba, July 1991

Paulli, Luca, 'A Project for a Space', Tema Celeste, March 2000

'Pick of the week: Art Djungel', Scotland on Sunday, 23 June 2002

Pil and Galia Kollectiv, 'Two Critics' Assessments: Altermodern: Tate Triennial 2009 London', Artpapers, May-June 2009

Prince, Mark, 'Southfork Ranch, Romania', Art Monthly, March 2003

'Provision', Modern Painters, March 2008

Rehberg, Vivian, 'Lyon Biennial', Frieze, no. 112, January-February 2008

Reust, Hans Rudolf, 'Simon Starling at Museum für Gegenwartskunst', Artforum, October 2005

Richardson, Craig, 'Zenomap', Contemporary, no. 51, 2003

Robecchi, Michele, 'Simon Starling', Contemporary, no. 85, 2006.

Römer, Stefan, 'Zusammenbiegen, was das Zeug halt', Texte zur Kunst, December 2002

Rosenberg, Angela, 'Simon Starling: Variations On A Theme', Flash Art, July-September 2001

Sandals, Leah, 'Avenue Questions & Artists: Henry Moore and More', Toronto National Post, 6 March 2008

Saunders, Wade, and Annet Rochette, 'Simon Starling Making Connections', Art in America, February 2010

Schultz, Deborah, 'The Office of Misplaced Events (Temporary Annex)', Art Monthly, January 2000

Schwabsky, Barry: 'Simon Starling', Map, no. 3, October 2005

Selvaratnam, Troy, 'The Starling Variations', Parkett, no. 67, 2003

Sharp, Jasper, 'Man vs. Nature', Art Review, December 2005

Shepeard, Paul, 'Edgeless, Modeless', Afterall, no. 1, 1999

'Simon Starling', Art in America, Summer 2008

Sinclair, Ross, 'Blue Boat Black', Frieze, no. 38, January-February 1997

Smee, Sebastian, 'A Very Laborious Production', Boston Sunday Globe, 15 March 2009

Smith, Roberta, 'The Natural World, in Peril and in Its Full Glory', New York Times, 13 September 2006

Sommer, Tim, 'Vieldeutiges Spiel um Erinnerungen', Leipziger Volkszeitung, 4 August 1999

Spiegler, Marc, 'Five Theories on Why the Art Market Can't Crash', New York Magazine, 3 April 2006

Stange, Raimar, 'Public Relations', Kunstbulletin, May 2001

Stange, Raimar, 'The Dialectrician', Spike Art, no. 7, 2006

Starling, Simon, 'Simon Starling', Domus, July-August 2007

Starling, Simon, 'Replication: Some Thoughts, Some Works', Tate Papers, Autumn 2007

Starling, Simon, 'A Concerted Overview', Kaleidoscope, March-April 2009

Starling, Simon: 'Micheal Stevenson: On How Things Behave', Artforum, December 2010

Starling, Simon, 'A Nuclear Masquerade', Tate etc., no. 21, 2011

Starling, Simon, 'Project for a Masquerade (Hiroshima): From Hard Graft to Happy Accident', Texte Zur Kunst, no. 82, June 2011

Stern, Steven, 'Ecotopia: The Second ICP Triennial', Time Out New York, 26 October-1 November 2006

Stewart, Claire, 'Simon Starling', Press and Journal, June 22, 2002

Sutherland, Giles, 'A New Leaf from an Old Book', Sunday Herald, 30 June 2002

Tazaki, Anni L., 'Ready-Made Made-Ready', Flyer, no. 5, 1999

'The Approval Matrix', New York Magazine, 31 October 2005

'The Nanjing Particles', Metroland, 11-17 December 2008

Tufnell, Rob, 'Made in Scotland', Tema Celeste, January-February 2003

Vanderbilt, Tom, 'A Thousand Words: Simon Starling', Artforum, May 2003

Van Gelder, Lawrence, 'Arts, Briefly: Turner Prize Finalists', New York Times, 19 October 2005

Van Gelder, Lawrence, 'Arts Briefly: Simon Starling Wins Turner Prize', New York Times, 6 December 2005

Vegh, Stephanie, 'Toronto: Simon Starling', Map, no. 114, 2008

Vetrocq, Marcia, 'Venice Biennale: Every Idea But One', Art in America, September

Viliani, Andrea, 'The Exotic', Kaleidoscope, no. 1, 2009

Vogel, Carol, 'Inside Art: Boss Prize Finalists', New York Times, 6 February 2004

Wainwright, Jean, 'Richard Long and Simon Starling', Art World, December 2008-January 2009

Weinrautner, Ina, 'Werke mit doppeltem Boden', Handelsblatt, 3 May 2001

West, Richard: 'Autoxylopyrocycloboros', Source, no. 58, 2009

Yablonsky, Linda, 'You Had to Be There', ArtNews, June 2009

PHAIDON PRESS LTD.
REGENT'S WHARF
ALL SAINTS STREET
LONDON N1 9PA

PHAIDON PRESS INC.
180 VARICK STREET
NEW YORK, NY 10014

WWW.PHAIDON.COM

First published 2012
© 2012 Phaidon Press Limited
All works of Simon Starling
are © Simon Starling

ISBN:
978-0-7148-6419-8

A CIP catalogue record of
this book is available from
the British Library.

Designed by Melanie Mues,
Mues Design, London

Printed in Hong Kong

PUBLISHER'S
ACKNOWLEDGEMENTS

Special thanks to Maja
McLaughlin, Tim Neuger,
Burkhardt Riemschneider, the
Henry Moore Foundation and
the Hiroshima Museum of Art.

Photographers: Kasper Akhøj
Pedersen, Adolf Bereute,
Martin P. Bühler, Tommaso
Buzzi, Ruth Clark, Marc
Domage, Andrew Dunkley,
Erma Estiwck, Arthur
Evans, Wolfgang Günzel,
José Luis Gutiérrez, Jeremy
Hardman-Jones, Keith Hunter,
Kassabian, Marcus Leith,
Tommaso Mattina, Aurélien
Mole, Keiichi Moto, Steve
Payne, Paolo Pellion, Tue
Schiørring, Simon Starling,
Anders Sune Berg, Cary
Whittier, Thomas Wrede,
Jens Ziehe.

ARTIST'S ACKNOWLEDGEMENTS

I would like to thank the
editors of this publication,
Michele Robecchi and Craig
Garrett, and the production
controller, Vanessa Todd.

Furthermore, I would like
to thank Henriette Bretton-
Meyer, Alison Starling,
Tim Neuger, Burkhardt
Riemschneider, Toby Webster,
Andrew Hamilton, Franco
Noero, Pierpaolo Falone,
Casey Kaplan, Uffe Holm, Elisa
Marchini, Thomas Boström
and the authors.

CONTEMPORARY ARTISTS:

Contemporary Artists is a series of authoritative and extensively illustrated studies of today's most important artists. Each title offers a comprehensive survey of an individual artist's work and a range of art writing contributed by an international spectrum of authors, all leading figures in their fields, from art history and criticism to philosophy, cultural theory and fiction. Each study provides incisive analysis and multiple perspectives on contemporary art and its inspiration. These are essential source books for everyone concerned with art today.

MARINA ABRAMOVIĆ KRISTINE STILES, KLAUS BIESENBACH, CHRISSIE ILES / VITO ACCONCI FRAZER WARD, MARK C. TAYLOR, JENNIFER BLOOMER / AI WEIWEI KAREN SMITH, HANS ULRICH OBRIST, BERNARD FIBICHER / DOUG AITKEN DANIEL BIRNBAUM, AMANDA SHARP, JÖRG HEISER / PAWEŁ ALTHAMER ROMAN KURZMEYER, ADAM SZYMCZYK, SUZANNE COTTER / FRANCIS ALŸS RUSSELL FERGUSON, CUAUHTÉMOC MEDINA, JEAN FISHER / UTA BARTH PAMELA M. LEE, MATTHEW HIGGS, JEREMY GILBERT-ROLFE / CHRISTIAN BOLTANSKI DIDIER SEMIN, TAMAR GARB, DONALD KUSPIT / LOUISE BOURGEOIS ROBERT STORR, PAULO HERKENHOFF (WITH THYRZA GOODEVE), ALLAN SCHWARTZMAN / CAI GUO-QIANG DANA FRIIS-HANSEN, OCTAVIO ZAYA, TAKASHI SERIZAWA / MAURIZIO CATTELAN FRANCESCO BONAMI, NANCY SPECTOR, BARBARA VANDERLINDEN, MASSIMILIANO GIONI / VIJA CELMINS LANE RELYEA, ROBERT GOBER, BRIONY FER / RICHARD DEACON JON THOMPSON, PIER LUIGI TAZZI, PETER SCHJELDAHL, PENELOPE CURTIS / TACITA DEAN JEAN-CHRISTOPHE ROYOUX, MARINA WARNER, GERMAINE GREER / MARK DION LISA GRAZIOSE CORRIN, MIWON KWON, NORMAN BRYSON / PETER DOIG ADRIAN SEARLE, KITTY SCOTT, CATHERINE GRENIER / STAN DOUGLAS SCOTT WATSON, DIANA THATER, CAROL J. CLOVER / MARLENE DUMAS DOMINIC VAN DEN BOOGERD, BARBARA BLOOM, MARIUCCIA CASADIO, ILARIA BONACOSSA / JIMMIE DURHAM LAURA MULVEY, DIRK SNAUWAERT, MARK ALICE DURANT / OLAFUR ELIASSON MADELEINE GRYNSZTEJN, DANIEL BIRNBAUM, MICHAEL SPEAKS / PETER FISCHLI AND DAVID WEISS ROBERT FLECK, BEATE SÖNTGEN, ARTHUR C. DANTO / TOM FRIEDMAN BRUCE HAINLEY, DENNIS COOPER, ADRIAN SEARLE / ISA GENZKEN ALEX FARQUHARSON, DIEDRICH DIEDERICHSEN, SABINE BREITWIESER / ANTONY GORMLEY JOHN HUTCHINSON, SIR ERNST GOMBRICH, LELA B. NJATIN, W. J. T. MITCHELL DAN GRAHAM BIRGIT PELZER, MARK FRANCIS, BEATRIZ COLOMINA / PAUL GRAHAM ANDREW WILSON, GILLIAN WEARING, CAROL SQUIERS / HANS HAACKE WALTER GRASSKAMP, MOLLY NESBIT, JON BIRD / MONA HATOUM GUY BRETT, MICHAEL ARCHER, CATHERINE DE ZEGHER / THOMAS HIRSCHHORN BENJAMIN H. D. BUCHLOH, ALISON M. GINGERAS, CARLOS BASUALDO / JENNY HOLZER DAVID JOSELIT, JOAN SIMON, RENATA SALECL / RONI HORN LOUISE NERI, LYNNE COOKE, THIERRY DE DUVE / ILYA KABAKOV BORIS GROYS, DAVID A. ROSS, IWONA BLAZWICK / ALEX KATZ CARTER RATCLIFF, ROBERT STORR, IWONA BLAZWICK / ON KAWARA JONATHAN WATKINS, 'TRIBUTE', RENÉ DENIZOT / MIKE KELLEY JOHN C. WELCHMAN, ISABELLE GRAW, ANTHONY VIDLER / MARY KELLY MARGARET IVERSEN, DOUGLAS CRIMP, HOMI K. BHABHA / WILLIAM KENTRIDGE DAN CAMERON, CAROLYN CHRISTOV-BAKARGIEV, J. M. COETZEE / YAYOI KUSAMA LAURA HOPTMAN, AKIRA TATEHATA, UDO KULTERMANN / CHRISTIAN MARCLAY JENNIFER GONZALEZ, KIM GORDON, MATTHEW HIGGS / PAUL MCCARTHY RALPH RUGOFF, KRISTINE STILES, GIACINTO DI PIETRANTONIO / CILDO MEIRELES PAULO HERKENHOFF, GERARDO MOSQUERA, DAN CAMERON / LUCY ORTA ROBERTO PINTO, NICOLAS BOURRIAUD, MAIA DAMIANOVIC / JORGE PARDO CHRISTINE VÉGH, LANE RELYEA, CHRIS KRAUS / RAYMOND PETTIBON ROBERT STORR, DENNIS COOPER, ULRICH LOOCK RICHARD PRINCE ROSETTA BROOKS, JEFF RIAN, LUC SANTE / PIPILOTTI RIST PEGGY PHELAN, HANS ULRICH OBRIST, ELIZABETH BRONFEN / ANRI SALA MARK GODFREY, HANS ULRICH OBRIST, LIAM GILLICK / DORIS SALCEDO NANCY PRINCENTHAL, CARLOS BASUALDO, ANDREAS HUYSSEN / WILHELM SASNAL DOMINIC EICHLER, ANDRZEY PRZYWARA, JÖRG HEISER / THOMAS SCHÜTTE JULIAN HEYNEN, JAMES LINGWOOD, ANGELA VETTESE / STEPHEN SHORE MICHAEL FRIED, CHRISTY LANGE, JOEL STERNFELD / ROMAN SIGNER GERHARD MACK, PAULA VAN DEN BOSCH, JEREMY MILLAR / LORNA SIMPSON KELLIE JONES, THELMA GOLDEN, CHRISSIE ILES / NANCY SPERO JON BIRD, JO ANNA ISAAK, SYLVÈRE LOTRINGER / SIMON STARLING DIETER ROELSTRAETE, FRANCESCO MANACORDA, JANET HARBORD / JESSICA STOCKHOLDER BARRY SCHWABSKY, LYNNE TILLMAN, LYNNE COOKE / WOLFGANG TILLMANS JAN VERWOERT, PETER HALLEY, MIDORI MATSUI LUC TUYMANS ULRICH LOOCK, JUAN VICENTE ALIAGA, NANCY SPECTOR, HANS RUDOLF REUST / JEFF WALL THIERRY DE DUVE, ARIELLE PÉLENC, BORIS GROYS, JEAN-FRANÇOIS CHEVRIER, MARK LEWIS / GILLIAN WEARING RUSSELL FERGUSON, DONNA DE SALVO, JOHN SLYCE / LAWRENCE WEINER ALEXANDER ALBERRO AND ALICE ZIMMERMAN, BENJAMIN H. D. BUCHLOH, DAVID BATCHELOR / FRANZ WEST ROBERT FLECK, BICE CURIGER, NEAL BENEZRA / ZHANG HUAN YILMAZ DZIEWOR, ROSELEE GOLDBERG, ROBERT STORR